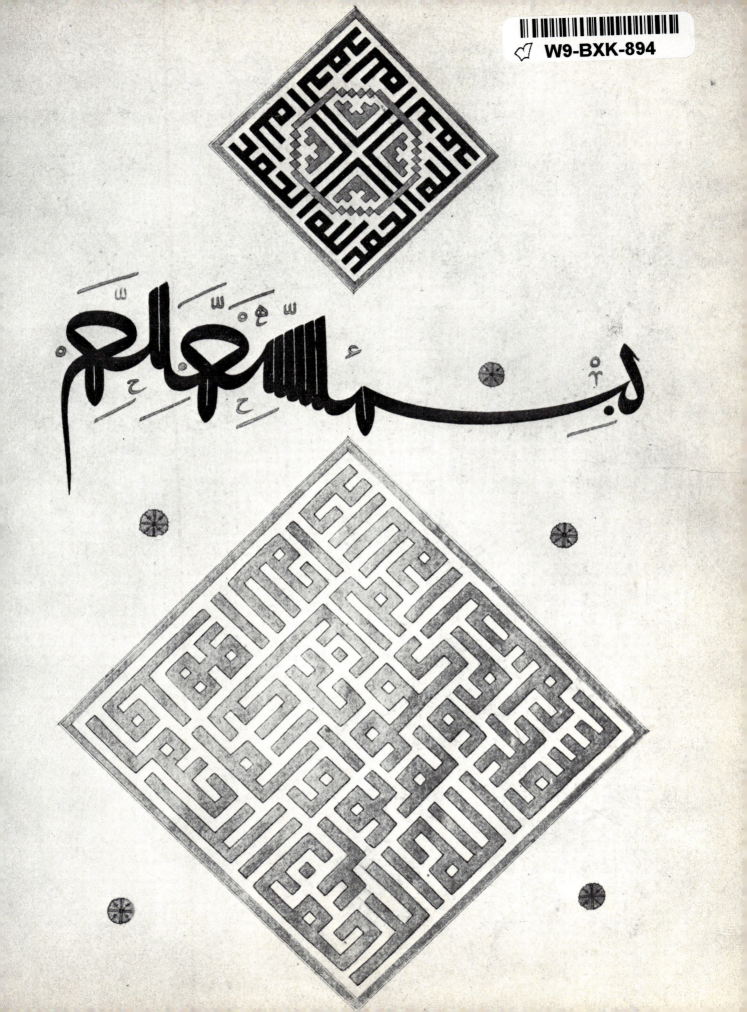

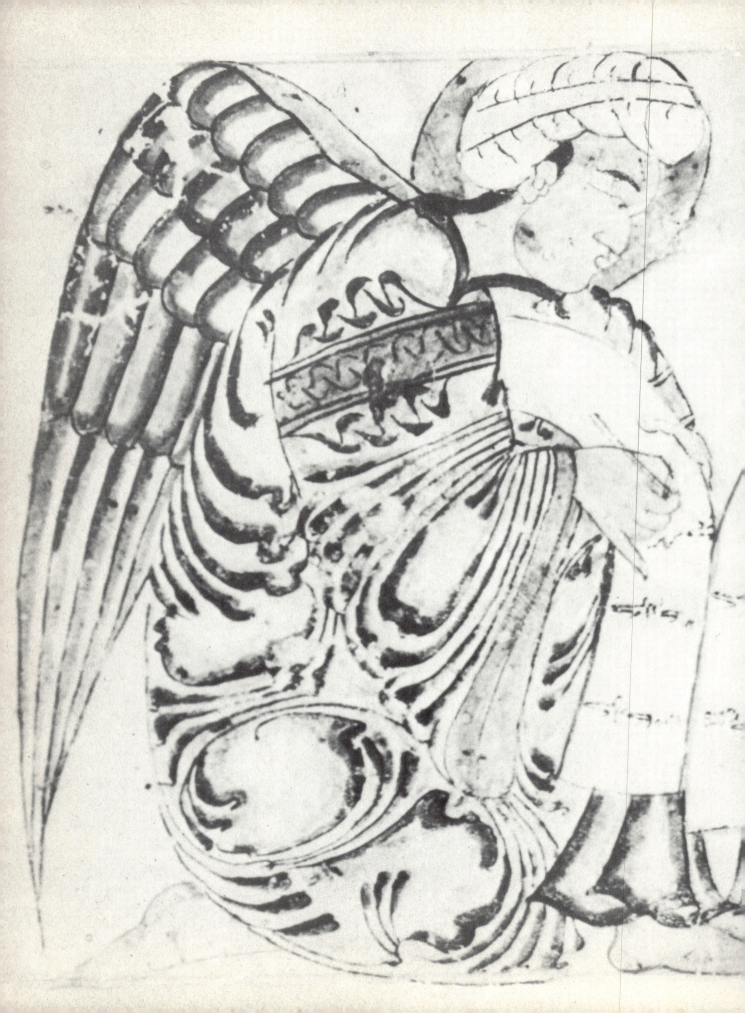

Islamic calligraphy

YASIN HAMID SAFADI

with 200 illustrations

THAMES AND HUDSON

To

His Excellency

Muhammad Mahdi al-Tajir

Page 1: Calligraphic page. At the centre the Basmalah, the formula *Bism Allāh al-Raḥmān al-Raḥīm*, 'In the Name of God, the Compassionate, the Merciful', written in a stylized linked form of one of the classic cursive scripts, Riqā'. The 'mazes' above and below are in square Kufic script, the upper one reading *al Ḥamd li-Llāh* – 'Praise be to God' – repeated four times, and the lower consisting of the Basmalah with the text of Sūrat al-Ikhlāṣ, 'Unity' (CXII, 1–4). It translates: 'Say, He is the one God, the eternal God, He begets none, neither is He begotten, and none is equal to Him.' By the hand of the celebrated Ottoman calligrapher Aḥmad Qaraḥiṣārī (d. 1555)

Title page: Two angels recording the good and bad deeds of men, from ῾Ajā᾿ib al-Makhlūqāt ('The Wonders of Creation') of al-Qazwīnī, a manuscript copied and illuminated at Wasit in Iraq in 1280. According to Muslim tradition, angels are God's scribes, messengers and servants

Grateful appreciation must be expressed to Miss Sheila Rockett in acknowledgment of her most generous help, especially in the bibliographical searches and the preparation of the index.

PICTURE RESEARCH: Georgina Bruckner MA

Filmset and printed in Great Britain by
BAS Printers Limited, Over Wallop, Hampshire

Contents

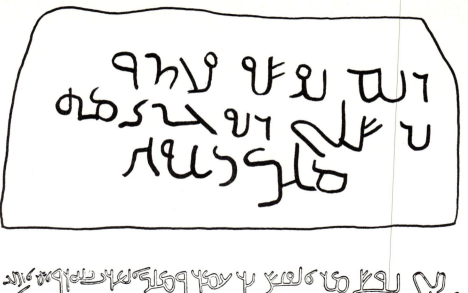

Nabataean inscriptions providing proof of the origins of Arabic script. The earliest inscription is on a tombstone from Umm al-Jimāl, dated c. 250 (top); the next is from the tomb of the poet Imru' al-Qays at Namārah, of 328; the third is from Zabad, dated 512, and begins *Bism al-ilāh* – 'In the name of god . . .'; the fourth is from Ḥarrān, dated 568, and begins *Anā Sharḥil* – 'I am Sharḥil . . .'; while the last is another inscription from Umm al-Jimāl, of the 6th century, and begins *Allāh ghafran* – 'May God forgive . . .'

Islamic calligraphy

Origins of the Arabic script

In contrast to other nations such as the ancient Egyptians, the Babylonians and the Chinese, whose complex writing systems date back thousands of years, the Arabs were late comers indeed. Although Arabic is only second to the Roman alphabet in terms of widespread use even today, the Arabic script was developed at a much later date.

The reason for this late development was that the Arabs were mainly a nomadic people and mistrustful of the written word. They relied to a very great extent on oral tradition for the retention of information and for communication. In pre-Islamic times, and especially in the sixth century, which was the heroic age of literature for the Arabs, poetry was perhaps the thing dearest to their hearts and the only means of literary expression, yet they relied almost exclusively on oral tradition for the perpetuation of their poems. According to Arab literary traditions, only the seven odes called *al-Muʿallaqāt*, which were considered absolute masterpieces, were committed to writing and especially honoured by being inscribed in golden letters and hung on the walls of the Kaʿbah at Mecca. Even after the advent of Islam in the early seventh century, the Qurʾān was at first mainly transmitted among the Muslims, not through the written word but by oral tradition. Nevertheless, once they recognized the necessity to commit their language to writing, they surpassed the world in the art of beautifying their script. They produced in a relatively short time an astonishing calligraphic development, transforming the Arabic script into an artistic medium that best reflected their genius and attracted their best artistic talents.

Arabic belongs to the group of Semitic alphabetical scripts in which mainly the consonants are represented. Although in the past there have been many contentious views about the origins of the Arabic script and its relation to those in the Semitic group, all serious scholars agree today that the North Arabic script, which eventually prevailed and became the Arabic of the Qurʾān, relates most substantially and directly to the Nabataean script, which was itself derived from the Aramaic script. Not only were the Nabataeans in close proximity to the other Arab tribes, but they had sustained commercial and cultural links with them. The Nabataeans, who were semi-nomadic Arabs, inhabited an area extending from Sinai and North Arabia to southern Syria, and established a kingdom centred around the main cities of Ḥijr, Petra and Buṣrā, which endured from 150 BC until it was destroyed by the Romans in about AD 105. Their language and script, as expected, outlived the destruction of their kingdom, and their script, especially, continued to have a profound impact upon the early development of Arabic writing. It is fortunate that the Nabataeans left us numerous inscriptions scattered in the area they inhabited. Particularly interesting from the point of view of this study are the inscriptions of Umm al-Jimāl, dating from about AD 250, the Namārah inscription of the famous pre-Islamic poet Imruʾ al-Qays, of AD 328, which represents an advanced transitional stage towards the development of the Arabic script, the Zabad inscription of AD 512 and the inscription of Ḥarrān from AD 568. A second inscription from Umm al-Jimāl, dating from the sixth century, confirms the derivation of the Arabic script from the Nabataean, and points to the evolution of distinct Arabic forms.

According to Arabic sources, these distinct forms constituted the so-called North Arabic script, which was first established in north-eastern Arabia and flourished particularly in the fifth century among the Arabian tribes who inhabited Ḥīrah and Anbār. From there it spread in the late fifth and early sixth century to Ḥijāz in western Arabia. Bishr ibn ʿAbd al-Malik is reputed to have introduced it into Mecca with the aid of his friend and father-in-law Ḥarb ibn Umayyah. It is Ḥarb, however, who is credited with having popularized its use among the aristocracy of Quraysh, the tribe of the Prophet Muḥammad. Among those who learnt writing from Bishr and Ḥarb, and became competent scribes, were ʿUmar ibn al-Khaṭṭāb, ʿUthmān ibn ʿAffān, ʿAlī ibn Abī Ṭālib, Talḥah ibn ʿAbd Allāh, Abū ʿUbaydah ibn al-Jarrāḥ and Muʿāwiyah ibn Abī Sufyān, all of whom were destined to play leading roles in the early development of Islam. The first three noted later became *al-Khulafāʾ al-Rāshidūn*, the so-called Righteous or Orthodox Caliphs, and Muʿāwiyah became the founder of the Umayyad dynasty which ruled the first great Muslim empire.

Soon after its establishment in Mecca, writing spread to the nearby town of Medina, where the tribes of Aws, Khazraj and Thaqīf took up the art of writing with an enthusiasm which rivalled that of Mecca. One of the scribes of Medina, Zayd ibn Thābit, attained great eminence, in that not only did he become the Prophet's most famous secretary, but he was entrusted with the task of collating and writing the first codex of the Qurʾān during the caliphate of ʿUthmān (644–56).

The earliest reference to Arabic script proper is with the name *Jazm*. This was most probably a further development of the Nabataean-derived forms of letters. Certain modifications were influenced by the Estrangelo type of Syriac script, which was much used, especially in Ḥīrah and Anbār in the late fifth or early sixth century. The Jazm's stiff and angular characteristics and the equal proportions of its letters no doubt influenced the development of the famous *Kufic* script, which followed some time later, and in which these same qualities predominate. The Jazm script continued to develop and gradually emerged as the script of all the Arabs, until, with the advent of Islam, it assumed the status of the sacred script which God had especially chosen to transmit His divine message to all men.

Māʾil (slanting) script in one of the oldest extant Qurʾāns, copied at Medina in the 8th century

Early calligraphic developments

It must be emphasized that the Qur'ān has always played a central role in the development of Arabic script. The need to record the Qur'ān precisely compelled the Arabs to reform their script and to beautify it so that it became worthy of the divine revelation. According to Islamic teachings, the Qur'ān was transmitted to the Prophet Muḥammad in the Arabic tongue through the intermediary of the Archangel Gabriel, and it therefore has the status of divine speech. The Prophet heard the first of these revelations in the cave of Ḥirā', near Mecca, with a voice commanding him: 'Recite in the name of thy Lord who created all things. He created man from a clot of blood. Recite! For thy Lord is most Beneficent. He has taught the use of the pen. He has taught man that which he knew not.' (Qur'ān, XCVI, 1–5). He continued to receive the revelation and to deliver it until his death in 632, after which the revelation stopped and was mainly transmitted from believer to believer orally by the Ḥuffāẓ (those who memorize the Qur'ān and can repeat it by heart). In 633, however, a number of these Ḥuffāẓ were killed in the battles that followed the death of the Prophet. This greatly alarmed the Muslim community, and especially ʿUmar ibn al-Khaṭṭāb, who was a close companion of Muḥammad and destined to be his second successor.

ʿUmar urged the first Caliph Abū Bakr to commit the Qur'ān to writing. The Prophet's secretary, Zayd ibn Thābit, was ordered to compile and collate the revelation into a book, which was later codified by the third Caliph ʿUthmān in 651. This canonized redaction was later copied into four or five identical editions and sent to the main Muslim regions to be used as standard codices from which henceforward all Qur'ān copies were to be produced, first in the scripts of Mecca and Medina, which were merely local variants of the Jazm script, then in the scripts of Kūfah, and later in most of the various Arabic scripts that were developed in the Muslim world.

Several calligraphic variants were developed from the Jazm script, each being called by a name relating it to its locality, such as the *Anbārī* of Anbār, the *Ḥīrī* of Ḥīrah, the *Makkī* of Mecca and the *Madanī* of Medina, but these different names did not imply that the variants had developed very distinctive characteristics; on the contrary, the available evidence points to the existence of only three main styles, which correspond to those known at Medina as *Mudawwar* (rounded), *Muthallath* (triangular) and *Tī'm* (twin, i.e. composed of both the triangular and the rounded). Of these three, only two styles were maintained, each with distinct features; one was cursive and easy to write, called *Muqawwar*, and the other, called *Mabsūṭ*, was angular and consisted of thick straight strokes forming rectilinear characters. These two main features governed the development of the early Meccan-Medinan scripts, and led to the formation of a few styles, the most important of which were *Mā'il* (slanting), *Mashq* (extended) and *Naskh* (inscriptional). It is interesting to note that these three styles were current in Ḥijāz when Kufic script was being developed in Kūfah, and endured until after the major reform of the Arabic scripts which was carried out in that city. The Mashq and the Naskh continued to be used after considerable improvements, whereas the Mā'il was discontinued, being replaced by the monumental and hieratic Kufic. There are a few extant examples of these early writings on parchment, and also in graffiti-type inscriptions on the rock walls of the mount of Salaʿ near Medina. Early papyri from the period of the Orthodox Caliphs have also come down to us, and most of these are written in the cursive type of script.

Early Naskh (inscriptional) on papyrus, dated 709. The text, in quite an elegant script, is an order from the Umayyad governor of Egypt, Qurrah ibn Sharīk, to a certain Basil instructing him to investigate a complaint

Developed Mashq (extended) script, from a Qur'ān copied c. 700–750

Kufic scripts

The establishment of the two new Muslim cities of Baṣrah and Kūfah, in the second decade of the Islamic era, gave rise to two groups of highly motivated and competing scholars who displayed intense interest in the Arabic language and its scripts. The Ḥīrah script was acknowledged to have been the leading script in that region, and it is not surprising that Kūfah was chiefly instrumental in bringing about the reform of the somewhat ungainly Meccan-Medinan script, for Kūfah was heir both to the population and to the culture of Ḥīrah. Although it must be assumed that the reforms were applied both to the rectilinear and curvilinear types of script, Kūfah became famous for reforming the first by making it conform to the discipline and some of the characteristics of the Syriac Estrangelo script. As a result, a new script was created, which had specific proportional measurements and a pronounced angularity and squareness, with short vertical strokes and extended horizontal lines. It became known as *al-Khaṭṭ al-Kūfī* (Kufic script), and not only superseded all the other earlier random attempts at improvement, but had the most profound effect upon the whole future development of Arabic calligraphy.

Inasmuch as the Meccan-Medinan scripts were very closely related, so were the Basran-Kufic scripts. The general opinion is that, after a short formative period, all the four scripts acquired a fundamental similarity, with only a few minor individual features, the most important of which was the moderately slanting strokes which were used in the scripts of Mecca and Medina, and which gave rise in the seventh century to the short-lived script called *Mā'il*. It can be seen that Mā'il has no orthographical or vowel marks, and no punctuation marks such as chapter headings or verse counts or section indicators, and no illumination, all of which conforms to the known features of script of an early date.

4, 14–15 The Mashq script also developed individual characteristics and became slightly more cursive, with a low vertical profile and horizontally extended strokes. The extent of the horizontal elongations was varied from line to line, even from word to word, in order to provide a balanced dispersal of the script mass on the page. Much was left to the discretion and taste of the individual calligrapher, provided that he observed certain basic rules such as not permitting horizontal prolongations of words consisting of three letters or less, or of words beginning a line, whilst extending words consisting of more than three letters. Furthermore, extended lines were normally followed by unextended ones, etc. In fact, the rules of the Mashq script grew so complex that it is not possible to describe them here in any great detail. Indeed, because of this complexity some of its rules were not always observed, and were later much simplified. These simplifications, with some improvements, helped the script to survive much longer than the Mā'il.

16–19 The Kufic script, which reached perfection in the second half of the eighth century, attained a pre-eminence which endured for more than three hundred years, and became by common consent the sole hieratic script for copying the Qur'ān. Because the Kufic script had a relatively low vertical profile, with almost no strokes below the main line of writing, but with extended horizontal strokes, it came to be written on surfaces of which the height was considerably less than the width. This feature was deliberately developed to give it a certain momentum, in order to compensate for its static quality. Indeed, all the Kufic Qur'āns which have come down to us have an oblong format. Even when the Kufic script, the use of which was not restricted to the copying of the Qur'ān, was employed epigraphically in Arabic inscriptions, or as an ornamental script, it was invariably written on oblong or extended rectangular panels.

It is significant that, until the beginning of the ninth century, Kufic Qur'āns received little illumination, but once this initial reluctance was overcome, various ornamental devices were evolved, many of which served necessary functions. Notable among these were the *ʿUnwān* (title pages), *Sūrah* (chapter)

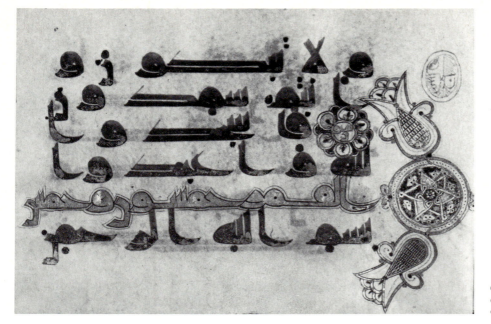

Qur'ān page with Sūrah heading, verse division and marginal ornaments, 9th century, probably copied in Kairouan

headings, verse divisions, verse counts, section indicators and colophons. These ornaments were at first used throughout the Muslim empire, and it is interesting to note that the more conservative Islamic West continued to use them with little modification until at least the end of the sixteenth century, whereas in the Islamic East they were substantially developed and modified after the tenth century, when distinct illuminative forms were especially designed for use with the Eastern Kufic script.

The early austere Kufic reflected the harsh cultural and social environment in which it grew, but when the times began to ripen into splendour and magnificence, Kufic mirrored this by developing purely ornamental forms.

Ornamental Kufic became an important element in Islamic art as early as the eighth century for Quranic headings, numismatic inscriptions and major commemorative writings. The simple elegance of the early ornamental Kufic found in the inscriptions at Kairouan and elsewhere is in contrast with the sumptuous richness of the epigraphy of the Fatimid, Seljuq and Ghaznawi periods. Muslim artists in Egypt and Syria under the Fatimid caliphs (909–1171) made extensive use of ornamental Kufic, most effectively on metal, glass, and textiles. In purely epigraphic terms, however, ornamental Kufic reached its peak in the eleventh century under the Seljuq sultans who held power during the latter period of the Abbasid caliphate.

5–6, 8–9, 11, 16–27

A fundamental point about Kufic epigraphy is that it was not subjected to strict rules, but gave the artist virtually a free hand in his conception and execution of its ornamental forms. At first the letters were extended into simple foliate and floral ornaments which did not interfere with the basic outlines, but especially from the beginning of the eleventh century, the letters themselves began to be used as ornaments, and this opened the way for the creation of ornamental letter forms. In addition, new geometric elements began to appear in the shape of plaiting, knotting and intertwining of the verticals of certain letters. The free ends of some letters, which at the beginning were simply squared off, began during the eleventh century to acquire ornamental extensions.

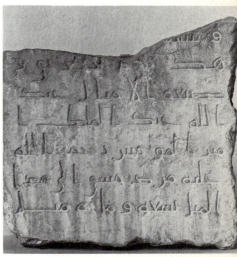

Early ornamental Kufic on a milestone placed on the Damascus–Jerusalem road by order of the Caliph ʿAbd al-Malik (685–705)

The epigraphic development of Kufic into more complex ornamental forms continued until late in the twelfth century, after which time the script lost its main function of expressing thoughts or communicating facts and became primarily decorative. The most important styles were the foliated, the floriated,

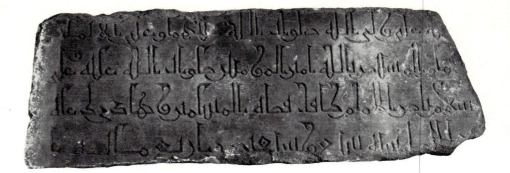

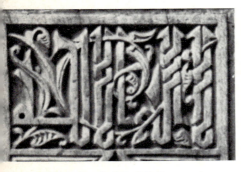

Foliated and plaited Kufic on a door
panel of the late 12th century,
probably from Iraq

the plaited, the knotted, the interlaced, the intertwined and the animated, in
which the letters take the form of human heads or figures, or animal shapes. As a
move in the opposite direction, and in contrast to this richness, the purest
angular form of Kufic was manipulated to form intricate geometric patterns
which can be seen on minarets and mosques and in maze-like calligraphic
patterns.

Ornamental Kufic was applied to every kind of surface, including brick,
stone, stucco, tile, wood, metal, glass, ivory, textiles and parchment, and
although it is found throughout the Islamic world, the best extant epigraphical
specimens are at Amid in south-eastern Turkey, at Kairouan in Tunisia, at
Cairo in Egypt, at Granada in Spain and at Ghazna in Afghanistan.

Eastern Kufic, a style first developed by the Persians in the late tenth
century, has certain characteristics that are markedly different from those of
standard Kufic. The most striking feature is that the long upstrokes remain very
vertical while the short strokes are inclined or bent to the left, thus giving a
dynamic forward movement and inducing certain European scholars to call it
'bent Kufic'. It was no doubt influenced by certain cursive scripts, for its lines
are more slender and more graceful than the standard Kufic, and it became
progressively lighter and more delicate.

The flourishes of certain letters were extended downward into the sublinear
area, a feature which it shared with Western Kufic, discussed later in this study.
Having freed itself from the bondage of the static form of standard Kufic,
Eastern Kufic went on to develop into a truly elegant style, which continued in
use until very recently as an ornamental script for headings in the Qur'ān.

One of the most beautiful derivatives of Eastern Kufic was the so-called
Qarmatian script, in which the Eastern Kufic characters, which by now had
acquired ornamental qualities, were integrated with a richly illuminated
ground consisting mainly of floral designs and arabesque. The name of this
script has never been satisfactorily explained. Two possible answers may be
offered. One is that its name related to *al-Qarāmiṭah*, a rebellious Muslim
movement which was founded by Ḥamdān Qarmaṭ in about 875 and later
extended to many parts of the Islamic empire, including Khurasan in Eastern
Persia, where the Qarmatian script was often used for copying the Qur'ān and
other important religious works. The Qarmatian movement endured for several
centuries, and it may well be that some of its members were responsible for the
script's development. A more likely explanation is purely linguistic: *qarmaṭa*

2, 28–30

Ornamental Eastern Kufic on a Qur'ān
frontispiece, Ottoman style, late 15th
century

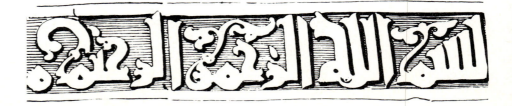

Foliated Kufic Basmalah, drawing of
the damaged inscription of Emir
Aḥmad at Amid, dated 1035

is a verb which forms part of an Arabic idiomatic phrase including the word *Khaṭṭ* (calligraphy), and reading: *qarmaṭa fī l-khaṭṭ*, which means to make the letters finer and to write the ligatures closer together. Close ligatures are indeed a feature of the Qarmatian script as compared with standard Kufic. Although extant specimens of Qarmatian Kufic are relatively rare, they are among the most splendid examples of Arabic calligraphy.

In the tenth century the standard Kufic script that was currently used in North Africa, and particularly in Tunisia and adjacent lands, began to develop certain individual features. This development proved to be of great consequence, as we shall see, because from this Western Kufic, all the various scripts of North and West Africa, and of Andalusia, are descended.

The reform of the Arabic script
The spirit of reform which produced the Kufic script was also directed to the functional use of the letters. It can be seen by studying the Arabic alphabet (p. 142) that there are many different consonants with identical letter outlines which are differentiated only by the use of one or more dots placed above, below or within a specific letter. The use of these dots, which is called *Naqṭ* or *I'jām* (letter-pointing), was only occasionally to be found in early Arabic scripts. Another feature is that only the consonants and the three long vowels ā, ū and ī are represented by letters. Unrepresented elements of Arabic speech include the short vowels *Fatḥah* (a), *Ḍammah* (u), *Kasrah* (i), the various diphthongs, the *Hamzah* (a glottal stop), the *Maddah* (vowel prolongation) and the *Shaddah* (double consonant) and *Sukūn* (vowelless).

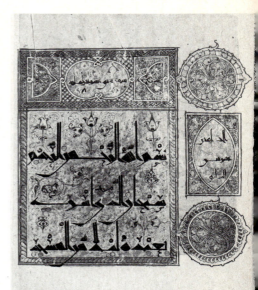

Qarmatian style of Eastern Kufic, with letter-pointing and occasional diacritical marks. Persian Qur'ān, 12th century

As a result of the Arab conquest of Syria, Egypt, Iraq, Persia and further afield both in the East and in the West, countless numbers of non-Arabs were converted to Islam. Very quickly, and especially encouraged by the Islamic teaching of equality between all believers, the nationality and culture of the neo-Muslims became less important to them than their affiliation to the Muslim community. Anyone who professed Islam and spoke Arabic was considered an Arab. To meet the great need to learn Arabic, and to ensure the correct pronunciation and interpretation of the Qur'ān, certain reforms became imperative.

Abū l-Aswad al-Du'alī (d. 688) was the legendary founder of Arabic grammar and is credited with inventing the system of placing large coloured dots to indicate those elements of Arabic speech that are not represented by letters. This system of diacritical marks, which is called *Tashkīl* (vocalization), became closely associated with the Kufic script and its derivative styles. It was later developed and supplemented by two pupils of Abū l-Aswad, Naṣr ibn 'Āṣim (d. 707) and Yaḥyā ibn Ya'mur (d. c. 708).

There still remained the problem of differentiating the consonants which shared identical letter outlines. This, according to Islamic tradition, was solved at the hands of al-Ḥajjāj ibn Yūsuf al-Thaqafī, the powerful and energetic Umayyad viceroy who was in charge of the eastern wing of the Muslim empire (694–714), and who ordered Naṣr and Yaḥyā to devise a system similar to that of Abū l-Aswad. Their system relied on the use of small black dots as differentiating marks, and adopted certain vowel signs from the Syriac. The dots were placed above or below the letter outline, either singly or in groups of two or three.

It is evident, however, that this system of letter-pointing was not an entirely new invention, since dots were similarly used with some letters in much earlier-dated inscriptions. It must be assumed, therefore, that Naṣr and Yaḥyā elaborated and codified earlier practices. It is also believed that Ḥasan al-Baṣrī (d. 729) made some contribution. Ḥajjāj, for his part, had the task of forcing the system's application against great initial reluctance.

The black dots were sometimes used simultaneously with Abū l-Aswad's system of coloured dots, and this tended to cause confusion. Even the

ب b

ت t

ث th

DIACRITICAL MARKS, OR
'VOCALIZATION'

Fatḥah (a) بَ ba

Ḍammah (u) بُ bu

Kasrah (i) بِ bi

Sukūn
(vowelless) بْ b

Shaddah
(doubled consonant) بّ bb

Cutting Hamzah أ

Joining Hamzah ٱ

Maddah آ

substitution of short diagonal strokes for dots did not satisfactorily solve the problem. A more drastic solution was needed, and one which would enable the scribe to write in a single coloured ink. This solution was provided by the famous Arab grammarian and philologist al-Khalīl ibn Aḥmad al-Farāhīdī (d. 786). Khalīl's system retained Ḥajjāj's system of letter-pointing by dots but replaced Abū l-Aswad's system of *diacritical dots* for vowels with one of eight new *diacritical marks* (see left, below).

There was reluctance to accept Khalīl's system in turn, and its application was initially restricted to secular writings; but once its merits were recognized, it rapidly gained wide currency in the East, where it was used in Qur'āns copied in Eastern Kufic script. In the Western wing of the Muslim empire, as we shall see, there was opposition to this new system, and due to conservatism the system of Abū l-Aswad continued in use there far longer than in the East. It is sometimes used even today for copying the Qur'ān. On rare occasions the systems of Abū l-Aswad, Ḥajjāj and Khalīl were used simultaneously.

The cursive scripts of that period, which we shall next be examining, with a few exceptions did not use the system of Abū l-Aswad, which was more suitable for larger scripts, but instead made full use of Ḥajjāj's system of letter-pointing and Khalīl's system of diacritical marks.

The systems of Ḥajjāj and Khalīl were soon merged into a single complementary system (left), which, although it was hardly ever used in early Kufic, was used at an early date in Eastern Kufic, and in all the cursive scripts. The consensus of opinion is that it gained ascendancy in the early eleventh century. It has survived with little modification, and is universally used today (see Arabic alphabet, p. 142).

It should be added, however, that ever since 'vocalization' was introduced there has been one objection to its use which remains valid even to the present day, and this is, that in employing it one implies imperfect knowledge on the part of the intended reader. Its use today, therefore, is reserved for important literary works, for religious texts including the Qur'ān, and for teaching purposes.

The development of the cursive scripts

Arabic writing, even at its very beginning in the Ḥijāz, may be said to fall into two very broad categories, one the *Muqawwar wa-Mudawwar* (curved and round), and the other the *Mabsūṭ wa-Mustaqīm* (elongated and straight-lined). The Mā'il and the Mashq and all the Kufic scripts relate to the second category, whereas to the first all the cursive scripts belong. It should be emphasized, however, that this general rule does not always apply, for a few calligraphic styles derived their characteristics from both categories, either at the point of their inception or subsequently through a stage of evolution. Reference has already been made to Ti'm, which arose out of both categories early in Medina, but was short-lived. The Western Kufic scripts were derived directly from standard Kufic but evolved in the direction of the cursive.

The 'curved and round' category dates back at least to the first decade of the Muslim era; its roots certainly reach back to pre-Islamic times, as we may observe from early Arabic specimens such as those found at the mount of Sala' (624–5), from the letters of the Prophet and the Orthodox Caliphs and from an inscription dedicating a dam built by Caliph Mu'āwiyah (661–80). It should be noted that the very early cursive scripts generally lacked elegance and discipline and were used mainly for secular purposes, and although these scripts were not derived from Kufic, they were certainly influenced by it, being directly affected by the improvements which produced the perfected Kufic. The system of diacritical marks and letter-pointing of Ḥajjāj and Khalīl were more readily incorporated into the cursive scripts than into Kufic, and have ever since been an integral part of these scripts.

The early dramatic development of scripts gave way to a slower pace of

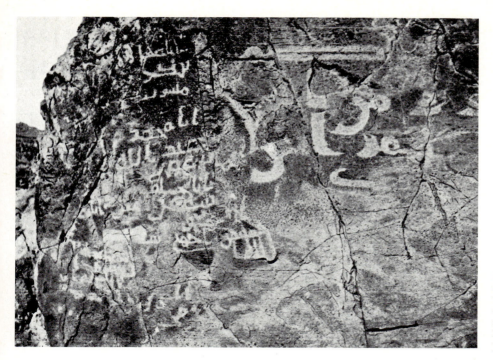

Early cursive graffiti at Mount Salaʿ near Medina. The inscription tells us that Abū Bakr and ʿUmar, who were destined to become the first and second Caliphs (successors to the Prophet), spent the night there praying, probably in 625

evolution during the Umayyad period (661–750). Unfortunately, the history of calligraphy in this period cannot be fully documented, because the caliphs of the succeeding Abbasid dynasty (750–1258), which rose upon the ruins of the Umayyads, were disastrously thorough in destroying Umayyad records, including most of the calligraphic specimens. They also effectively suppressed historical accounts relating to it, as a result of which our knowledge of the calligraphic development of the latter part of this period is rather fragmentary.

There has been frequent mention in Arabic sources of Quṭbah al-Muḥarrir, said to have been the first of a long line of Umayyad calligraphers, who distinguished himself by directing his great talent to the development and improvement of the secular cursive scripts that were current during his lifetime. Quṭbah is credited, in a few Arabic sources, with having invented the four major scripts, *Ṭūmār*, *Jalīl*, *Niṣf* and *Thuluth*; and some attribute to him also the invention of *Thuluthayn*. He is also known to have copied Arab histories

Early cursive script in a letter sent by the Prophet Muḥammad to the ruler of al-Ḥasā in the Gulf during the early 7th century and (below) in an inscription dated 677 dedicating a dam built by Caliph Muʿāwiyah (661–80), who founded the Umayyad dynasty

بسم الله الرحم الرحيم
لا اله الا الله وحده لا شريك
له محمد رسول الله امر بصنع هذ
الدكة عبد الله هشام امير المؤمنين
...الله على...

Umayyad Kufic inscription, dedicating a pool built for Caliph Hishām (724–43), with distinctly triangular letters

Developed Ṭūmār (*see* p. 21), reading *Allāh amalī*, 'God is my hope'

and anthologies, and is particularly noted for having adorned the miḥrāb of the Prophet's Mosque in Medina with verses from the Qur'ān written in gold Jalīl script. Another famous calligrapher was Khālid ibn al-Hayyāj, the official calligrapher of the Umayyad Caliph al-Walīd ibn ʿAbd al-Malik (705–15), who was reported to have copied many large Qur'āns in both Ṭūmār and Jalīl. There is a general agreement that all these scripts were initially and primarily evolved as secular scripts to meet the need of the ever-expanding volume of official, commercial and social correspondence, and for the production of secular manuscripts. There is some contention about the real significance of the names of these early cursive scripts. It is clear, however, that Jalīl was very large and monumental and was reserved for use by the most exalted people in society. Ṭūmār was also large, for it was written with large pens on uncut *ṭūmārs* (full sheets or rolls of parchment or paper). There is some consensus of opinion that the Ṭūmār script was purely rectilinear, whereas Jalīl, its near equal in size, was at least a little more curvilinear, with noticeable rounding of most letters. Ṭūmār is reputed to have been formulated on the direct instruction of the first Umayyad Caliph Muʿāwiyah (661–80), and later became the royal script used by the Umayyad caliphs. There are also some claims, which are not unlikely, that Jalīl was developed during the reign of Caliph ʿAbd al-Malik (685–705), who was the first to legislate the compulsory use of the Arabic script for all official and state registers. His son and successor Caliph Walīd was perhaps the first great patron of calligraphy, and was mainly responsible for introducing Jalīl and Ṭūmār for royal correspondence and for large Qur'āns.

The Niṣf and Thuluth scripts which relate directly to Jalīl were mainly used as ordinary secular scripts. Niṣf (half) derives its name from being approximately half the size of Jalīl or Ṭūmār; the width of the *Alif* (letter *a*) of Ṭūmār was taken as a basic unit of measurement, and is supposed to have been equal to about twenty-four horse's hairs. Similarly, the names Thuluth (one third) and Thuluthayn (two thirds), indicate the ratio of their size to that of Ṭūmār.

A rival theory is that the names Niṣf, Thuluth and Thuluthayn indicate the ratio of straight strokes to curves of these scripts. According to this theory, for instance, a third of the Thuluth script would consist of straight strokes. It is probable that each of these two theories tells some of the truth.

The degree of cursiveness in these scripts appears consistently to increase with the scaling down of the size of the letters. It is noticeable also that generally the higher or more important the occasion or purpose of writing, the larger the pen, the sheet and the script that were considered suitable for it.

Some Arabic sources list many names of cursive scripts, but these names cannot be taken to indicate a classification structure. The scripts do not in the main constitute distinctly variant styles, and should be considered as alternative names for very closely related styles, or as referring to minor or localized scripts. Discussion of these is outside the scope of this study, which is confined to the major scripts.

In the early decades of the Abbasid period (750–1258), two Syrian calligraphers, al-Ḍaḥḥāk ibn ʿAjlān and Isḥāq ibn Ḥammād, deserve to be especially mentioned. Their fame, however, rests more on their apparently outstanding artistic abilities than on their inventive skills. Isḥāq is singled out for his achievements in introducing a greater degree of lightness and elegance to the Thuluth and the Thuluthayn, and for popularizing their use. His pupil Yūsuf al-Sijzī (d. 825) created two more delicate varieties of these scripts, which came to be called *Khafīf al-Thuluth* and *Khafīf al-Thuluthayn*. He also modified the Jalīl by refining its lines a little and by closing and rounding its open curves, but retained its feature of large-headed letters. This resulted in an elegant and delicate script which soon attracted the attention of Faḍl ibn Sahl, the Vizir of the Caliph al-Maʾmūn (813–33). Faḍl greatly admired this new script and ordered it to be used for all the official records and registers, naming it *Riyāsī* (ministerial). Ibrāhīm al-Sijzī (d. 815), Yūsuf's brother, was also an accomplished calligrapher, and he passed on his skills to one of his outstanding pupils, called al-Aḥwal (the squint-eyed) al-Muḥarrir. Aḥwal derived several cursive calligraphic styles from the Riyāsī script, to each of which he assigned a function, such as the writing of prose narratives, anthologies, registers, religious texts, pigeon-post messages, etc. Most of these styles were short-lived, however, and the few which have survived to the present day passed through the meticulous hands of later calligraphers who subjected them to strict calligraphic rules. Six of these styles came to be known as *al-Aqlām al-Sittah* or *Shish Qalam* (the six pens, or calligraphic styles) and are, according to accepted tradition, Thuluth, Naskhī, Muḥaqqaq, Rayḥānī, Riqaʾ and Tawqīʾ.

Despite all its dynamic development up to the late ninth century Arabic calligraphy was now about to enter its most glorious phase. Abū ʿAlī Muḥammad ibn Muqlah (d. 940) and his brother Abū ʿAbd Allāh were tutored in the art of calligraphy by Aḥwal, and both became accomplished calligraphers in Baghdad at an early age. It was Abū ʿAlī ibn Muqlah's genius and his knowledge of geometric science which were responsible for bringing about the most important single development in Arabic calligraphy. Whenever the name of Ibn Muqlah is mentioned in the following pages, therefore, it refers to Abū ʿAlī, who was the true founder of Arabic cursive calligraphy. He was Vizir to the three Abbasid caliphs al-Muqtadir (908–32), al-Qāhir (932–4) and al-Rāḍī (934–40). He was unfortunate in having been associated with caliphal affairs during their most turbulent times, when oppression, corruption and political intrigue were prevalent. This led first to his torture, and the cutting-off of his right hand and his tongue, and finally to his death at the hands of Caliph al-Rāḍī in 940; nevertheless, he seems to have accomplished a task which no other calligrapher before or after was able to equal, and which has earned him a high place in the literary annals of Islam.

It has been established that by the late ninth century more than twenty cursive styles were in common use, many of which lacked the elegance of the perfected Kufic, and all of which were in urgent need of discipline to avoid the inevitable degeneration and proliferation into an endless multiplicity of styles.

Ibn Muqlah, therefore, set himself the task of designing a cursive script which would be at the same time beautiful and perfectly proportioned, so that it could effectively compete with the Kufic script. He laid down a comprehensive system of basic calligraphic rules based on the rhombic dot as a unit of measurement. He redesigned the geometric forms of the letters and fixed their relative shape and size using the rhombic dot, the 'standard' Alif and the 'standard' circle. For this system, the rhombic dot was formed by pressing the pen diagonally on paper so that the length of the dot's equal sides were the same

Ibn Muqlah's system. Top: *Alif* scaled to the seven rhombic dots placed vertex to vertex; centre: standard *Alif* and standard circle; *above*: proportional measurements – the letter *ʿAyn*; *left*: selected letters illustrating the application of the system

أ ب ف ك ف ح ع د ر و ل ن ق ص س ص م ه ي ط

as the width of the pen. The standard *Alif* was a straight vertical stroke measuring a specific number of rhombic dots placed vertex to vertex, and the number of dots varied, according to style, from five to seven; the standard circle had a radius equal to *Alif*. Both standard *Alif* and standard circle were also used as basic geometric forms.

It is beyond the scope of this study to describe Ibn Muqlah's complex geometric and mathematical system further, save to say that he succeeded admirably in giving the art of calligraphy precise scientific rules, according to which each letter is rigorously disciplined and related (*mansūb*) to the three standard units, the rhombic dot, the *Alif* and the circle. This new method of writing was called *al-Khaṭṭ al-Mansūb*, and it proved to be readily applicable. Ibn Muqlah is reputed to have pioneered its application to the six major cursive scripts mentioned earlier, as well as to a few others. The only surviving specimens believed to be in his hand are preserved in the Iraqi Museum in Baghdad. These consist of nine pages in Naskhī and Thuluth, with a colophon notation attributing them to Ibn Muqlah.

Ibn Muqlah's pupils, Ibn al-Simsimānī and Ibn Asad, continued much in the tradition of their master, and it fell to one of their pupils, a talented young artist called Abū l-Ḥasan ʿAlī ibn Hilāl, better known as Ibn al-Bawwāb (d. 1022), to add significantly to Ibn Muqlah's work. Without violating any of the rules, he managed with an artist's soul to give grace and elegance to the geometric harmony of the letters designed by Ibn Muqlah. This more graceful style came to be known as *al-Mansūb al-Fāʾiq* (the elegant Mansūb). Ibn al-Bawwāb's artistic contribution to Arabic calligraphy in general, and to the six scripts in particular, is valued as highly as that of his great predecessor. Ibn al-Bawwāb perfected and beautified all the six styles, but especially favoured the Naskhī and the Muḥaqqaq scripts, which ideally suited his genius, and in which he is still unsurpassed. Although he is reported to have written sixty-four Qurʾāns and a large number of secular works, only one of his Qurʾāns and fragments of his secular works remain to the present day.

As a witness to the quality of calligraphy during the twelfth century we may especially mention just one example, a magnificent Qurʾān in Muḥaqqaq which was copied in 1160 by Masʿūd ibn Muḥammad al-Kātib al-Iṣfahānī, whose father was famous both as a man of letters and as the biographer and close friend of the great Ṣalāḥ al-Dīn (Saladin).

During the following century Yāqūt al-Mustaʿṣimī (d. 1298) devised a new method of trimming his reed-pens, giving them an oblique cut. This enabled him to give the already elegant six scripts a new dimension of grace and beauty, as if, by his hand, calligraphy had attained an ideal upon which it would not be possible to improve. To crown his achievements Yāqūt evolved a new style from Thuluth, which became known as *Yāqūtī*, and which is said to have surpassed all other styles.

Yāqūt is reputed to have been a strict tutor, requiring his pupils to practise for long hours. He himself practised daily by copying two sections from the Qurʾān, a routine which he apparently refused to break even when Baghdad was being sacked by the Mongol armies in 1258, for while the city was still burning, he took refuge in a minaret, pen and ink in hand, and practised writing on a piece of linen. This delightful anecdote, which may well be true, is illustrated in miniature-paintings depicting Yāqūt writing at the top of a minaret. Yāqūt lived a long life, and was by all accounts a most prolific calligrapher, but this is not reflected in the quantity of extant works by his hand. Indeed, genuine Yāqūt specimens are extremely rare and are considered among the most valuable Islamic treasures that have come down to us.

Having attained these levels of perfection, the cursive scripts, particularly Thuluth, went on to evolve special ornamental forms which began to be used in Qurʾāns and in secular manuscripts, and which permitted them to compete successfully with Kufic in the field of epigraphy.

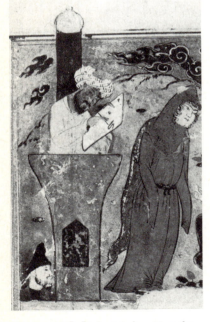

The great Yāqūt depicted writing the letter *Kāf* while taking refuge in a minaret during the sacking of Baghdad by the Mongol armies in 1258. Detail from a Persian miniature-painting

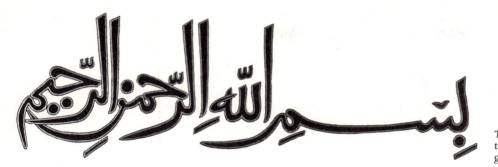

The Basmalah in Thuluth according to the style of Ibn al-Bawwāb, black with gold outlines

The major scripts according to classical tradition

The classical tradition of Islamic calligraphy, which was established by Ibn Muqlah and lent beauty by Ibn al-Bawwāb, and which had attained its ideal in the splendid achievements of Yāqūt, now entered a period of consolidation. It is *67, 104* appropriate, therefore, to pause at this point to look at the major cursive scripts in more detail.

The *Sittah* (six) scripts according to classical tradition, Thuluth, Naskhī, Muḥaqqaq, Rayḥānī, Riqāʿ and Tawqīʿ, have already been introduced above.

Thuluth, a static and somewhat monumental script, was mainly used for *31–47* decorative purposes in manuscripts and inscriptions. An ornamental variety of Thuluth was developed by Ibn al-Bawwāb and Yāqūt, and this became so closely associated with the Qurʾān and other religious texts that it rightly assumed the status of hieratic script. It was mostly used in headings, titles and colophons. Qurʾāns copied entirely in Thuluth are extremely rare. A magnificent seven-volume Qurʾān in the British Library is unique in being *34* copied entirely in finest gold Thuluth.

Although it would not be wrong to concede the claim that Naskhī, as a *48–57* general term, dates back to the late eighth century, the script did not appear in a more systematized form until the end of the ninth century. It was not, then, counted among the elegant scripts and was used mostly for ordinary correspondence, especially on papyri. Its main appeal to the ordinary man was that it had an easy-to-write cursive geometric form, without any structural complexities. The Arabs, having learnt the art of manufacturing paper from the Chinese in around 750, introduced its use throughout Muslim lands, and it soon replaced other writing materials such as papyrus and parchment. Its ready availability enabled the Naskhī script, too, to spread throughout the Islamic East. Since the Naskhī script lacked strict conformity, it had the most to gain from Ibn Muqlah's system. Ibn Muqlah himself formulated perfect proportional Naskhī characters, which dramatically elevated it to the rank of a major script. The final touches were provided by the hand of Ibn al-Bawwāb, who had a marked preference for Naskhī, and transformed it into a script worthy of the Qurʾān. This can be seen in the only surviving Qurʾān by his *32* hand, which was copied in Naskhī with headings in Thuluth in 1001.

A Qurʾān in small Naskhī, dated 1036, a mere fourteen years after the death of *48* Ibn al-Bawwāb, illustrates its dramatic and rapid ascendancy into the exclusive group of Quranic scripts. Yet another fine example of a Naskhī Qurʾān, dating *49* from the twelfth century, has letters and words exceptionally well formed and well spaced. With such fine Naskhī Qurʾāns as exemplars, it is not surprising that Quranic Naskhī attained a very high standard which has been maintained to the present day, and that there are more Qurʾāns copied in Naskhī than in all the other Arabic scripts together.

Muḥaqqaq was the name first given to an early script in which the letters *58–65* were less angular than Kufic, with well-spaced ligatures; the whole being 'meticulously produced', as its name implies. This very meticulous attention to certain details was considered at the time a sufficient mark of excellence. With the discovery of paper around 750 and its rapid spread, Muḥaqqaq also became

Quranic scroll with Sūrah headings in Riqā' (top and fourth band), the Basmalah in Thuluth verging on Tawqī' (in black ink, second and fifth bands), and Quranic text commencing in minute Naskhī (third and sixth bands) and continuing in Ghubār. Turkey, 17th century

more widely used and less deliberately controlled. During the caliphate of al-Ma'mūn (813–33) it acquired a certain roundness which made it easier to write, and it became the preferred style of the *Warrāqūn* (professional scribes). Modified by Ibn Muqlah when he subjected it to his Mansūb system, and established by him as a great script which could always be meticulously reproduced, it continued, however, to retain its main features of extended upstrokes and almost no downstrokes or deep sublinear flourishes. Its full perfection was realized at the hands of Ibn al-Bawwāb (d. 1022), who gave it shallow and sweeping horizontal sublinear flourishes for impetus and more extended upstrokes for grandeur. This made it, for more than four centuries, the favourite script for large Qur'āns throughout the Islamic East, and especially

62
60, 63
during the thirteenth and fourteenth centuries in Egypt under the Mamluk sultans, and in Iraq and Persia under the Il-Khanid Mongols.

66–70
The Rayhānī script was said to have been derived from Naskhī, but it is evident that it also has some of the features of Thuluth, though it is much more delicate. It is mainly because of this delicacy that some sources wrongly associate its name with *al-Rayhān* (basil), a plant noted for its delicate stems. This feature is accentuated because the strokes and flourishes of its letters end in sharp points, and its diacritical marks are very fine and are always applied with a different pen with a much smaller cut. The diacriticals are often in colour. Another feature of Rayhānī, as compared with Thuluth, is that its vertical strokes are straight and extended.

Despite its derivation, Rayhānī developed a close affinity with Muhaqqaq, to which it may be considered a sister script. Rayhānī, however, is usually written with a pen the cut of which is about half as wide as that used for Muhaqqaq. One of its most distinctive characteristics, which it shares with Muhaqqaq, is that the centres of the loops of the letters are never filled in. Unlike Muhaqqaq, however, it makes full use of sublinear flourishes, as does Thuluth, though its curves are more open than those of Thuluth. Rayhānī, too, became a favourite script for large Qur'āns, and was especially preferred in Persia under the Il-

66
Khanid sultans who were contemporary with the Mamluk sultans of Egypt. Although some sources attribute its creation to Ibn al-Bawwāb because he enhanced its beauty, it must rightfully be attributed to 'Alī ibn 'Ubaydah al-Rayhānī (d. 834), from whom it derives its name. One of the most beautiful

67
specimens of this script to reach us is a magnificent Qur'ān copied by the hand of Yāqūt.

71–3
Tawqī' (signature), which is also known as Tawāqī', was invented in the time of the Caliph Ma'mūn, and is supposed to have derived its forms from the Riyāsī script, which the Abbasid caliphs used when signing their names and titles. It has a close affinity with Thuluth, though its letters are more rounded. It shares many characteristics with Riqā', described below. The lines in Tawqī', however, are thicker than in Riqā' and its curves are less rounded, which gives it the appearance of a much heavier script. It is also a larger and much more elegant script than Riqā', and is usually reserved for important occasions. Tawqī' did not develop fully until late in the eleventh century. Its establishment as a major script was brought about by Ahmad ibn Muhammad, called Ibn al-Khāzin (d. 1124), who was a second generation pupil of Ibn al-Bawwāb whom he admired and emulated. The same calligrapher is credited with the invention of Riqā', and was responsible for its development into a major script closely related to Tawqī', indeed regarded as its twin. During the late fifteenth century, a heavier variety of Tawqī' was developed in Turkey, which was not only similar in size to Thuluth but verged even more closely on many of its characteristics. This developed Tawqī', like Thuluth, became much favoured by the Turks, but was not as popular among the Arabs as Riqā'.

74
The Riqā' script, also called *Ruq'ah* (small sheet), from which it gets its name, was derived from both Naskhī and Thuluth. The geometric forms of its letters, particularly the flourishes of the final letters, resemble those of Thuluth in

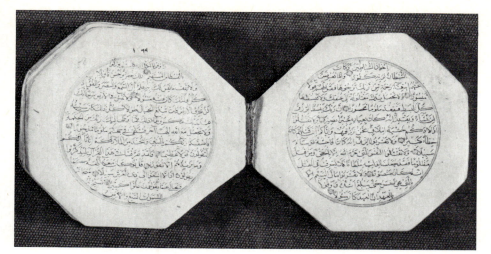

Ghubār script in a miniature octagonal
Qurʾān copied in Shiraz in 1543.
Maximum text width only 1¾ inches
(4.5 cm)

many respects, but it is much smaller and with more rounded curves, and its *Alifs* are never written with barbed heads. Other characteristics are that the centres of the loops of its letters are invariably filled in, its horizontal lines are very short and its ligatures are densely structured, with the final letters of the preceding words often linked to the first letters of the following words. It was mainly used for personal correspondence and less important secular books, all of which would have been written on medium-size paper. Riqāʿ was one of the favourite scripts of the Ottoman calligraphers, and received many improvements at the hands of the famous calligrapher Shaykh Ḥamdullah al-Amāsī (d. 1520). It was progressively simplified by later calligraphers until it eventually became one of the most popular and widely-used scripts. It is extensively used today as the preferred script of handwriting throughout the Arab world.

According to traditional opinion, four more cursive styles are to be regarded as major in addition to the 'six styles'. These four are Ghubār and Ṭūmār, introduced below, and Taʿlīq and Nastaʿlīq which will be discussed later.

The invention of the Ghubār (dust) script, which is also known under its full name of *Ghubār al-Ḥalbah*, is attributed to al-Aḥwal, who apparently derived it from the Riyāsī script in the ninth century. Although it was described at an early date as a cursive script with very rounded letters and without a single straight line, a developed version of Ghubār which survives to the present day consists of minute rounded letters with certain geometric characteristics relating it both to Thuluth and to Naskhī. It was initially devised for writing messages and brief correspondence on tiny sheets of paper to be sent by pigeon-post, but was later used for various other purposes, and even for the copying of miniature Qurʾāns. Many early specimens of this script have come down to us, including several miniature Qurʾāns copied in rectangular, hexagonal and octagonal format. The Ghubār script has enjoyed popularity up to the present day, and we shall return to it when discussing recent calligraphic developments.

The Ṭūmār script has already been described as one of the earliest Arabic scripts (p. 16). Although it still retained its large and heavy characters, by the tenth century it had lost its static and angular characteristics. Under the hands of Ibn Muqlah, Ibn al-Bawwāb and Yāqūt al-Mustaʿṣimī it acquired elegant letters with graceful curves, not unlike those of an exaggeratedly large Thuluth.

The Maghribī scripts

There has been frequent reference in earlier pages to the Islamic West and the Islamic East; it must be stressed, however, that these two general terms do not specifically refer to any political reality, nor do they reflect a definite cultural division. The terms are used here as a simplification of the very complex and composite world of Islam which is usually referred to by Muslims as *Dār al-*

Western Kufic in a Qur'ān copied in Kairouan, 10th century, without letter-pointing and with only a few diacritical marks

Islām. Its composite nature produced diverse artistic trends which were nevertheless overshadowed by an acute sense of religious unity and a certain measure of affiliation to a rich and common cultural heritage. With this consideration in mind, Dār al-Islām may be said to consist of two main sectors, one in the East, generally referred to as *al-Mashriq*, and the other in the West which is known as *al-Maghrib*. The Mashriq, or the Islamic East, consists of all the Islamic countries to the east of present-day Libya, including Turkey. The Maghrib, or the Islamic West, comprises all the present Arab countries west of Egypt and also includes Andalusia, the Muslim part of Spain during the Middle Ages.

Throughout the historical development of the Islamic civilization, the Maghrib evolved its own distinctive form of Islamic art. It is not surprising, therefore, that it also had a separate calligraphic development.

The development of Western Kufic took place in Kairouan, in present-day Tunisia, a town first established by the Arabs in 670. It rose dramatically to become the most important city in the newly-conquered Muslim territories in North Africa, and soon became the capital of a new dynasty. The Aghlabids (800–909), who established their dynasty after they broke away from the Abbasid caliphate in Baghdad, were great patrons of the arts. As their capital, Kairouan flourished and became an important cultural and religious centre, first under the Aghlabids and later under their successors the Fatimids (909–1171). The Great Mosque became a centre for learning and a school for calligraphy where a large number of Qur'āns were copied. Kairouan thus played a central role in the development of Western Islamic calligraphy.

1, 75 The main distinguishing feature of Western Kufic is the noticeable rounding of the angles of the earlier Kufic, and the modification of its predominantly rectangular forms into more cursive ones with definite curves and almost perfect semicircles. Such curves and semicircles are most evident in the flourishes of the final forms of certain letters. It is these types of flourishes which are extended into the sublinear area of the script and which became a distinctive feature of Western Kufic and later of the Maghribī scripts.

The Mansūb system of Ibn Muqlah did not find favour in the Maghrib, and as no other system was applied, Western Kufic evolved directly from standard Kufic without any constraining discipline. It relied instead on the exceptional aptitude of the people of the Maghrib for emulating the calligraphy of acknowledged masters and being guided by an artistic sensibility which grew more and more conservative. The result of this virtually free calligraphic development proved on the whole to be remarkably beautiful.

Western Kufic did not deliberately adopt any of the calligraphic features which evolved in the Islamic East as a result of the application of Ibn Muqlah's rules; nor did the Eastern cursive scripts themselves gain much popularity in the Islamic West; consequently, of the many Eastern cursive scripts, only Thuluth and Naskhī were used to a limited extent, and even these did not gain ready acceptance, but were, rather, extensively modified until they became identifiable as Western. Moreover, since they were mostly used in Andalusia, it would be appropriate to call them Andalusian Thuluth and Andalusian Naskhī.

81, 85, 84

Standard Kufic continued in use for many centuries as a monumental script, and as elsewhere developed exaggeratedly decorative forms for use in epigraphy. The tendency towards a more cursive form continued, culminating in the eleventh century in a dramatic development.

This development was the establishment of a cursive script which owes little 76–80 to the other cursive scripts of the East, yet surpasses many of them in the delicacy of its lines, the free flow of its open curves, its clear and rounded loops, and above all in its very deep sublinear flourishes which give it a unique quality of integration, not only between the letters and the words, but also between the lines. The slender and delicate curves and flourishes reach out and touch other letters in adjoining words. Other characteristics of the *Maghribī* are that its upstrokes invariably terminate with a slight curve to the left, and have relatively blunt ends, whereas its downstrokes have tapering lines, with sweeping curves also to the left which may extend into the area of the word below. Furthermore, the short upstrokes for certain letters such as *ṭ*, *ẓ* and *k* are always written inclined towards the right.

Khalīl's system of diacritical marks was used in Maghribī, with some rare exceptions, from the very beginning, but some elements of Abū l-Aswad's system, such as the use of coloured dots to indicate *Hamzah* and *Maddah*, were retained and continued to be used simultaneously with the system of Khalīl. Ḥajjāj's system of letter-pointing was also used with Maghribī, except that the Arabic letters for f and q are written ف and ق in the East, but are usually written ڢ and ڧ in Maghribī.

Bold Western Kufic in the splendid Ḥādinah Qur'ān, copied in Kairouan in 1020, with a few vowel marks but no letter-pointing

The lightness and grace of the Maghribī script were often effectively contrasted with the massive ornamental Kufic which was chosen for the headings. The size of the script relative to the page, and its density, were left to the discretion of the calligrapher and the need of the occasion. The difference in a single script may range, given the same size of page, from two or three monumentally written words per line to a densely copied line consisting of twelve words or more. It is in keeping with Western conservatism that whereas in the East paper became the normal writing material after the eighth century, parchment continued to be used in the Maghrib until the end of the fourteenth century. The oblong format was also retained for a longer time, indeed was still used as late as the eighteenth century.

Although Maghribī was first formulated at Kairouan, it soon spread to become the most widely-used script throughout North-West Africa and Muslim Spain. This inevitably exposed the standard early Maghribī script to local influences which eventually produced slightly variant regional styles. It must be stressed, however, that Maghribī retained most of its characteristics and permitted only minor modifications. The simple act of copying acknowledged masters, rather than applying a laid-down system of calligraphic rules which yet allowed some individual discretion in inessentials, also helped to stabilize the Maghribī script, and induced the calligraphers to maintain a conformity within the family of Maghribī scripts.

Despite this conformity it is possible to distinguish four styles, *Qayrawānī*, *Andalusī*, *Fāsī* and *Sūdānī*. Qayrawānī was certainly the earliest to develop and the first to give way to another script, in this case the Fāsī. It was usually written on medium-size parchments which were often oblong in shape. It generally shows a hint of resemblance to Naskhī, and has very short upstrokes. When

Examples of Qayrawānī style of Maghribī script, without vowel marks (top), and Fāsī style of Maghribī script, with vowel marks and letter-pointing

copying the Qur'ān, its monumental variety is used, which is relatively heavier, fully vocalized and meticulously executed. In secular works, however, only very essential vocalization is used, and the letters are not only smaller, but depart from regular forms.

78, 122 Andalusī is easier to recognize because it is more compact than the other styles and has smaller letters. Its lines are very fine and it is generally more delicate than its sister scripts. It is not usually found semi-vocalized, and when fully vocalized it follows the system of Khalīl, but at the same time it employs coloured dots for the *Hamzah* and *Maddah* according to Abū l-Aswad's system. Although this style had its origins in Qurtubah (Cordoba), the most illustrious city of al-Andalus (Andalusia) – hence it is also known as *Qurtubī* – it quickly established itself as the regional style for the whole of Muslim Spain. It also crossed the Straits and spread to Morocco, and subsequently established close affinity with Fāsī. The eventual loss by Islam of all its domains in the Iberian Peninsula, however, resulted in the forcible deportation of nearly all Muslims on Spanish soil; with them the Andalusian script and its calligraphers were also ousted and found refuge in Morocco. This naturally resulted in the amalgamation of Andalusī and Fāsī into one script.

Fāsī was larger and less compact than Andalusī, and had deeper flourishes, and it transmitted these characteristics to Andalusī when the two were amalgamated. The resulting script was simply called Maghribī. An ornamental variety of this Maghribī soon developed, and was usually written or engraved in monumental size with long upstrokes each extending to the same height, the whole creating a solid rectangular panel which was usually filled with arabesque and floral designs.

Sūdānī was first developed in Timbuctu, which was founded in 1213 and became the most important Islamic centre in the sub-Saharan region of North-West Africa. Sūdānī, which takes its name from the Arabic term *Bilād al-Sūdān* (lands of black Africans), spread throughout the Islamic belt from Mauritania to the Sudan. It became the preferred script amongst the Hausas, the Fulanis and other Muslim peoples who inhabit these sub-Saharan regions, which extend as far south as Nigeria. In addition to its common Maghribī characteristics, its lines are thick and its letters are densely written, all of which combine to give it a heavy and somewhat clumsy appearance. There is very little evidence to suggest that Sūdānī has undergone any process of systematization or been subjected to any strict discipline. As a result many of its strokes tend to be irregular.

The resurgent Maghribī script which resulted from the amalgamation of Andalusī and Fāsī in the early seventeenth century began to assert itself successfully as the major script in North-West Africa. Only Sūdānī, which developed separately, still retains its name and is currently used by all the Muslims of sub-Saharan West Africa, whenever they write in the Arabic characters, whereas Maghribī is the predominant script in present-day Morocco, Algeria and Tunisia, and to a lesser extent also in Libya.

Sūdānī style Maghribī script, with letter-pointing and full vocalization, in a Qur'ān copied in northern Nigeria, early 19th century

Later calligraphic developments

The thirteenth century, which we left with Yāqūt, was an age of destruction and reconstruction in the Islamic East. The destruction was brought about by Chengiz Khan (1155–1227) and his Mongol armies, and culminated in the capture of Baghdad by his son Hulagu in 1258 and the final collapse of the Abbasid caliphate. The reconstruction followed almost immediately with the establishment of Mongol rule, and Hulagu's son Abaqa (1265–82) was the first ruler to assume the new dynastic title of *Il-Khan* (Lord of the Tribe). It must be considered remarkable that Islam was able, after having been so devastated, to rise again and continue with undiminished vitality. Less than half a century after the destruction of Baghdad, Islam triumphed over its heathen conquerors, for, not only was Hulagu's great-grandson Ghazan (1295–1305) converted to

Islam, but he made it the state religion throughout his domains. Ghazan became a learned and devout Muslim and devoted much of his time to the enhancement of Islam and the revival of its culture. He greatly encouraged the Islamic arts, including those of calligraphy and book illumination.

This excellent tradition was continued by his brother and successor Uljaytu (1306–16), whose reign was rich in superb artistic and literary achievements. He was fortunate in having as ministers two enlightened men, Rashīd al-Dīn and Saʿd al-Dīn, who encouraged him to patronize learned men, artists and calligraphers. Under him, the Il-Khanid art of calligraphy and illumination reached its zenith, as can be seen from a magnificent Qurʾān in Rayḥānī 66 commissioned by Uljaytu and copied and illuminated in 1313 by ʿAbd Allāh ibn Muḥammad al-Hamaḏānī. Another master calligrapher of the early Il-Khanid period, who had been tutored by Yāqūt, Aḥmad al-Suhrawardī, has left us a Qurʾān copied in Muḥaqqaq in 1304. Yāqūt attracted a large number of pupils, 63 who not only emulated him but proudly attributed their works to him, which helped to perpetuate his fame.

Uljaytu was followed by his son Abū Saʿīd (1316–34), in whose reign the political decline of the dynasty began, but the high level of its cultural life, including the art of calligraphy, continued for a little longer. This is particularly fortunate because most of Yāqūt's pupils flourished during this period. Among those who became master calligraphers in their own right, in addition to the three already mentioned, were Mubārak Shāh al-Quṭb (d. 1311), Sayyid Ḥaydar (d. 1325), Mubārak Shāh al-Suyūfī (d. 1334), ʿAbd Allāh al-Ṣayrafī (d. 1338) who left us an exquisite calligraphic page, signed and dated 1323, ʿAbd Allāh Arghūn (d. 1341) and Yaḥyā l-Jamālī l-Ṣūfī. It is fortunate that al-Ṣūfī has left 60 us a magnificent Qurʾān in gold Muḥaqqaq with vowels in blue, dated 1345, as a monument to his calligraphic skills. Another was Muḥammad ibn Yūsuf al-Ābārī, who left us a Qurʾān copied in Thuluth verging on Rayḥānī, which is 31 of considerable interest.

The Il-Khanids were succeeded towards the end of the fourteenth century by the Timurid dynasty, which was founded by the great Timur, better known in English as Tamerlane (d. 1405). Although he was notorious throughout the world as a great destroyer, he became in his later years, after having been fully converted to Islam, a great patron of all aspects of Islamic art. He often gathered the best artisans, scholars, artists and calligraphers in the territories he conquered, and carried them off to his capital, Samarqand.

Timur paid special attention to the art of calligraphy, and was directly responsible for the creation of a new style of Qurʾān illumination which was called after him, and which replaced the earlier Mongol style of the Il-Khanids. In contrast to the Il-Khanid style, which aimed to achieve grandeur with large Qurʾāns copied in monumental script with bold and geometrically structured illumination, the Timurid style aimed to create a balance between beauty and grandeur by combining a clearly written script in large Qurʾāns with extremely fine, intricate, softly coloured illumination of floral patterns, integrated with ornamental Eastern Kufic so fine as to be almost invisible. Of the larger scripts used, Rayḥānī was consistently preferred, and its delicacy was emphasized by writing its vowels with an even finer pen than usual. Naskhī was used to a lesser extent, but given a greater clarity and purity of line which later influenced the scripts of Persian Taʿlīq and Indian Naskhī. Although the practice of using various styles and different sizes of script on the same page dates back to the time of Ibn Muqlah, the Timurids were probably the first to extend it to the 54, 107, Qurʾān. 112

The qualities and characteristics of the Timurid period were most especially reflected in their large Qurʾāns, some of which are among the largest ever produced. A delightful anecdote which tells of Timur's love of large Qurʾāns is the story of ʿUmar Aqṭaʿ, whom Timur commissioned to write a Qurʾān. ʿUmar at length presented Timur with a Qurʾān copied in Ghubār script, so tiny as to

fit under a signet ring. This Timur disdained to accept because of its small size; whereupon 'Umar retired hurt but undaunted and copied another Qur'ān in Ṭūmār, each page of which measured almost a metre in width; and for this he was generously rewarded.

This fine calligraphic tradition was continued by Timur's successors. His son Shah Rukh (1405–47) was a devout Muslim who held calligraphy in such high esteem that he commissioned many excellent Qur'āns. He also had one of his sons professionally tutored. One of the few Qur'āns from his time to survive is
61 by the hand of the noted Timurid calligrapher Muḥammad al-Ṭughrā'ī, copied in 1408 in large gold Muḥaqqaq. Shah Rukh's son Ibrāhīm Sulṭān became one of the most outstanding calligraphers of the period, as can be seen from a Qur'ān
69 he copied in gold Rayḥānī in 1431. Another of Shah Rukh's sons, Baysunghur (d. 1433), was the most talented of the remarkably cultured Timurids and must
70 rank among the world's greatest bibliophiles. Throughout his life he patronized the arts and scholarship, gathering around him artists, calligraphers, bookbinders and illuminators who developed the outstandingly elegant style of the Timurid school of book production, notable for superb illuminated Qur'āns and splendid volumes of Persian epics, with exquisite miniature-paintings and other illuminations.

Another lover of books was Sultan Ḥusayn (d. 1506), at whose court in Herat the finest Timurid Qur'āns were produced. Among the many excellent Timurid calligraphers, the most talented, in addition to those already mentioned, were 'Abd Allāh ibn Mīr 'Alī, Ja'far al-Tabrīzī, Muḥammad Mu'min ibn 'Abd Allāh, 'Abd Allāh al-Ṭabbākh and his pupil 'Abd al-Ḥaqq al-Sabzavārī.

The Mamluks, who established their dynasty (1250–1517) mainly in Egypt and Syria, managed to save their part of Dār al-Islām from the destruction that befell the Eastern provinces, thus ensuring for themselves cultural continuity. Their keen appreciation of Islamic art in general made them enthusiastic
64 patrons of the arts of calligraphy and Qur'ān illumination, which were cultivated until they reached the highest possible standards, rivalling those attained in the East under the Il-Khanids. Indeed, even today many of the Mamluk Qur'āns are considered absolute masterpieces that may never be equalled. The first great Mamluk Sultan was Rukn al-Dīn Baybars I (1260–77), who distinguished himself both in war and in peace and was a great patron of the arts. Baybars was followed by a long line of Mamluk sultans, the greatest of whom were Qalāwūn (1279–90) and his son al-Nāṣir, who ruled on three occasions between 1293 and 1340, al-Ashraf (1363–76) and Barqūq (1387–98).

It is fortunate that a considerable number of Mamluk Qur'āns have come down to us. The greatest of the Mamluk calligraphers was Muḥammad ibn al-
34 Waḥīd, who left us the unique Qur'ān in Thuluth, mentioned earlier, which he copied in 1304 for the High Chamberlain Baybars, later Sultan Baybars II (1308–09). Three of the calligraphers who flourished during the long reign of al-Nāṣir, and have left us examples of their work to testify to their excellent calligraphic skills, are Muḥammad ibn Sulaymān al-Muḥsinī, Aḥmad ibn Muḥammad al-Anṣārī and Ibrāhīm ibn Muḥammad al-Khabbāz. 'Abd al-Raḥmān
62 ibn al-Ṣāyigh is famous for having copied in Muḥaqqaq the largest known Mamluk Qur'ān, which has an open span of more than two metres, using only one reed pen, in the incredibly short time of sixty days. This Qur'ān, which was also splendidly illuminated, was produced in 1397, no doubt for Sultan Barqūq, after whom Mamluk power began to decline. The very high standard of calligraphy, however, continued to be maintained for nearly a century after this date, as can be
50 seen from an extant Qur'ān which was prepared for al-Malik al-Ashraf in 1496 by Shāhīn al-Inbitānī, who copied it in large Naskhī.

The Mamluk period was an age of great cultural achievement, and there is general agreement that Arabic calligraphy attained its ultimate perfection in Egypt and Syria during the first century of Mamluk rule. While this is
108 particularly true of the Mamluk art of Quranic calligraphy and illumination, it

is also reflected in the use of calligraphy on other materials such as metal, glass, ivory, textiles, wood and stone. This extensive use of calligraphy, which was remarkable for its scope and quality, gave rise to special styles of Thuluth and Naskhī, which have ever since been associated with this period. 39, 98, 132

The decline of the Timurid dynasty, which accelerated rapidly towards the end of the fifteenth century, allowed the Safavids to rise under their energetic leader who later assumed the title of Shah Ismāʿīl (1502–24). This Safavid dynasty, which endured until 1736, was the longest and most glorious of the later dynasties that ruled in Persia and Iraq. Despite the constant conflict with their enemies, the Safavids succeeded in ushering in a new era in Persian cultural life, which had a lasting influence on the development of Islamic art, not only within their realm, but also in the empire of their arch-enemies the Ottomans.

An extremely important calligraphic development took place during the reigns of Shah Ismāʿīl and his successor Shah Tahmasp (1524–76). Under their encouragement the Taʿlīq script was properly formulated and developed into a widely used native script, which later led to the development of Nastaʿlīq. In view of their dominance among the Persian, Urdu and Turkish-speaking peoples, and their important contribution to Islamic calligraphy generally, these two relatively young scripts were elevated to the status of major scripts.

The Taʿlīq (hanging) script, according to some Arabic sources, was developed by the Persians from an early and little known Arabic script called Fīrāmūz, an unpretentious cursive script which was apparently in use until the early ninth century. The general opinion, however, is that Taʿlīq only became established as a defined script after the invention of Riyāsī in the ninth century. Its development was particularly influenced by Riqāʿ and Tawqīʿ, to such an extent that some Persian sources relate its derivation directly to these two scripts, and attribute its invention to Tāj-i Salmānī, a calligrapher from Isfahan about whom very little is known. The calligrapher ʿAbd al-Ḥayy from the town of Astarabad, however, seems to have played a greater role in its early development, for he was encouraged by his patron Shah Ismāʿīl to lay down the basic rules for the writing of Taʿlīq, and not only popularized Taʿlīq among the Persian peoples, but encouraged its use for certain types of official documents. Although Taʿlīq never gained great favour with the Arabs, it became the native calligraphic style among the Persian, Indian and Turkish Muslims. 88, 91–2, 114–15

Persian calligraphers soon developed from Taʿlīq a lighter and much more elegant variety which came to be known as Nastaʿlīq, though they continued to use Taʿlīq as a monumental script and for important occasions. Turkish calligraphers, on the other hand, remained for a long time faithful to the basic rules of early Taʿlīq. Even after adopting most of the changes brought about by Nastaʿlīq, which they accepted as improvements, the Turks continued to insist on the name Taʿlīq for the style. 86, 89–90, 110–11

Nastaʿlīq (compounded from the names Naskh and Taʿlīq) should therefore be considered as a variant style of Taʿlīq which was developed in the late fifteenth century by the Persians, and has ever since been their national script. All important sources agree that the Persian calligrapher Mīr ʿAlī Sulṭān al-Tabrīzī (d. 1416) was the founder of this script, and he is also credited with devising the complex rules which govern it. According to legend Mīr ʿAlī, who was a devout Muslim, prayed earnestly to be granted the gift of creating a beautiful new calligraphic style. The Imam ʿAlī, the Prophet's cousin and fourth Orthodox Caliph, to whom all Muslim calligraphers trace their pedigree, appeared to him in a dream and instructed him to study a certain bird. Soon afterwards, he was visited in his dreams by a flying grouse, and was inspired to model his letters on the shape of its wings. Legend apart, the bold and clear lines of Nastaʿlīq and its perfectly rounded curves do suggest a bird in flight. Its clarity and geometric purity combine to give Nastaʿlīq a seemingly casual elegance which belies its highly sophisticated and strictly applied rules.

There are certain features common to Ta'līq, Nasta'līq, and Riqā'. Among these are the relative lack of pointed elevations, *Asnān* (teeth), in the horizontal lines of certain letters such as *s* and *sh*, frequent filling in of the centres of the loops of most of the letters, and the ending of most of the unjoined letters in very thin and pointed lines. Another common feature is that the curves display marked contrast in their line-width, which changes abruptly from the maximum to the thinnest possible line that can be drawn by the same pen.

During Shah Tahmasp's reign (1524–76), Nasta'līq replaced Naskhī, and became the natural script to use for copying Persian anthologies, epics and other literary works. Ever since the reign of the great Shah 'Abbās (1588–1629) it has been used in most of the Persian illuminated secular manuscripts, especially those with miniatures. Although it was used to a lesser extent by other Muslim peoples, it had a considerable influence upon the development of their calligraphic art in general, and on Naskhī in particular. Both Arab and Turkish calligraphers in the Ottoman Empire developed a new hybrid style of small Naskhī verging on Ta'līq which may simply be called Ottoman Naskhī, and which was frequently used for writing and copying the prolific literary output of the period.

Ta'līq and Nasta'līq were seldom used for copying the Qur'ān, and so far as is known, there is only one complete extant Qur'ān in Nasta'līq. This superb copy, made for Shah Tahmasp by Shāh Maḥmūd al-Nīshābūrī in 1539, testifies to the ultimate clarity, strength and beauty that Nasta'līq can attain.

As if to compensate for the exclusion of Nasta'līq from the prestigious group of Quranic scripts, the Safavids strove to set their mark upon the art of Quranic calligraphy and illumination. The Qur'āns of this period had the special feature of pages divided into two or more compartments containing scripts of markedly different sizes. Often these compartments would number as many as seven, with vertical ones being used as illuminative devices to enhance the already rich illumination.

Mīr 'Alī al-Tabrīzī was followed by a long and impressive line of Muslim calligraphers, mainly Persians, who have left us a rich harvest of Nasta'līq calligraphic specimens. Among the early masters of this script who deserve a special mention are 'Abd al-Raḥmān al-Khawārizmī, a fifteenth-century pioneer who reached a very high level of competence. He was followed and emulated by his two sons, 'Abd al-Raḥīm Anīsī and 'Abd al-Karīm Pādshāh.

The reign of the great Shah 'Abbās which saw Persian culture reach new heights was also the golden age for Nasta'līq. It produced a large number of master calligraphers, the most famous of whom were Qāsim Shādī, Shāh Kabīr ibn Uways al-Ardabīlī, Kamāl al-Dīn Hīrātī, Ghiyāth al-Dīn al-Iṣfahānī; the last and probably the greatest of this generation of Persian calligraphers was 'Imād al-Dīn al-Ḥusaynī. The prestige enjoyed by these master calligraphers may be illustrated by an historical anecdote concerning 'Imād al-Dīn, whose social standing was so high that he dared disdain the royal patronage of Shah 'Abbās, and refused to comply with his request to produce for him a copy of the Persian epic, the Shāhnāmah of Firdawsī. The Shah having sent him a small sum of money with his order as an advance payment in 1615, enquired for the book after a lapse of almost a year, whereupon 'Imād al-Dīn responded by sending him only a few lines from the first page of the book, which he deemed to be all that the Shah was entitled to in respect of his initial payment. This so angered Shah 'Abbās that he never forgave 'Imād al-Dīn, and soon afterwards engineered his death.

Arabic calligraphy developed in India and Afghanistan along much more traditional lines. A minor cursive script called *Behārī* appeared in India during the fourteenth century, the main characteristics of which are its wide, heavy and extended horizontal lines, which contrast markedly with its thin and delicate verticals. Its letters are well spaced and its flourishes are open-curved and very pronounced, and it was often written in multiple colours, mainly

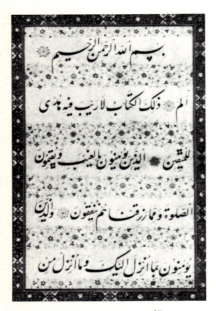

Detail of the only extant Qur'ān in Nasta'līq, copied for Shah Tahmasp by Shāh Maḥmūd al-Nīshābūrī in 1539

88, 105

black with gold, red and blue. Despite its evident cursiveness, this script has affinities with a more angular script which was developed at Herat in the early fourteenth century as a clumsy revival of standard Kufic, and we may call it Herati-Kufic. This script, which was used in Afghanistan, no doubt also influenced the development of the Ottoman *Siyāqat* script which is described below.

The many millions of Chinese Muslims who used the Arabic script, at least for liturgical purposes, usually adopted the calligraphic styles which were current in Afghanistan, with slight modifications. In addition to these, they evolved a special script called *Ṣīnī* (Chinese) with very fine lines and exaggerated roundness, which they used mostly on their ceramic and chinaware. A purely ornamental style was derived from *Ṣīnī*, which retained its roundness, but was easily distinguished by its very thick and almost triangular verticals and its comparatively thin horizontal lines.

On the whole, Muslim calligraphers in both India and Afghanistan were directly influenced by Persian calligraphers. Indian Muslims adopted Nastaʿlīq as a national script and applied it considerably to Urdu, but in Afghanistan and certain parts of the Indian subcontinent, a slightly developed Naskhī continued in use. The main characteristics of this script, which we may term Indian Naskhī, are its heavier, bolder and more widely-spaced letters. Its curves are also more perfectly rounded, which gives it a solidity that is lacking in ordinary Naskhī. Thuluth developed along the same lines, and is therefore called Indian Thuluth. These developments were fully consolidated under the Moghul dynasty (1526–1857) which ruled in India and Afghanistan. Calligraphy was especially favoured by the Moghul emperors Bābur (d. 1530), Akbar (1556–1605) and Jahāngīr (1605–28). The last named so keenly admired and sought after the calligraphy of ʿImād al-Dīn al-Ḥusaynī, that he promptly rewarded with a high rank anyone who presented him with a specimen by the hand of this great Persian calligrapher.

The Ottoman dynasty, which takes its name from its founder ʿUthmān, dates back to the early fourteenth century, but the Ottomans' empire was not fully established until they had defeated the Mamluks in 1517, and inherited their domains in Syria, Egypt and Arabia. Soon afterwards, they were able to incorporate almost the whole of the Arab world into their empire. This closed the glorious chapter of Mamluk calligraphy and opened a new and perhaps a final one in the long history of Islamic calligraphy. From this date until very recently, therefore, the history of the arts of Islam became associated with the Ottoman Turks. This also applied to the art of calligraphy, which the Ottomans quickly assimilated and proceeded to develop with great devotion 26, 94, and imagination. They became renowned for their love of calligraphy, and 131 not even their constant conflicts with their arch-enemies in Persia prevented them from admiring their calligraphic traditions and applying Taʿlīq to their own language. This close association extended to the arts of calligraphy, book illumination and binding to such an extent that it becomes on occasions very difficult to tell with certainty whether a given manuscript was produced in Turkey or in Persia.

Not only did the Ottomans accept most of the current calligraphic scripts and excel in them, but they also developed some new and purely indigenous styles. 147–8 They esteemed Arabic calligraphy highly, and felt its sacredness very intensely. This is reflected in the exceptionally large number of illuminated Qurʾān manuscripts which were produced, in the prolific use of ornamental scripts in mosques, schools and public buildings, and in the thousands of 47, 119, 139 calligraphic manuscripts of secular works which are still extant in Turkey and 33 elsewhere.

The greatest contribution to Islamic calligraphy was that of Shaykh Ḥamdullah al-Amāsī (d. 1520), who is considered the greatest master of the 35, 51 whole Ottoman period. He taught calligraphy to the Ottoman sultan Bāyazīd II

Behārī script in a Qurʾān copied in India, probably late 14th century. The word ʿAllāh' is picked out in red or gold

The Basmalah in Ṣīnī script

(1481–1520), who esteemed him most highly and paid him the ultimate compliment of holding the inkpot while the Shaykh wrote his lines.

Of the many gifted pupils of Ḥamdullah the most renowned is Aḥmad Qaraḥiṣārī (d. 1555), who left us many examples of his calligraphy. It became a tradition for Ottoman sultans to patronize the good calligraphers of their time. This led to the rise of a very large number of excellent calligraphers, most of whom deserve to be studied in detail, but here we should mention ʿUthmān ibn ʿAlī, better known as Ḥāfiẓ ʿUthmān (d. 1698), who ranks second only to Ḥamdullah, each of whom headed a line of famous calligraphers. Indeed, all later Turkish calligraphers tried to trace their lineage to them, and revered them highly.

The continued development of calligraphy in Turkey and elsewhere led to the creation of a few derivative scripts to meet particular needs, and also to extremely contrived calligraphic innovations, on the whole ornamental and designed primarily to delight or impress.

The most important of the derivative styles were *Shikasteh, Shikasteh-āmīz, Dīvānī* and *Jalī*. Shikasteh (broken form) and its ornamental sister script Shikasteh-āmīz are Persian developments which directly relate to Taʿlīq and Nastaʿlīq. The creation of Shikasteh is attributed to a certain Shafīʿ from Herat. The most celebrated exponent of this script, however, was Darwīsh ʿAbd al-Majīd Ṭāliqānī. In addition to its close affinities to early Taʿlīq, Shikasteh is characterized by an exaggerated density, resulting from closely connected ligatures and very low and inclined verticals, and also by the lack of vowel marks. It is mostly used for personal and business correspondence and in normal Persian and Urdu handwriting. Shikasteh-āmīz is often used in chancelleries and similar official business. It is larger and less compact than Shikasteh, and is usually written on illuminated or coloured paper.

Dīvānī is an Ottoman development parallel to Shikasteh, and was especially developed in the late fifteenth century from the Turkish Taʿlīq by Ibrāhīm Munīf. It was later refined by the famous Shaykh Ḥamdullah, primarily for use in chancelleries. It is excessively cursive and superstructured, with its letters undotted and unconventionally joined together, and it has no vowel marks. Dīvānī also developed an ornamental variety called *Dīvānī Jalī*, which was also known as *Humāyūnī* (imperial).

The full development of Jalī is attributed to Ḥāfiẓ ʿUthmān and his disciples, who also applied it to the other major scripts, strictly for ornamental purposes. The main characteristic of Jalī is its profuse embellishment with various decorative devices, which do not necessarily have any orthographical value, so that the whole appears a solidly structured mass, forming straight or slightly curved rectangles or other geometric formats.

The art of diminutive writing, which is based primarily on the Ghubār script, has become more popular in recent times. Modern calligraphers have reduced Ghubār to an extremely minute size, writing on objects no bigger than a grain of rice. The complete text of the Qurʾān, amounting to exactly 77,934 words, has been accommodated on the shell of a single hen's egg, and very recently on a single sheet of paper measuring no more than 55 by 45 centimetres. Complete Qurʾāns no bigger than a thumb are worn as amulets by countless Muslims. If the most famous calligraphers in this field are Ismāʿīl ibn ʿAbd Allāh, better known as Ibn al-Zamakjalī (d. 1386) and Qāsim Ghubārī (d. 1624), twentieth-century artists have also achieved excellence, including the Egyptian Ḥasan ʿAbd al-Jawād, who wrote three chapters of the Qurʾān on a single grain of wheat; the Lebanese Nasīb Makārim, who wrote a national anthem consisting of 287 words on a single grain of rice; and Dāwūd al-Ḥusaynī from Afghanistan, who wrote legibly 555 words on a surface no bigger than a square inch.

Zulf-i ʿarūs (the bride's lock of hair) is a style which seems to relate both to Rayḥānī and to Nastaʿlīq. It has thick lines which end in very fine coils, with finial-like extensions resembling tiny curls.



112, 149

33

147–8, 150,
152–3
87, 116

Examples of Dīvānī (top) and Dīvānī Jalī script

Qurʾān copied in Ghubār by Ḥāfiẓ ʿUthmān, reproduced actual size

Example from India of the script called Zulf-i ʿarūs – 'bride's lock of hair', c. 1820

123, 149

Gulzār is the technique of filling the area within the outlines of relatively large letters with various ornamental devices, including floral designs, geometric patterns, hunting scenes, portraits, small script and other motifs. It is often used in composite calligraphy, when it is also surrounded by other decorative units and calligraphic panels.

Muthannā or *Aynalī* is the art of mirror writing, in which the unit on the left reflects the unit on the right. This technique is also known as *Maʿkūs* (reflected).

Zoomorphic calligraphy, which dates back to the fifteenth century, acquired a wider appeal more recently. Mostly Thuluth, Naskhī, Taʿlīq or Nastaʿlīq are used in this way, and are extensively modified and manipulated to build up forms resembling animals, birds, etc. The tops of certain vertical letters were sometimes modified to form the outlines of a human figure, an anthropomorphism which is frowned upon by some Muslims.

The *Ṭughrā*, a calligraphic device which became especially famous as the emblem of the Ottoman sultans, developed in the hands of successive generations of calligraphers to reach heights of elegant and elaborate ornamentation.

A more modern development is *al-Khaṭṭ al-Sunbulī*, a heavy and highly stylized script that was probably derived mainly from the Dīvānī script. Although it is distinctive and fairly attractive, it is not widely used today.

Another modern script which is in the same category as Sunbulī is *Ḥarf al-Nār*, which has the added characteristic, as its name suggests, of resembling tongues of flame.

Siyāqat is a functional script developed by the Ottomans for use in Government offices, particularly those which issue licences and similar documents in connection with commercial or financial affairs. It is characterized by its straight and heavy lines and its relative angularity, which relate it to Herati-Kufic script that was used in Afghanistan and in certain parts of India.

Ḥurūf al-Tāj (crown letters) is probably the most modern script of all. It was developed in Egypt in 1930 by Muḥammad Maḥfūẓ for King Fuʾād I, who wanted to introduce into Arabic the use of capital letters. So far, however, this has not met with significant success, and Arabic continues to be written without capitals.

Today, the special honour paid to calligraphers by all Muslims throughout their history continues, and is reflected in the esteem and rewards conferred on the few outstanding contemporary calligraphers.

Bird formed of the Basmalah in bold Thuluth. The crown is also composed of the Basmalah, written in connected Thuluth, while the neckband reads: *yā Raḥmān yā Raḥīm* – 'O Merciful, O Compassionate'. Turkey, probably 19th century

The first revelation of the Qurʾān deals with the art of writing, a gift which God had bestowed on man (Qurʾān, XCVI: 'He has taught the use of the pen. He has taught man that which he knew not.'). The second Quranic revelation is entitled *al-Qalam* 'The Pen' (Qurʾān, LXVIII: 'By the Pen and by what they write.'). One 93–8 of the many sayings on calligraphy which are attributed to the Prophet Muḥammad is 'Good writing makes the truth stand out.' It is not surprising, therefore, that calligraphy has been patronized and encouraged at the highest level throughout its history, becoming the most important visible factor that relates the Muslims to each other, and manifesting itself in all branches of Islamic art, as the illustrations which follow show.

The Qurʾān, which is the word of God and touches every aspect of Muslim life, has always been an object of devotion and the focus for the artistic genius of Islam. This not only elevated calligraphy to the level of a sacramental art, but made the many hundreds of exquisite Qurʾān copies which were produced the best documentary evidence of the art itself. Accordingly, Qurʾān pages are numerous among the illustrations which follow. At the same time, the full richness and complexity of the art of calligraphy is only to be appreciated through a study of the profusion of inscriptions on brick, stone, brass, tile, pottery, wood and other materials, and in addition, of the important non-Quranic scripts and styles which have evolved at various times at the hands of inspired calligraphers.

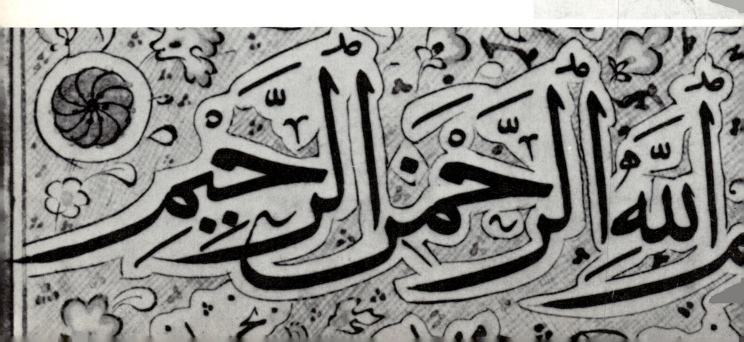

The Basmalah – 'In the Name of God, the Compassionate, the Merciful'

The invocation *Bism Allāh al-Raḥmān al-Raḥīm* – 'In the Name of God, the Compassionate, the Merciful' – known as the Basmalah, is used before chapter-openings throughout the Qur'ān (1–3). Two of the examples are in Kufic script: Western Kufic from the 10th century (top); and Eastern Kufic from the 11th century (centre); the third example (below) is in a classic cursive script, Rayḥānī, with Sūrah (chapter) headings in ornamental Eastern Kufic, and dates from the late 15th century

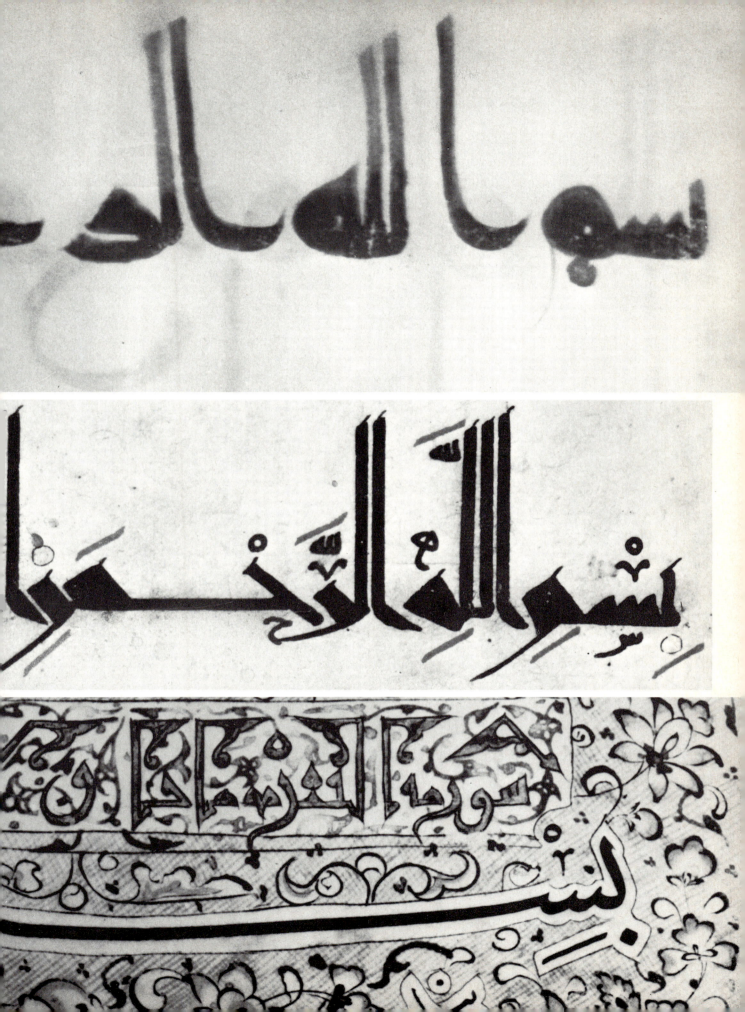

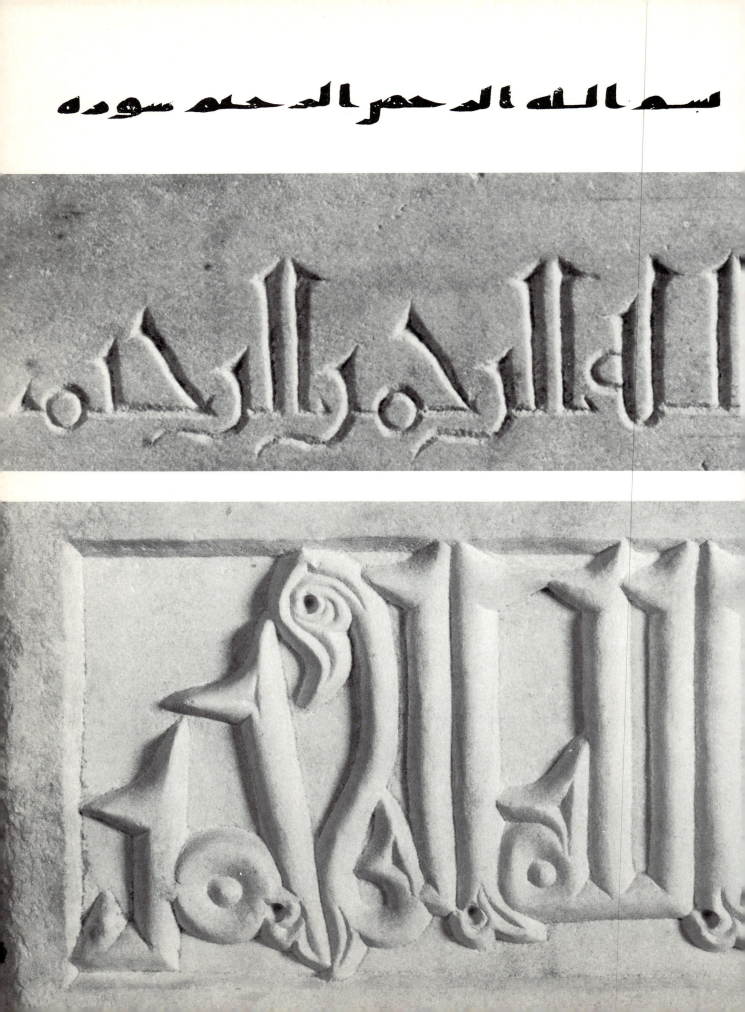

4 Mashq Basmalah from a Qur'ān copied *c.* 700–750, probably in Medina

5 (below) Ornamental Kufic Basmalah, incised on marble, from an Egyptian tombstone dated 966/7

The words of the Basmalah – *Bism Allāh al-Raḥmān al-Raḥīm* – appear in various calligraphic styles – written, incised, carved, beaten or moulded – in each of the introductory plates (1–13). The wide variety of shapes taken by these identical words reveals the unique flexibility of which the Arabic script is capable.

7 (above) Kufic Basmalah from a 17th-century Turkish ornamental calligraphic page (*see also* 150)

6 The first three words of the Basmalah in typical Fatimid Kufic, carved in marble, from a 10th-century Egyptian tombstone

8 Foliated Kufic Basmalah on a wooden tomb-cover. Baghdad 1227

9 Contracted form of the Basmalah, known as the *Tasmiyah*, reading *Bism Allāh* – 'In the name of God' – in Kufic on an open-metalwork mosque lamp. Egypt, early 11th century

10 (opposite) Thuluth Basmalah in the metalwork grill of a door, commissioned by Shah Sulaymān I and dated 1693. The inscription is from the Qur'ān, Sūrat an-Naml, 'The Ant' (XXVII, 30), which contains the story of Solomon and the Queen of Sheba. It translates: 'It is from Solomon and it is in the Name of God, the Compassionate, the Merciful'. This verse is the only occurrence of the Basmalah in the actual text of the Qur'ān

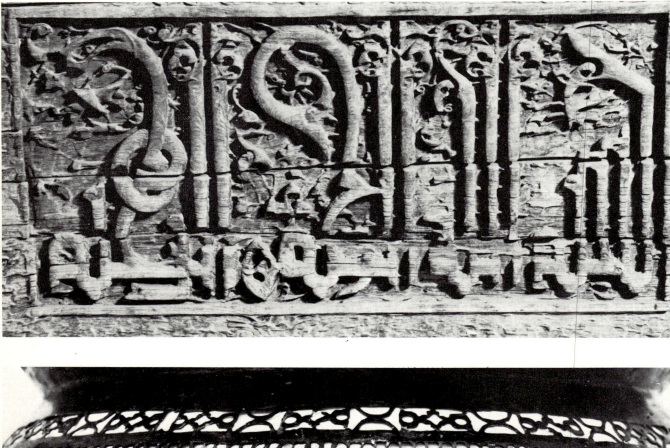

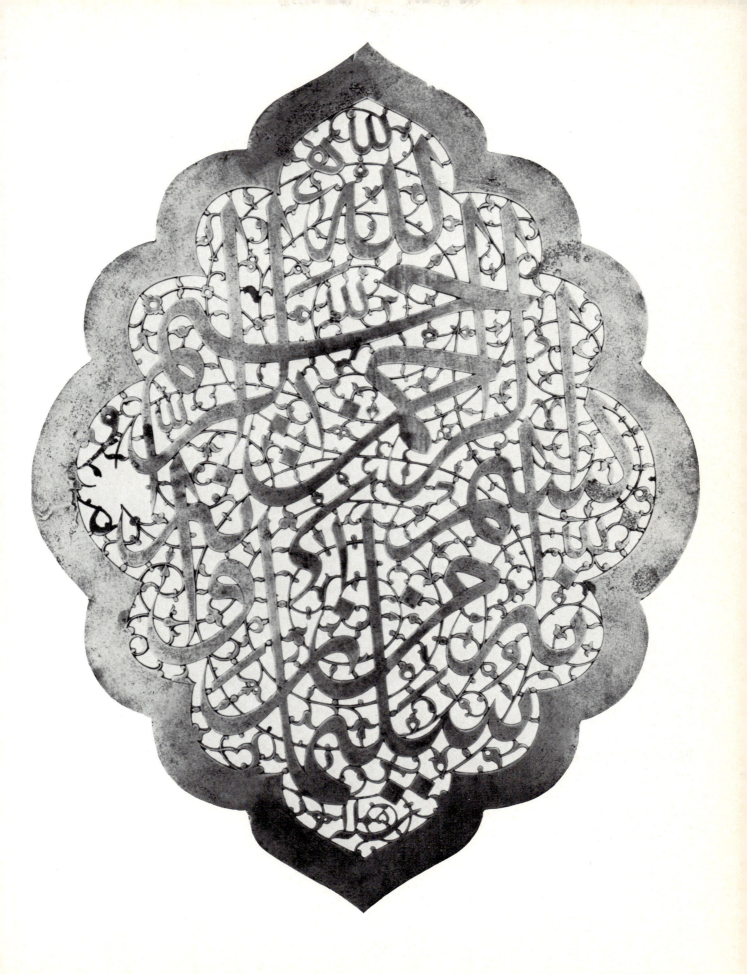

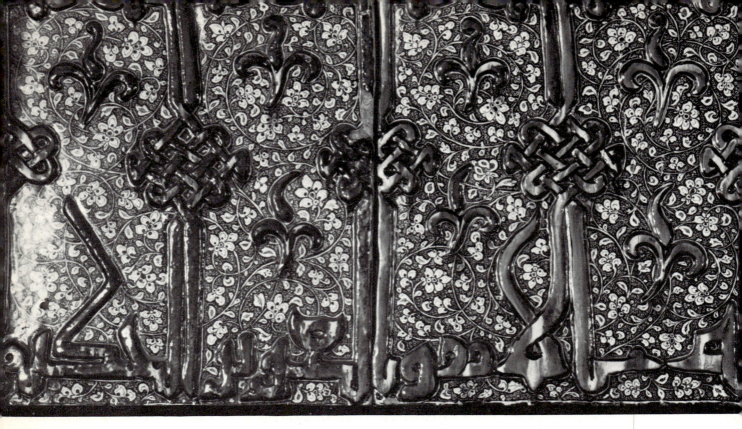

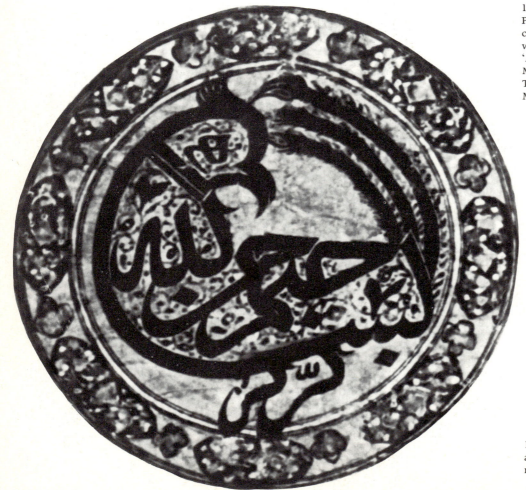

11 Knotted Kufic Basmalah on Persian lustre tiles, late 13th century. The inscription begins with the last letter of the word 'Allāh', and continues, 'the Merciful, the Compassionate. There is no God but He, the Mighty, the Wise '

12 Zoomorphic Basmalah used as a talisman on a Persian marriage contract, dated 1760

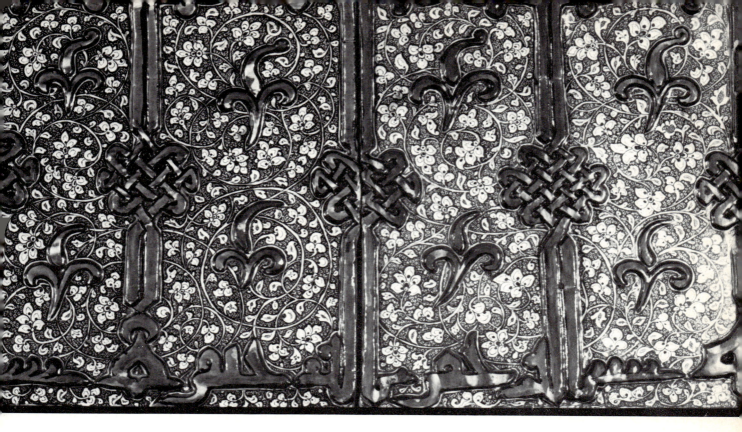

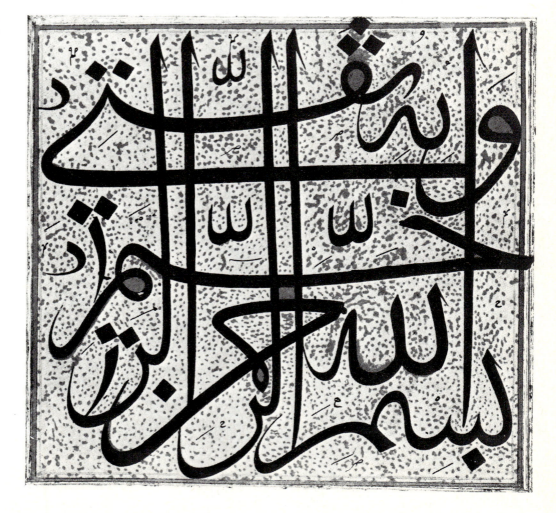

13　Thuluth Basmalah (in the lower section) with the added words 'My trust in Him', on a tile, probably from Persia, late 17th century

MASHQ

Early Mashq was first developed at Mecca and Medina during the first century of Islam (7th century AD) when the town of Kūfah was also developing its own Kufic calligraphic style. The complex rules which governed the early Mashq were gradually simplified until the developed Mashq came to resemble the Kufic script. The examples show a particular characteristic of Mashq, the perfectly balanced dispersal of the script on the page, in varied degrees of density.

14 Mashq densely applied, from a Qur'ān, Sūrat al-Baqarah, 'The Cow' (II, 141–3). Copied in Kairouan, 10th century

15 Mashq perfectly dispersed on the page, from a Qur'ān, Sūrat al-A'rāf, 'The Heights' (VII, 19, 20, 22). Probably from North Africa, 9th century

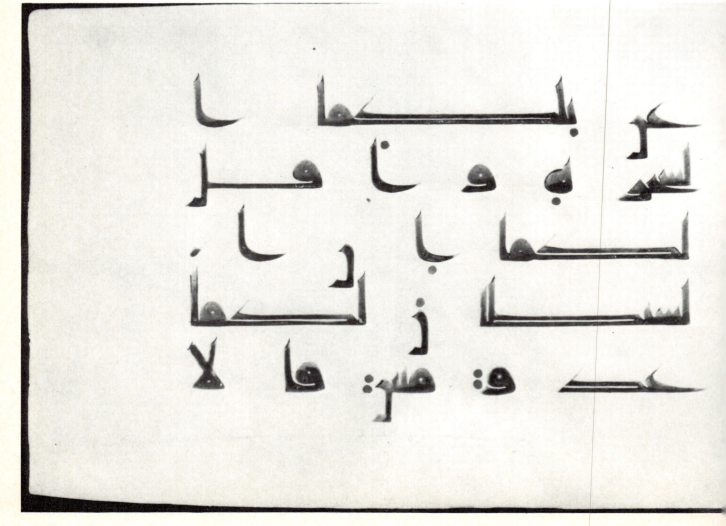

KUFIC

The Kufic script not only replaced most of the earlier scripts and reached perfection during the second Islamic century (8th century AD), but had the most profound effect on Islamic calligraphy generally. In contrast with its low verticals, its horizontal lines are extended, and it was deliberately written on oblong surfaces, the width being considerably more than the height, which gave it a certain dynamic momentum. Early Kufic Qur'āns, mostly on vellum, were rather austere in appearance, but from the beginning of the 9th century they became more ornamented, with illuminated decorative devices, many of which also served specific functions.

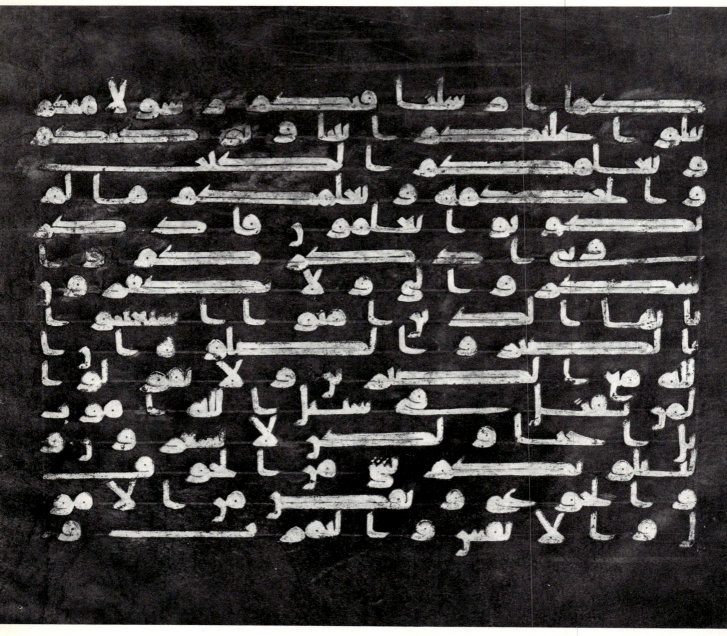

16 Kufic script in gold on blue vellum, from a unique Qur'ān, Sūrat al-Baqarah, 'The Cow' (II, 151–5). Probably copied in Kairouan, early 10th century

17 Kufic script with occasional letter-pointing and diacritical dots, and with an illuminated Sūrah heading and verse mark, from a Qur'ān, Sūrat al-Ḥajj, 'The Pilgrimage' (XXII, 1). Probably copied in Kairouan, 9th century

18 Kufic script with occasional diacritical dots, Sūrah heading and verse divisions, from a Qur'ān, the end of Sūrat al-Sajdah, 'The Prostration' (XXXII, 30). Probably copied in Kairouan, 9th century

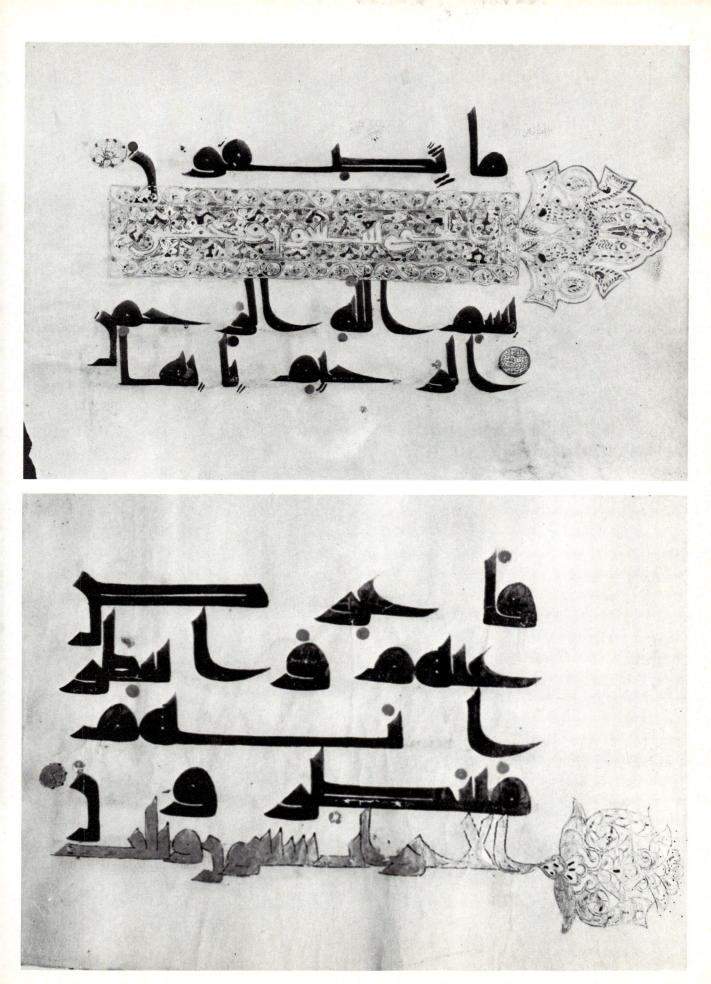

Muslim artists made extensive use of
ornamental Kufic, which they
applied most effectively to marble,
stone, metal, glass, textiles, ivory,
wood, and parchment or vellum.

19 Ornamental Kufic inscription
carved in marble, from the tomb of
the Ghaznawid Sultan Maḥmūd
al-Ghāzī, Ghaznah, Afghanistan,
1030

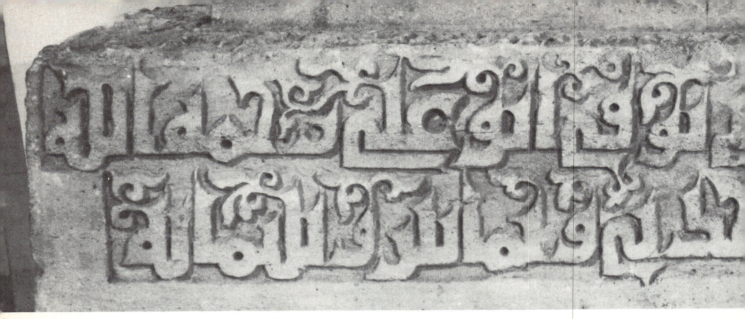

Ornamental Kufic developed
many widely different forms,
such as the foliated, the
floriated, the plaited, the
knotted, the interlaced and
intertwined, and the
animated. It was also
manipulated to form
geometric or maze-like
patterns

20 Foliated Kufic carved
on a tombstone dated 991,
probably from the Gulf (abov

21 Foliated Kufic
engraved on an ivory
casket. The inscription
includes the words *Amīr
al-Mu'minīn* – 'Commander
of the Faithful', one of the
titles of the Umayyad
caliphs who ruled Muslim
Spain. Cordoba, late 10th
century

22 Foliated Kufic
engraved on the rim of a
Seljuq gold wine-bowl. It is
inscribed with verses in
praise of wine by the
Abbasid poet Ibn
al-Tammār al-Wāsiṭī.
Persia, early 11th century

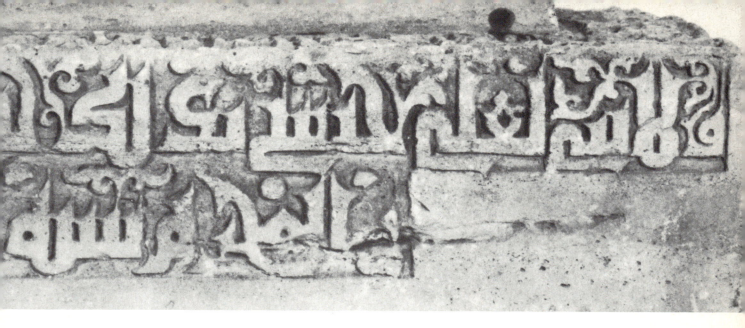

23 Woven ornamental Kufic, a benedictory statement on a silk and cotton cloth from Persia, late 10th century

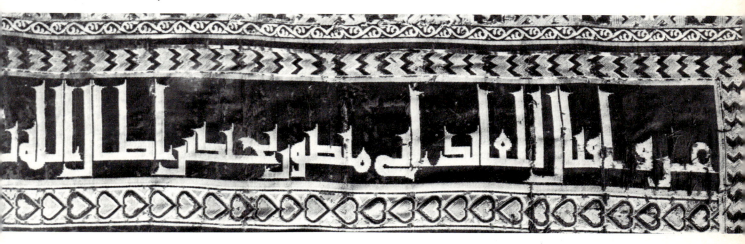

24 Calligraphic band of copper and silver inlay with the verticals rising above the characters and interlacing into a knotted motif, then escaping upwards to create the delightful motif of a row of human faces, six to each unit. The text consists mainly of benedictory phrases. Brass ewer from Khurasan, Persia, c. 1200

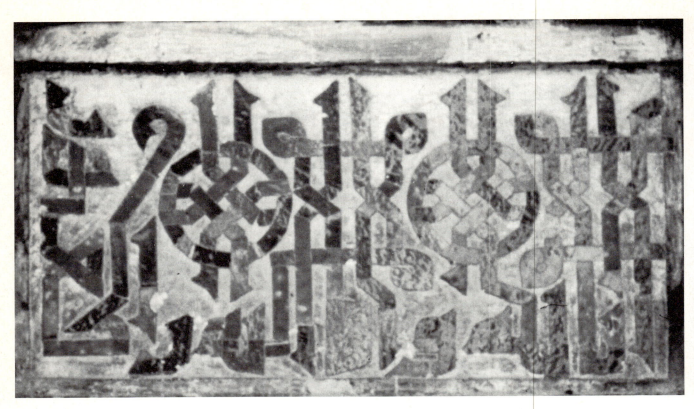

25 Plaited and knotted Kufic inscription on a wall of Keykavus hospital, Sivas, Turkey, probably early 13th century

Ornamental Kufic evolves, after the 12th century, into increasingly intricate patterns, contrived to astonish and delight rather than to communicate facts or ideas.

26 Plaited and foliated Kufic on one of the columns of Yeni Cami, Bursa, Turkey, 16th century

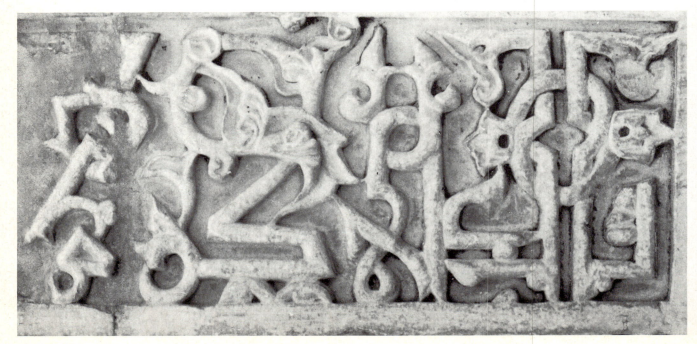

27 Square Kufic on a glazed tile. The darker overlay is the
word *Huwa* ('He') repeated four times, the white pattern reads
Allāh, lā ilāh illā huwa – 'Allāh, there is no God but He'. The tile
is said to have come from the Royal Mosque (Masjid-i Shāh) built
by Shah ʿAbbās in Isfahan in the early 17th century

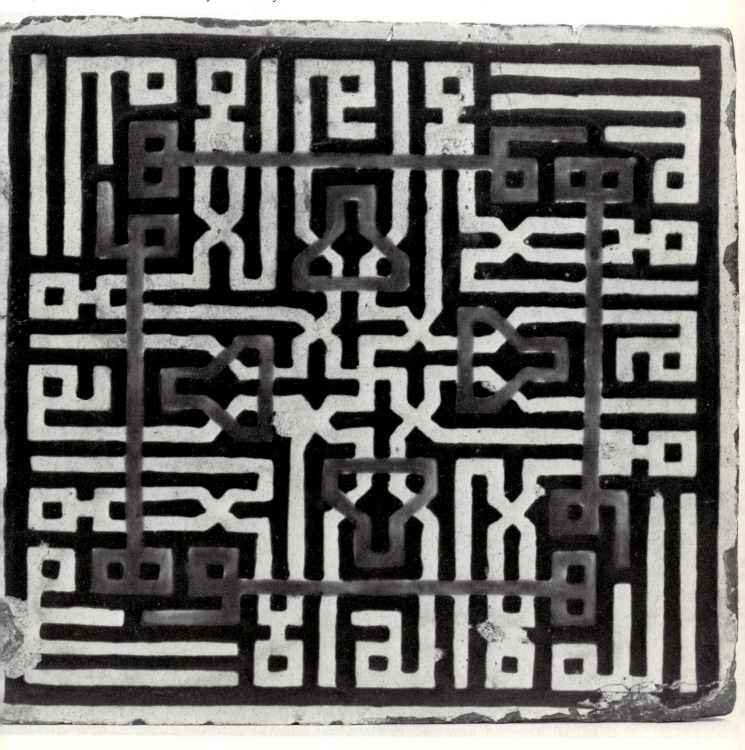

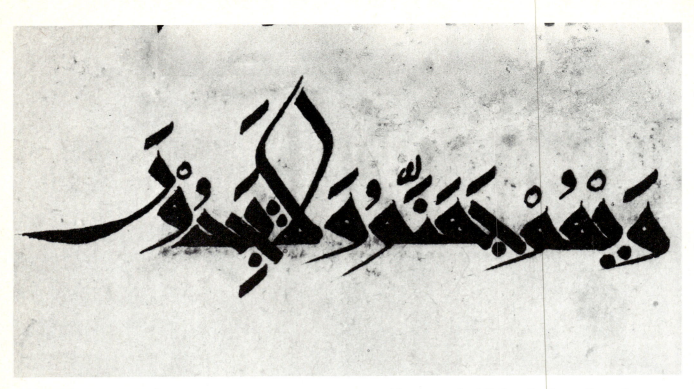

EASTERN KUFIC

Eastern Kufic script is more delicate than the standard Kufic, and was developed by the Abbasid calligraphers in the late 10th century. Its main characteristic is that its long upstrokes remain vertical with left-facing barbed heads, while its short strokes are bent to the left. Its lower flourishes extend into the sublinear area.

28 Bold Eastern Kufic, fully 'vocalized' according to the system of Khalīl (see p. 14). Detail of a Qur'ān, Sūrat al-Nisā', 'Women' (IV, 121), copied in Iraq or Persia during the Abbasid caliphate, probably in the late 10th century

29 Eastern Kufic Qur'ān, Sūrat al-Ṭāriq, 'The Morning Star' (LXXXVI, 1–9), with full diacritical marks and letter-pointing. Iraq or Persia, 11th century

30 Eastern Kufic Qur'ān, Sūrat al-Nūr, 'Light' (XXIV, 31), with letter-pointing and diacritical marks and dots. Persia, 11th century

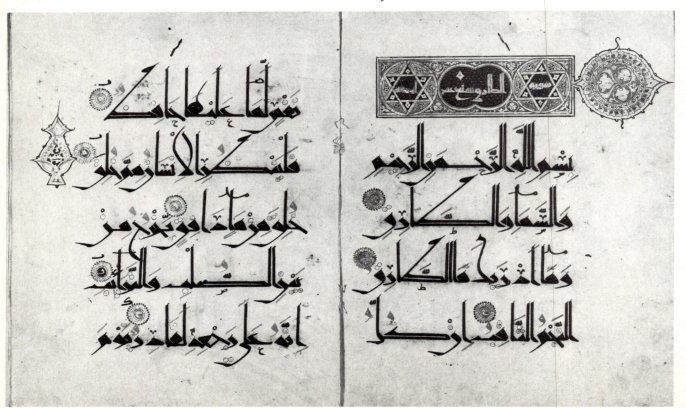

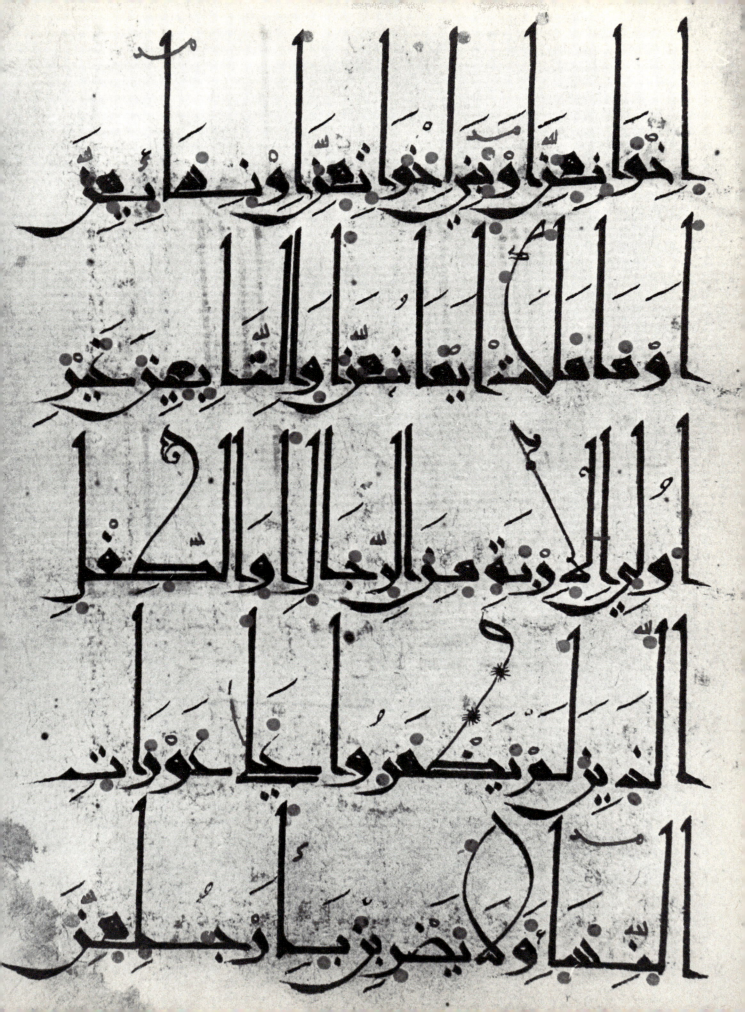

THE 'SIX STYLES' OF CURSIVE WRITING

The 'six styles' known in Arabic as *al-Aqlām al-Sittah*, and in Persian and Turkish as *Shish Qalam*, are cursive scripts which were first raised to the status of major scripts when they were subjected to strict calligraphic rules by Ibn Muqlah (d. 940). They gained grace and beauty at the hands of succeeding master calligraphers, and in particular with Ibn al-Bawwāb (d. 1022), the great Yāqūt al-Mustaʿṣimī (d. 1298), Shaykh Ḥamdullah al-Amāsī (d. 1520) and Ḥāfiẓ ʿUthmān (d. 1698). The names of these classical cursive scripts are Thuluth, Naskhī, Muḥaqqaq, Rayḥānī, Tawqīʿ and Riqāʿ.

THULUTH

Thuluth was first formulated in the 7th century during the Umayyad caliphate, but did not develop fully until the late 9th century. The name means 'a third' – whether because of the proportion of straight lines to curves, or because the script was a third of the size of another popular contemporary script, the Ṭūmār, is not known. Though rarely used for copying Qurʾāns, Thuluth has enjoyed enormous popularity as an ornamental script for calligraphic inscriptions, titles, headings and colophons. It is still counted as the most important of all the ornamental scripts.

31 One of the extremely rare Qurʾāns in Thuluth, copied in 1337 by Muḥammad ibn Yūsuf al-Ābārī, probably in Iraq. The word 'Allāh' is picked out in gold. The Thuluth here verges on Rayḥānī, and the commentary between the lines is in Turkish Naskhī. From Sūrat al-Fath, 'Victory' (XLVIII, 1–3)

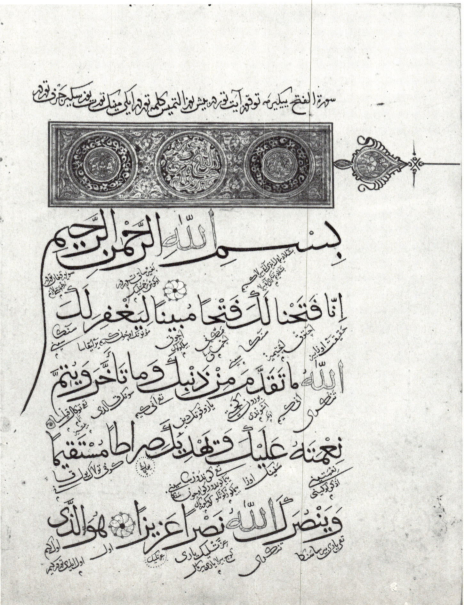

32 (opposite page) Ornamental Thuluth in the hand of the great calligrapher Ibn al-Bawwāb, from a Qurʾān copied in Baghdad, dated 1000. The text is the heading of Sūrat al-Falaq, 'The Daybreak' (CXIII)

33 Thuluth from a calligraphic page which translates: 'The Lightning almost takes away their sight' (Qurʾān, Sūrat al-Baqarah, 'The Cow', II, 20). Attributed to Ḥāfiẓ ʿUthmān, Turkey, probably 17th century

34 Thuluth in a Qurʾān copied by the great Mamluk calligrapher Muḥammad ibn al-Waḥīd for Baybars II in 1304. From Sūrat al-Shuʿarāʾ, 'The Poets' (XXVI, 161)

35 Detail in the hand of the most famous of all Ottoman calligraphers, Shaykh Ḥamdullah. The test is part of an anecdote and translates: 'A wise man was asked: What is humility?' Istanbul, early 16th century

سورة القارعة خمس أيات

يكاد البرق يخطف أبصارهم

إذ قال لهم أخوهم لوط ألا تتقون إني

قيل للحكيم ما التواضع

36 Thuluth set in clouds, from a Qur'ān, Sūrat al-Anfāl, 'The Spoils' (VIII, 41), copied in Persia in 1306

37 Ornamental Thuluth used for the title of a 17th-century Arabic copy of *Kitāb al-Āthār*, a text by the famous astronomer Abū l-Rayḥān Muḥammad al-Bīrūnī (d. 1048)

38 Thuluth on a ground decorated with arabesque and floral designs, with a Persian translation in Nastaʿlīq script set in clouds. Probably early 16th century

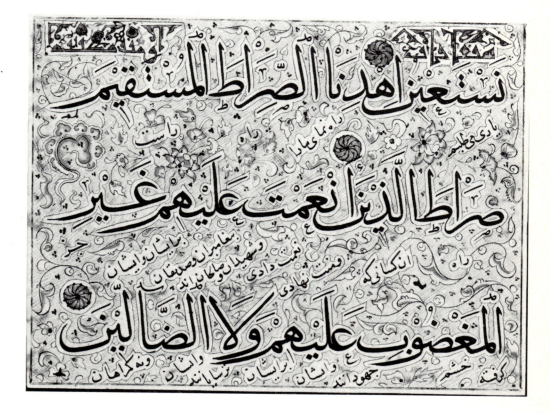

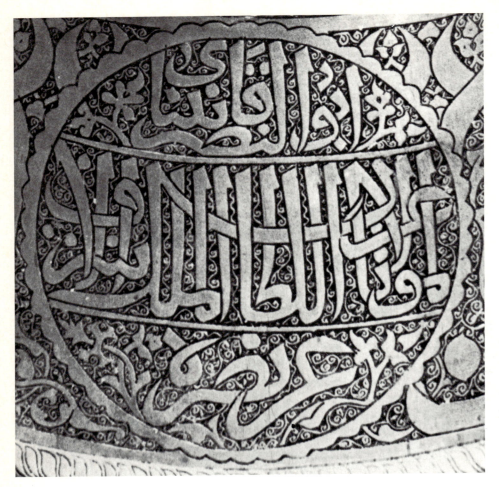

39 Thuluth for the blazon of the Mamluk Sultan al-Malik al-Ashraf Qāytbāy on a brass candlestick presented to the shrine of the Prophet in Medina in 1482

40 Elegant Thuluth carved on a glazed earthenware panel, with the ground richly decorated with arabesque. The Basmalah on the right is followed by a Quranic inscription. From a tomb dated 1538, near Bukhara, eastern Persia

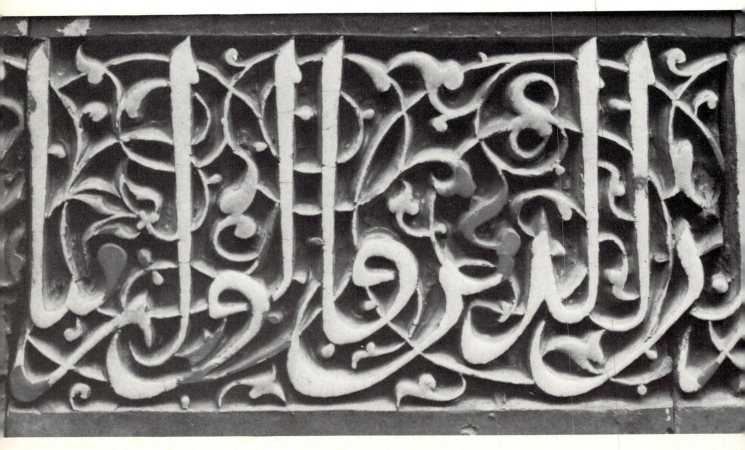

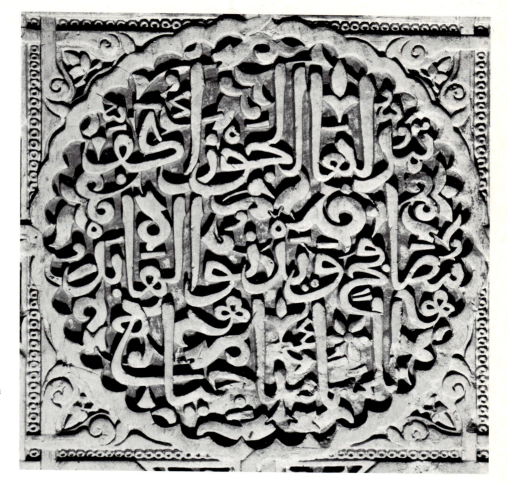

41 A poem in Andalusian Thuluth, carved on a stucco-work roundel in the Hall of the Two Sisters in the royal palace of the Alhambra, Granada. The inscription, by the illustrious Arab poet and statesman Ibn Zamrak (d. 1393), is a celebration of the beauty of the Alhambra itself. The poem may be translated:

The Twins stretch forth a friendly
* hand in greeting to her,*
The celestial moon draws near
* whispering affection*

42 (left) Animated Thuluth integrated with a complex hunting scene, the elongated vertical stems of the letters terminating in human heads. The discernible text reads al-ʿIzz, 'the glory'. From a bronze bowl with silver inlay, probably from Iraq, late 13th century

44 Ornamental Thuluth on a brass cauldron, dated 1375, in the Masjid-i Jumʿah in Herat. The bands at the top are Quranic inscriptions with dedications to the owner, Muḥammad ibn ʿAlī, below

43 (left) Thuluth on a frieze-tile, translating: 'It was written on the first day of Shaʿbān of the year AH 709'. Persia, 1310

45 Ornamental Thuluth dated 1109, dedicating the minaret of the Ḥaẓrat Ṣāliḥ mosque at Daulatabad, Balkh, Afghanistan. The inscription is part of a dedication which begins, after the Basmalah: 'The building of this minaret was ordered by the exalted Emir Abū Jaˁfar Muḥammad ibn ˁAlī . . .'

46 Thuluth with Kufic in the upper half, on a panel of glazed tiles. Both inscriptions are Quranic; the Kufic is the beginning of the Throne Verse (II, 255), the Thuluth the beginning of a verse which occurs in several locations in the Qurˀān and translates 'O You who believe, if . . .'. Probably from Masjid-i Malik, Kerman, Persia, built during the 11th century but repeatedly restored

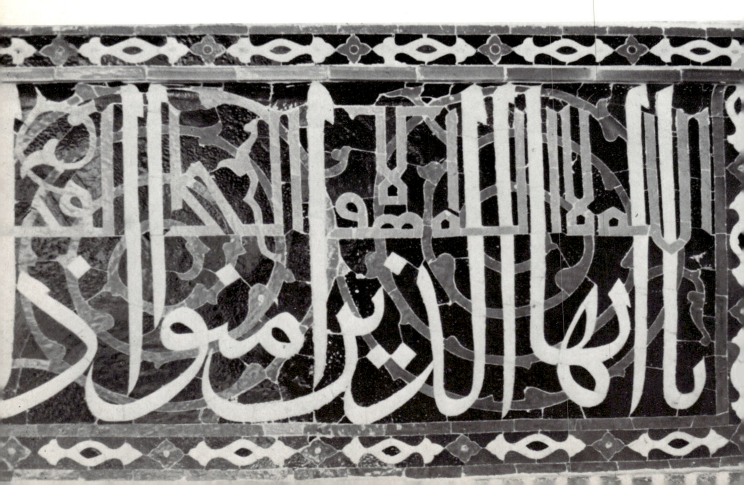

47 Large Thuluth script decorating the central medallion of a
dome in the mosque of Hagia Sophia, Istanbul, 16th century.
The Ottomans were the last, enthusiastic heirs to the tradition of
Islamic calligraphy. The Quranic inscription, beginning with the
Basmalah, is from Sūrat al-Nūr, 'Light' (XXIV, 35)

NASKHĪ

Naskhī was one of the earliest cursive scripts to evolve, but gained popularity only after it had been redesigned by Ibn Muqlah in the 10th century. It was transformed by Ibn al-Bawwāb and others into an elegant script worthy of the Qurʾān, and ever since, more Qurʾāns have been written in Naskhī than in all the other scripts together. It appealed particularly to the ordinary man because it was relatively easy to read and write.

It is nearly always written with short horizontal stems, and with almost equal vertical depth above and below the medial line. The curves are full and deep, the uprights straight and vertical, the words generally well spaced.

48 (below) Small Naskhī, dense but fully vocalized and of the highest order throughout. Qurʾān copied by Ibrāhīm ibn ʿAlī in 1036, probably in Iraq

49 Naskhī sparsely applied to give a monumental effect. Qurʾān copied by ʿAlī ibn Jaʿfar ibn Asad, about 1165 in Syria

فَأَخَذْنَاهُ وَجُنُودَهُ فَنَبَذْنَاهُمْ فِي

الْيَمِّ وَهُوَ مُلِيمٌ ۞ وَفِي عَادٍ إِذْ

أَرْسَلْنَا عَلَيْهِمُ الرِّيحَ الْعَقِيمَ ۞

مَا تَذَرُ مِن شَيْءٍ أَتَتْ عَلَيْهِ إِلَّا

50 Elegant Naskhī in a large Qur'ān copied for the Mamluk Sultan al-Malik al-Ashraf by Shāhīn al-Inbitānī, in 1469 in Cairo

51 Naskhī Qur'ān copied by the Ottoman calligrapher Shaykh Ḥamdullah al-Amāsī, in the early sixteenth century (top right)

52 Naskhī Qur'ān with typical late Safavid marginal ornaments consisting of verse counts and section indicators in Thuluth script. Eastern Persia, 17th century

53 Disciplined late Naskhī, in a Qur'ān copied by the Persian poet and musician Wiṣāl Shīrāzī in the early 19th century. Space has been left for a Persian translation which is not supplied

54 Naskhī Qur'ān copied in Herat in 1563, with first, middle and last lines in Thuluth. The margin ornaments which indicate the passage of five and ten verses are in Eastern Kufic

لَئِنْ آتَيْتَنَا صَالِحًا لَّنَكُونَنَّ مِنَ الشَّاكِرِينَ ۝ فَلَمَّا آتَاهُمَا صَالِحًا جَعَلَا لَهُ شُرَكَاءَ فِيمَا آتَاهُمَا فَتَعَالَى اللَّهُ عَمَّا يُشْرِكُونَ ۝ أَيُشْرِكُونَ مَا لَا يَخْلُقُ شَيْئًا وَهُمْ يُخْلَقُونَ ۝ وَلَا يَسْتَطِيعُونَ لَهُمْ نَصْرًا وَلَا أَنفُسَهُمْ يَنصُرُونَ ۝ وَإِن تَدْعُوهُمْ إِلَى الْهُدَى لَا يَتَّبِعُوكُمْ سَوَاءٌ عَلَيْكُمْ أَدَعَوْتُمُوهُمْ أَمْ أَنتُمْ صَامِتُونَ ۝ إِنَّ الَّذِينَ تَدْعُونَ مِن دُونِ اللَّهِ عِبَادٌ أَمْثَالُكُمْ فَادْعُوهُمْ

فَلْيَسْتَجِيبُوا لَكُمْ إِن كُنتُمْ صَادِقِينَ ۝ أَلَهُمْ أَرْجُلٌ

يَمْشُونَ بِهَا أَمْ لَهُمْ أَيْدٍ يَبْطِشُونَ بِهَا أَمْ لَهُمْ أَعْيُنٌ يُبْصِرُونَ بِهَا أَمْ لَهُمْ آذَانٌ يَسْمَعُونَ بِهَا قُلِ ادْعُوا شُرَكَاءَكُمْ ثُمَّ كِيدُونِ فَلَا تُنظِرُونِ ۝ إِنَّ وَلِيِّيَ اللَّهُ الَّذِي نَزَّلَ الْكِتَابَ وَهُوَ يَتَوَلَّى الصَّالِحِينَ ۝ وَالَّذِينَ تَدْعُونَ مِن دُونِهِ لَا يَسْتَطِيعُونَ نَصْرَكُمْ وَلَا أَنفُسَهُمْ يَنصُرُونَ ۝ وَإِن تَدْعُوهُمْ إِلَى الْهُدَى لَا يَسْمَعُوا وَتَرَاهُمْ يَنظُرُونَ إِلَيْكَ وَهُمْ لَا يُبْصِرُونَ

خُذِ الْعَفْوَ وَأْمُرْ بِالْعُرْفِ وَأَعْرِضْ عَنِ الْجَاهِلِينَ

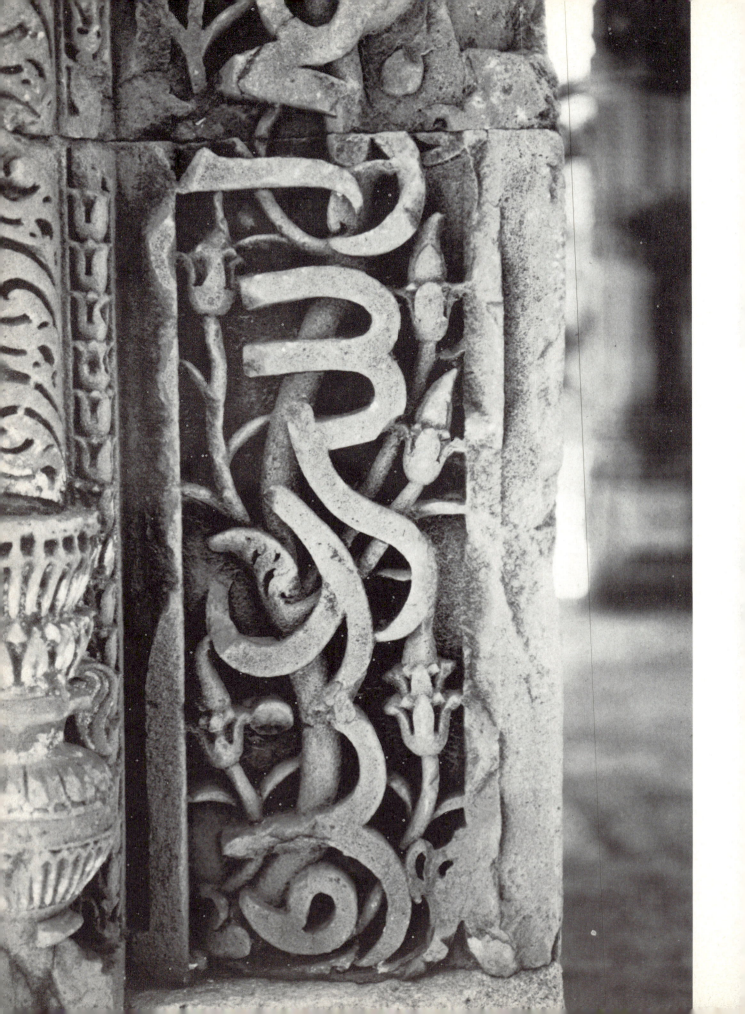

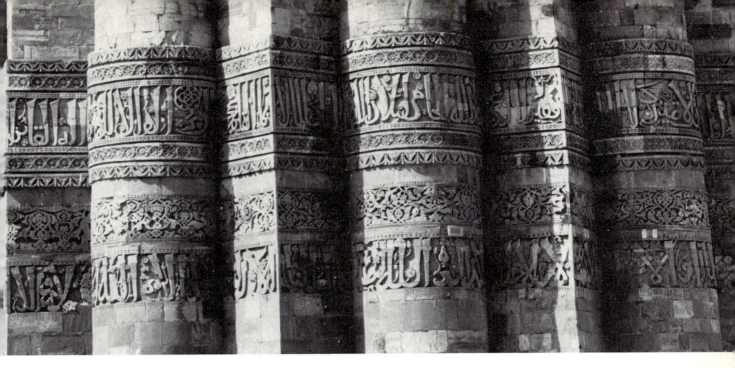

55 (left) Stylized Indian Naskhī decorating the walls of the Quṭb Minār, the famous Islamic victory tower near Delhi, which was begun about 1192. The strong curves of the calligraphic lines help to harmonize the calligraphy with the decorative plant-stems

56 Ornamental Indian Naskhī in linked calligraphic bands on the walls of the Quṭb Minār. The flourishes of most letters are very pointed and curled, in contrast to the verticals

57 Ornamental Indian Naskhī carved in marble, from the miḥrāb of the Qila-i-Kuhna mosque, Delhi. The shallow curvatures extend forward into the sublinear area of the following word. The two words which appear complete in the illustration are part of a Quranic inscription and read: *Kull Shay*', 'all things'

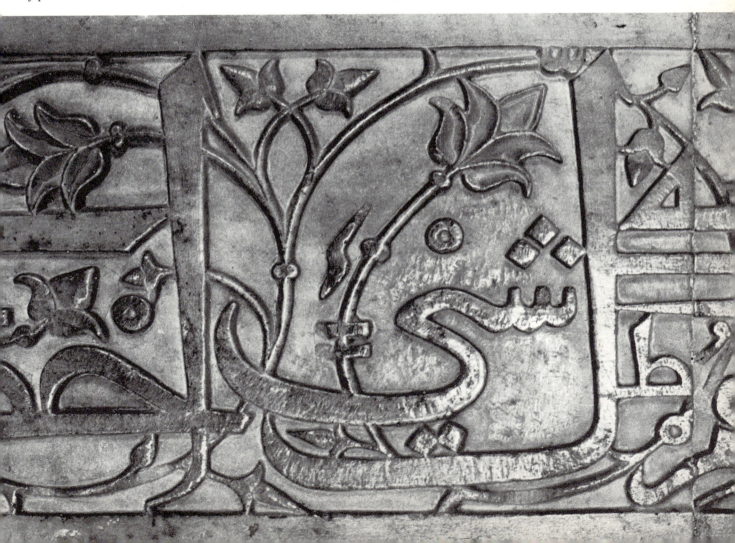

MUḤAQQAQ

Muḥaqqaq, which means 'meticulously produced', was standardized by Ibn Muqlah and reached perfection at the hands of Ibn al-Bawwāb and Yāqūt. Like Naskhī, Muḥaqqaq became an extremely popular script for copying Qur'āns. Its shallow sublinear curves and horizontally extended mid-line curvatures, combined with its compact word-structure, give it a leftward-sweeping impetus. Its varieties range from a somewhat rugged script (59) to writing with delicate outlines and soft curves (60), and a bolder type with characteristics of both Thuluth and Naskhī (61).

58 One of the oldest surviving Muḥaqqaq Qur'āns, Sūrat al-Ḥajj, 'The Pilgrimage' (XXII, 1–5), copied by Mas'ūd ibn Muḥammad al-Kātib al-Iṣfahānī in 1160

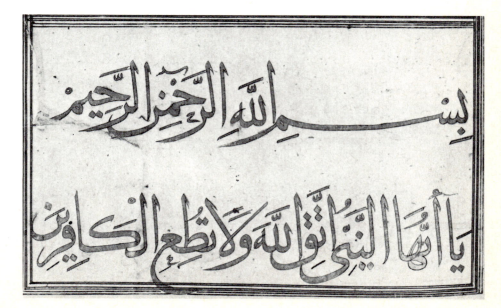

59　Early Muḥaqqaq with verse
counts and section indicators, from an
illuminated Qur'ān, Sūrat al-A'rāf,
'The Heights' (VII, 106–8). Probably
copied in Syria, late 12th century

60　Delicate Muḥaqqaq from a
Qur'ān, Sūrat Yūnus, 'Jonah' (X, 1),
copied by Yaḥyā l-Jamālī l-Ṣūfī in
Shiraz, Persia, in 1345

61　Large Muḥaqqaq from a Qur'ān,
Sūrat al-Aḥzāb, 'The Confederates'
(XXXIII, 1). Copied by Muḥammad
ibn Muḥammad al-Ṭughrā'ī in 1408,
probably in Persia

لَهُ مِنْ أَمْرِهِ يُسْرًا ۞ ذَلِكَ أَمْرُ اللَّهِ أَنْزَلَهُ إِلَيْكُمْ وَمَنْ يَتَّقِ اللَّهَ يُكَفِّرْ عَنْهُ سَيِّئَاتِهِ وَيُعْظِمْ لَهُ أَجْرًا

أَسْكِنُوهُنَّ مِنْ حَيْثُ سَكَنْتُمْ مِنْ وُجْدِكُمْ وَلَا تُضَارُّوهُنَّ لِتُضَيِّقُوا عَلَيْهِنَّ وَإِنْ كُنَّ أُولَاتِ حَمْلٍ

فَأَنْفِقُوا عَلَيْهِنَّ حَتَّى يَضَعْنَ حَمْلَهُنَّ فَإِنْ أَرْضَعْنَ لَكُمْ فَآتُوهُنَّ أُجُورَهُنَّ وَأْتَمِرُوا بَيْنَكُمْ بِمَعْرُوفٍ

وَإِنْ تَعَاسَرْتُمْ فَسَتُرْضِعُ لَهُ أُخْرَى ۞ لِيُنْفِقْ ذُو سَعَةٍ مِنْ سَعَتِهِ وَمَنْ قُدِرَ عَلَيْهِ رِزْقُهُ

فَلْيُنْفِقْ مِمَّا آتَاهُ اللَّهُ لَا يُكَلِّفُ اللَّهُ نَفْسًا إِلَّا مَا آتَاهَا سَيَجْعَلُ اللَّهُ بَعْدَ عُسْرٍ يُسْرًا

وَكَأَيِّنْ مِنْ قَرْيَةٍ عَتَتْ عَنْ أَمْرِ رَبِّهَا وَرُسُلِهِ فَحَاسَبْنَاهَا حِسَابًا شَدِيدًا وَعَذَّبْنَاهَا

عَذَابًا نُكْرًا فَذَاقَتْ وَبَالَ أَمْرِهَا وَكَانَ عَاقِبَةُ أَمْرِهَا خُسْرًا ۞ أَعَدَّ اللَّهُ لَهُمْ عَذَابًا شَدِيدًا

فَاتَّقُوا اللَّهَ يَا أُولِي الْأَلْبَابِ الَّذِينَ آمَنُوا قَدْ أَنْزَلَ اللَّهُ إِلَيْكُمْ ذِكْرًا رَسُولًا يَتْلُو عَلَيْكُمْ آيَاتِ

اللَّهِ مُبَيِّنَاتٍ لِيُخْرِجَ الَّذِينَ آمَنُوا وَعَمِلُوا الصَّالِحَاتِ مِنَ الظُّلُمَاتِ إِلَى النُّورِ وَمَنْ يُؤْمِنْ بِاللَّهِ

وَيَعْمَلْ صَالِحًا يُدْخِلْهُ جَنَّاتٍ تَجْرِي مِنْ تَحْتِهَا الْأَنْهَارُ خَالِدِينَ فِيهَا أَبَدًا قَدْ أَحْسَنَ اللَّهُ لَهُ

رِزْقًا ۞ اللَّهُ الَّذِي خَلَقَ سَبْعَ سَمَاوَاتٍ وَمِنَ الْأَرْضِ مِثْلَهُنَّ يَتَنَزَّلُ الْأَمْرُ بَيْنَهُنَّ لِتَعْلَمُوا

62 The largest-known Mamluk Qur'ān (each page measuring 43 by 32 inches, 108.5 by 82 cm), copied in Muḥaqqaq by ʿAbd al-Raḥmān ibn al-Ṣāyigh in Cairo in 1397, reputedly in the incredibly short time of sixty days and with a single pen. Sūrat al-Ṭalāq, 'Divorce' (LXV, 6–12)

63 Bold Muḥaqqaq script set in clouds, from a Qur'ān copied by one of the outstanding pupils of the great Yāqūt, Aḥmad al-Suhrawardī, in Baghdad in 1304. Sūrat al-Anfāl, 'The Spoils' (VIII, 41)

64 Muḥaqqaq on a ground of scrollwork arabesque, in an illuminated Qur'ān copied by the Mamluk calligrapher Aḥmad ibn Muḥammad al-Anṣārī, in Cairo in 1334. Sūrat al-Nās, 'Men' (CXIV, 1–2)

65 Muḥaqqaq Qur'ān, Sūrat al-Nisā', 'Women' (IV, 1), copied in the 14th century

RAYḤĀNĪ

Rayḥānī was first developed during the 9th century, and has characteristics in common with Naskhī, Thuluth, and Muḥaqqaq. Like Naskhī it has a deep sublinear area. Its flourishes resemble those of Thuluth, though they are more delicate. Its curves, like those of Muḥaqqaq, are a little angular, pointing almost horizontally leftwards. The diacritical marks and other orthographic signs are always written with a finer pen than the characters of the script.

66 Elegant Rayḥānī in a Qurʾān copied by ʿAbd Allāh ibn Muḥammad al-Hamadānī for the Il-Khanid Sultan Uljaytu in 1313. The text is Sūrat al-Qalam, 'The Pen' (LXVII, 1–5), and begins, after the Basmalah, 'By the inkstand and the pen and what they write . . .'

67 Rayḥānī Qurʾān copied by the great Yāqūt al-Mustaʿṣimī in 1286 in Baghdad. A fine example of Rayḥānī with a strong Muḥaqqaq influence. Sūrat Ibrāhīm, 'Abraham' (XIV, 1–7)

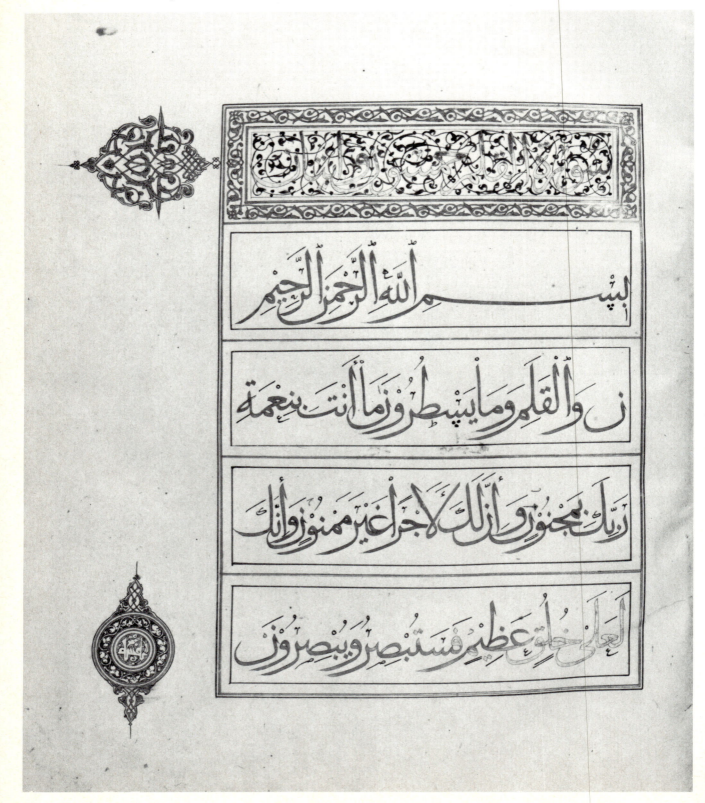

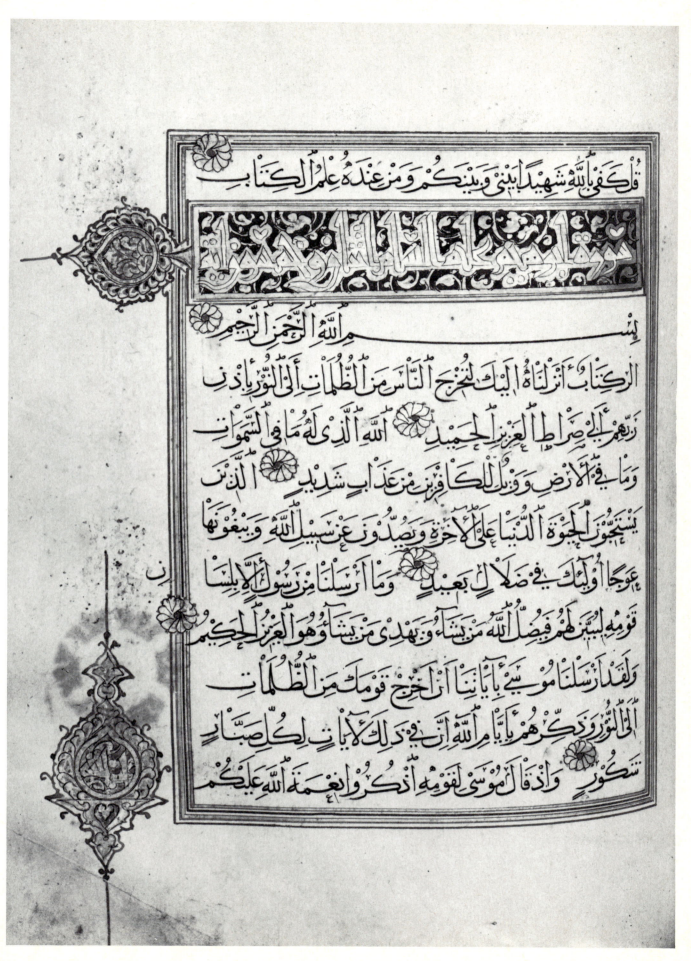

قُلْ كَفَىٰ بِٱللَّهِ شَهِيدًۢا بَيْنِى وَبَيْنَكُمْ وَمَنْ عِندَهُۥ عِلْمُ ٱلْكِتَٰبِ

بِسْمِ ٱللَّهِ ٱلرَّحْمَٰنِ ٱلرَّحِيمِ

الٓر ۚ كِتَٰبٌ أَنزَلْنَٰهُ إِلَيْكَ لِتُخْرِجَ ٱلنَّاسَ مِنَ ٱلظُّلُمَٰتِ إِلَى ٱلنُّورِ بِإِذْنِ رَبِّهِمْ إِلَىٰ صِرَٰطِ ٱلْعَزِيزِ ٱلْحَمِيدِ ۞ ٱللَّهِ ٱلَّذِى لَهُۥ مَا فِى ٱلسَّمَٰوَٰتِ وَمَا فِى ٱلْأَرْضِ ۗ وَوَيْلٌ لِّلْكَٰفِرِينَ مِنْ عَذَابٍ شَدِيدٍ ۞ ٱلَّذِينَ يَسْتَحِبُّونَ ٱلْحَيَوٰةَ ٱلدُّنْيَا عَلَى ٱلْءَاخِرَةِ وَيَصُدُّونَ عَن سَبِيلِ ٱللَّهِ وَيَبْغُونَهَا عِوَجًا ۚ أُو۟لَٰٓئِكَ فِى ضَلَٰلٍۭ بَعِيدٍ ۞ وَمَآ أَرْسَلْنَا مِن رَّسُولٍ إِلَّا بِلِسَانِ قَوْمِهِۦ لِيُبَيِّنَ لَهُمْ ۖ فَيُضِلُّ ٱللَّهُ مَن يَشَآءُ وَيَهْدِى مَن يَشَآءُ ۚ وَهُوَ ٱلْعَزِيزُ ٱلْحَكِيمُ ۞ وَلَقَدْ أَرْسَلْنَا مُوسَىٰ بِـَٔايَٰتِنَآ أَنْ أَخْرِجْ قَوْمَكَ مِنَ ٱلظُّلُمَٰتِ إِلَى ٱلنُّورِ وَذَكِّرْهُم بِأَيَّىٰمِ ٱللَّهِ ۚ إِنَّ فِى ذَٰلِكَ لَءَايَٰتٍ لِّكُلِّ صَبَّارٍ شَكُورٍ ۞ وَإِذْ قَالَ مُوسَىٰ لِقَوْمِهِ ٱذْكُرُوا۟ نِعْمَةَ ٱللَّهِ عَلَيْكُمْ

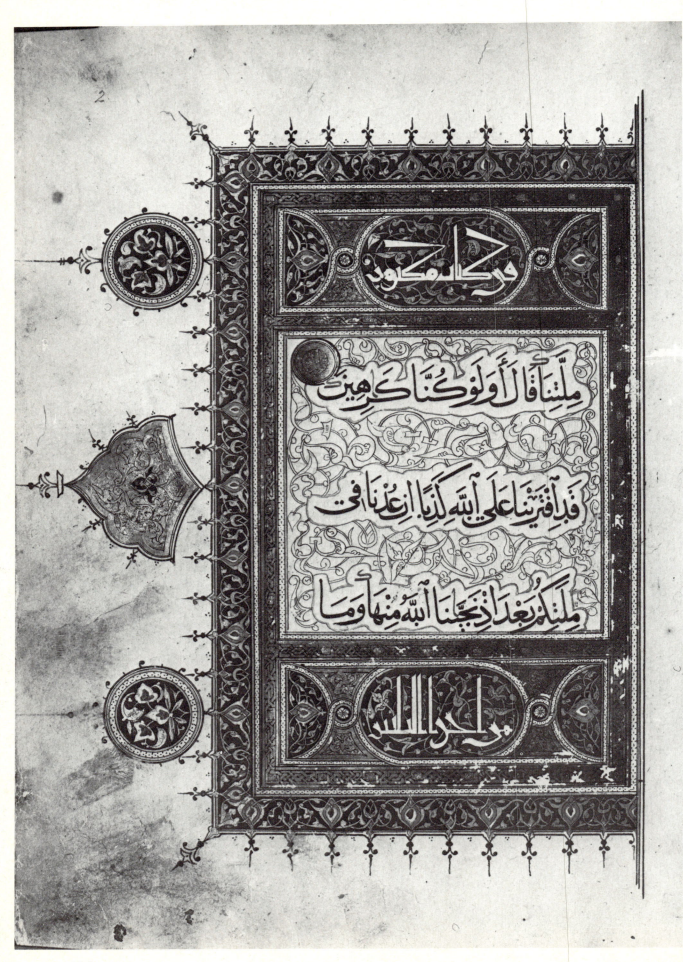

68 Rayḥānī in an illuminated Qur'ān, Sūrat al-A'rāf, 'The Heights' (VII, 88–9), copied in Egypt in the 14th century, probably for the Mamluk Sultan Barqūq, and later donated by his son Sultan Faraj to a mosque in Cairo. The frontispiece inscriptions above and below are in ornamental Eastern Kufic

69 Elegant Rayḥānī with very fine diacritical marks, from a Qur'ān, Sūrat Ṭā-Hā (XX, 1–6), copied by Ibrāhīm Sulṭān, grandson of the great Tamerlane, in Shiraz, Persia, in 1431

70 Rayḥānī set in clouds, from a large Qur'ān copied by the great Timurid prince Baysunghur, who was vizir to his father Shah Rukh at Herat, Persia, where he died in 1433. The text is the beginning of Sūrat al-Fajr, 'The Dawn' (LXXXIX, 1–6)

TAWQĪʿ AND RIQĀʿ

The last two of the 'six styles' of cursive writing, Tawqīʿ and Riqāʿ, are sister scripts, and both have a close affinity with Thuluth. Tawqīʿ was invented by the 9th century, and was soon adopted by the Abbasid caliphs as the royal script for writing their names and titles. It is more horizontally extended than Riqāʿ, is often written linked, and is usually well spaced, with only a few diacritical marks. A heavy, ornamental variety of Tawqīʿ, even more closely resembling Thuluth, developed gradually, and was especially favoured by the Ottoman calligraphers.

Riqāʿ is more rounded and densely structured, with short horizontal stems. It developed in a different direction, becoming much simplified. It is today the preferred script for handwriting throughout the Arab world.

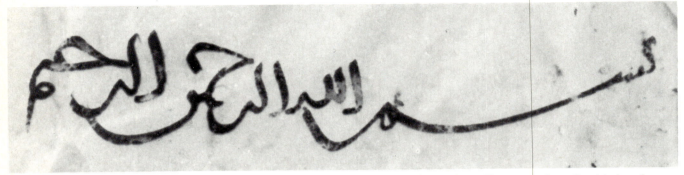

71 The Basmalah in Tawqīʿ script, without diacritical marks or letter-pointing. Detail from the colophon statement of the Ḥāḍinah Qurʾān, copied in Kairouan in 1020

72 Tawqīʿ verging on Riqāʿ, the heading for Sūrat Yūnus, 'Jonah' (X), from a Qurʾān copied in Shiraz by Yaḥyā l-Jamālī l-Ṣūfī in 1344

73 Tawqīʿ verging on Thuluth, detail from a calligraphic page, probably by the hand of Ḥāfiẓ ʿUthmān, Turkey, 17th century. The text translates: 'The Prophet of mercy and saviour of the Muslim community'

قال مكحول عن معاذ بن جبل بلغنا ان الله

تعالى كلم موسى ثلاثة آلاف وخمس مائة

آية فكان آخر كلامه يا رب أوصني قال

أوصيك بأمك حتى قاله سبع مرات

ثم قال يا موسى لا إن رضاها رضاي وسخطها سخطه

MAGHRIBĪ

In the Western wing of the Muslim empire the evolution of Kufic took a new direction. At first there was a noticeable rounding of the angles and a dramatic increase in the depth of the sublinear curves. From 10th-century Tunisia (Kairouan) this development spread to all North-West Africa and Muslim Spain, heralding the so-called Maghribī (Western) script, which was to acquire an elegance equal to the cursive scripts of the East.

The characteristics of Maghribī are its free flow and open curves, and its flourishes extending deeply into the sublinear area – even reaching down and touching adjacent words on the line below. Its verticals and downstrokes are slightly curved to the left. All these characteristics give Maghribī script a unique quality of lightness and grace. This is shared by the styles derived from it, such as the Andalusian.

77 Light and free-flowing Maghribī from a Qur'ān, Sūrat al-Sajdah, 'The Prostration' (XL, 38), copied in Granada in the 13th century. Characteristically, the quarter and half circles reach right down to the line below. *Lām-Alif* (the second word on both lines) is written with a half circle and a hooked diagonal stroke, a feature which is unique to a few Andalusian Qur'āns of this period

78 Andalusian style Maghribī from a Qur'ān, Sūrat Saba', 'Sheba' (XXXIV, 27–31), copied in Valencia in the 12th century. The high density of the script is in marked contrast to the preceding examples, and is a characteristic feature of Andalusian style script of this period

79, 80 Colophon (right) and page (left) from a Maghribī Qur'ān, Sūrat al-Fatḥ, 'Victory' (XLVIII, 1–7), copied in 1568 for the Sultan of Morocco, 'Abd Allāh ibn Muḥammad. The Sūrah heading is in Western Kufic. Verse divisions are marked with loose knots, and the end of each group of five verses is indicated by an ornamental letter *Hā'*, to which Arabic tradition gives the numerical value five

75 Bold Western Kufic from the splendid Ḥāḍinah Qur'ān, Sūrat al-Baqarah, 'The Cow' (II, 255), copied by ʿAlī ibn Aḥmad al-Warrāq at Kairouan in 1020

76 Bold Maghribī from a Qur'ān, Sūrat al-Nisā', 'Women' (IV, 117–19), copied in Morocco in the 11th century

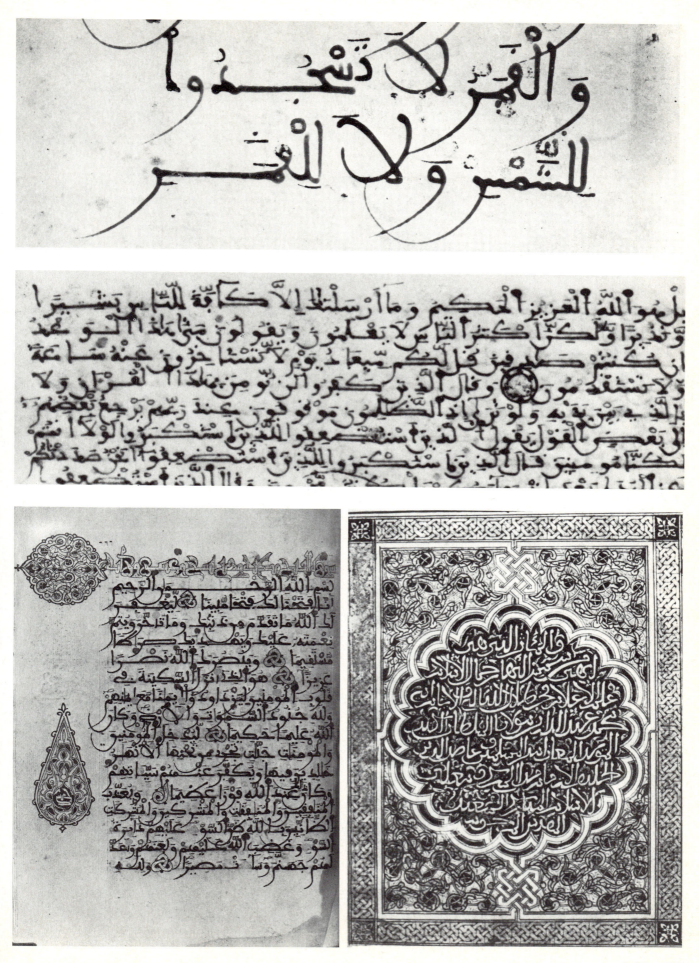

81 Andalusian ornamental Thuluth inscription
woven in silk, with enlarged detail (below) to show the
long verticals ending in barbed heads. The whole
inscription reads *'Izz li-mawlānā l-sulṭān*, 'Glory to our
lord, the Sultan', repeated, while the detail shows
'Glory to our lord'. Granada, late 14th century

82　Modern Maghribī inscribed on a wooden tablet. The text is the name of the Prophet Muḥammad and, in smaller script: 'Muḥammad is the Messenger of God, may God's blessing and peace be upon him.' Rabat, late 19th century

83　Standard of the Almohad Caliph Abū Yaʿqūb Yūsuf II, captured in 1212 at the battle of Las Navas de Tolosa, which marked the turn of the tide against Islam in Spain. The calligraphic panels are Quranic texts (the vertical ones are to be read from the back of the cloth), mainly from Sūrat al-Ṣaff, 'The Battle Array' (LXI, 10–12), and translate: 'O believers, shall I point out to you a profitable course that will save you from a woeful scourge. Have faith in Allāh and his Prophet and fight for His cause with your wealth and your lives; that would be best for you, if only you knew it. He will forgive you your sins and admit you to gardens with running streams, and house you in pleasant mansions in the gardens of Eden.'

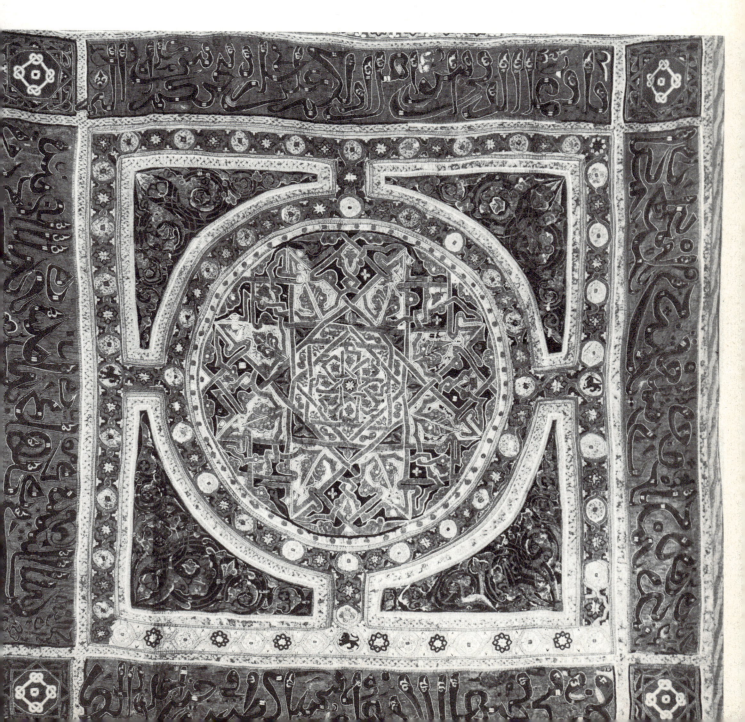

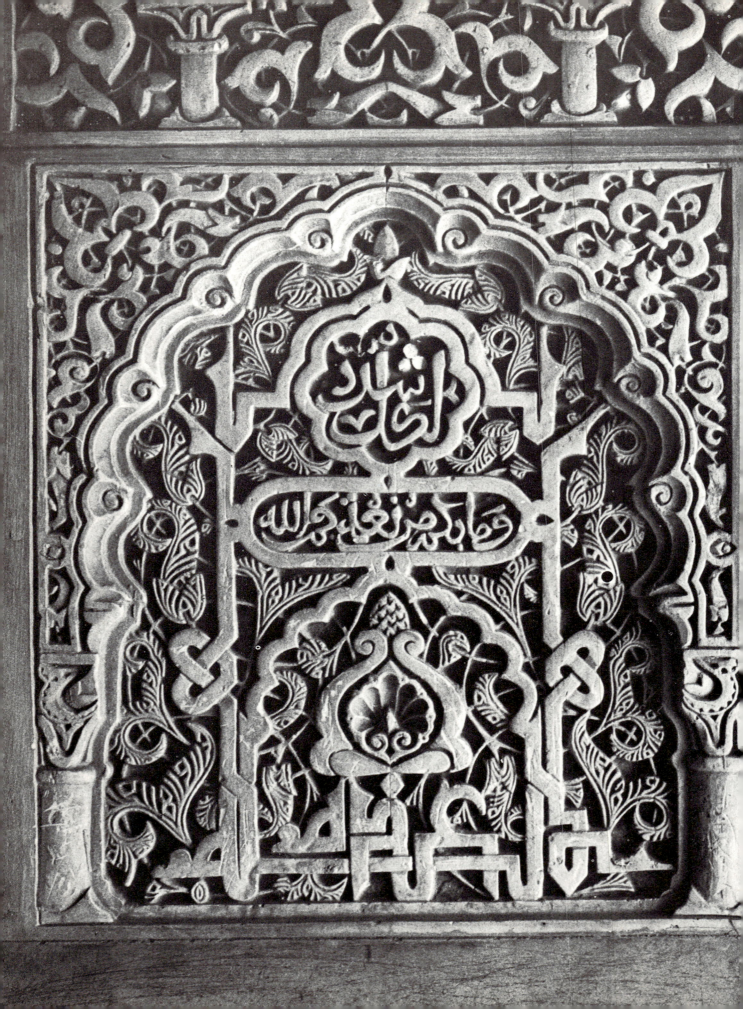

84 Highly stylized knotted Kufic, carved in stucco-work on a
wall of the royal palace of the Alhambra, Granada. It can be read
with difficulty as 'Glory to God'. The central Quranic
inscription, from Sūrat al-Naḥl, 'The Bee' (XVI, 53), is in
ornamental Andalusian Naskhī, and translates, 'All blessings are
from God'. 14th century

85 Andalusian Thuluth on wall tiles from the Bū-ʿInāniyyah
Madrasah in Meknès, which was completed by Abū ʿInān Fāris
(d. 1358), the eleventh ruler of the Marinid dynasty. This detail
of the inscription reads *al-Ḥamd li-Llāh alliḏī*, 'Praise be to God
who . . .'. The script is densely structured and its forms have
been adapted to harmonize with the arabesque pattern

TA῾LĪQ, NASTA῾LĪQ AND SHIKASTEH

During the 16th century in Persia an extremely important calligraphic development took place with the formulation of Ta῾līq (hanging) script from Riqāʿ and Tawqiʿ. From Ta῾līq, an even lighter and more elegant form evolved, known as Nasta῾līq; and derived from both Ta῾līq and Nasta῾līq was Shikasteh (broken form), which is characterized by an exaggerated density in the superstructured letters.

86 Calligraphic page in Nasta῾līq script set in clouds and bearing the date AH 1127 (1715). The text is Islamic prayers and invocations, and praise of the Prophet Muḥammad and his family

87 Page in densely structured Shikasteh written by Nawab Murīd Khān in India, probably during the 17th century

88 Detail from a decorated calligraphic page of Persian verse in elegant Ta'līq, written by Mīr 'Imād al-Ḥusaynī in the early 17th century

89 Ornamental Nastaʿlīq, on a ground decorated with floral designs. The text is in praise of Imām ʿAlī, the fourth Orthodox Caliph (successor to the Prophet), whose assassination in 661 brought about schism in Islam. His *Shiʿah*, or followers, declared him the First Imām, and the Shīʿah sect still has a great following today, particularly in Persia and Iraq

90 Elegant Nastaʿlīq signature on the famous Ardabil carpet, probably the largest and most beautiful carpet in the world. The text may be translated freely as: 'I have no earthly refuge, but only Heaven. I have no place but this to rest my head. The work of the servant of the court, Maqṣūd Kāshānī AH 946 [1540].' The carpet was produced during the reign of the Safavid Shah Tahmasp, probably for the Holy Shrine at Ardabil, Persia

91 Composite page of Persian text in large ornamental Taʿlīq and small Nastaʿlīq by Shāh Maḥmūd al-Nīshābūrī, Persia, early 16th century

92 Persian verses in Taʿlīq on the rim and the body of a late 12th-century lustre vase. The band at the base of the neck is Arabic written in ornamental Naskhī

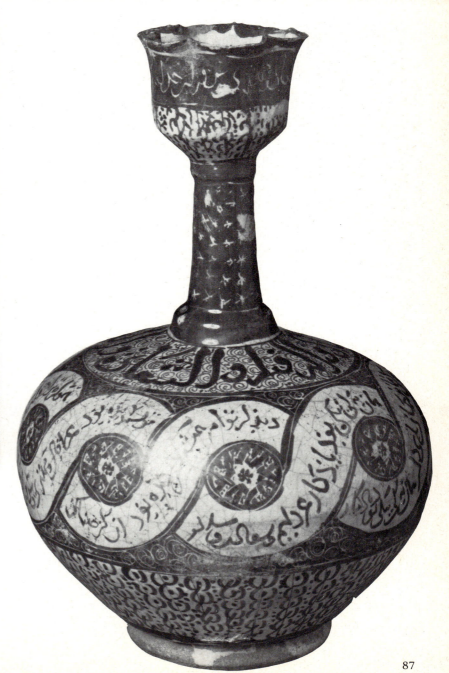

The calligrapher and his page

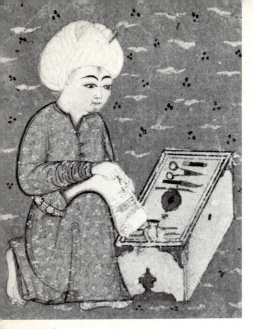

93 The calligrapher at work, seated on the floor in the traditional posture with one knee drawn up to support the paper. Writing implements arranged on a table in front of him include scissors, a knife for cutting the pens, brush and reed pens (*Qalams*), ink pot (*Dawāt*) and probably a sharpening stone. From a 16th-century Turkish manuscript of *'Ajā'ib al-Makhlūqāt* ('The Wonders of Creation') by al-Qazwīnī

94 Set of calligrapher's tools. The pen rest is ivory, the ink pot and pen case are silver, the pen box is 'Persian' lacquer. Turkey, probably 17th century

95 (right) Porcelain pen rest of the kind generally used with the brush type of qalam, most favoured by Chinese Muslim calligraphers. It is in the shape of a five-peaked mountain with an inscription in Naskhī reading *al-Qalam qabl kull shay*' – 'There was first the pen'. China, Cheng-te period 1506–21

96 (centre right) Mortar for grinding the various ingredients used to make ink, of bronze with silver inlay, in the shape of a bird. Persia, probably late 12th century

97 (far right) Qalams – the reed pens preferred for Islamic calligraphy at all periods, and still an essential tool for the true calligrapher. The traditional way to hold the pen is with middle finger, forefinger and thumb well spaced out along the shaft. Only the lightest possible pressure is applied. Examples from Turkey, late 17th or early 18th century

98 (below) Pen box of brass inlaid
with gold and silver, inscribed with
Kufic on the edge of the lid, Mamluk
Thuluth inside. The Thuluth
translates: 'Glory to our Lord the
reigning Sultan, the victorious King,
the learned, the holy warrior . . .'. The
Sultan referred to is al-Malik
al-Manṣūr Muḥammad, who ruled in
Egypt 1361–3

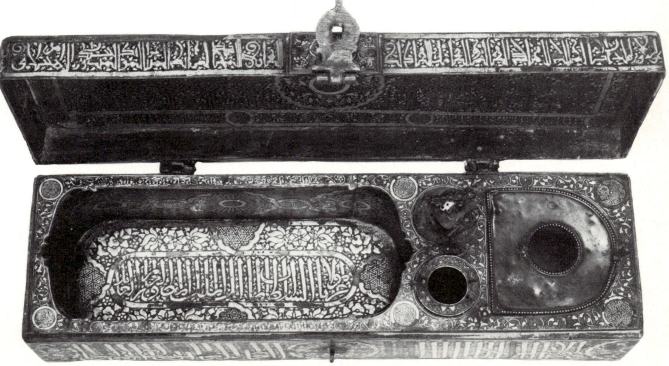

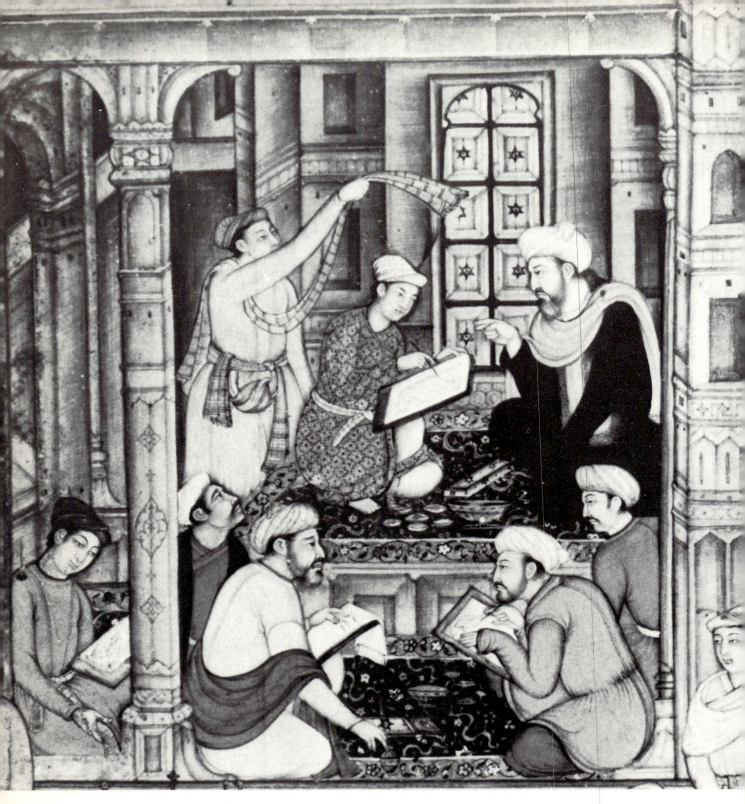

99 A young prince receiving instruction in calligraphy, while around him artists are seated, painting. From an Indian Moghul manuscript, *Akhlāq-i Nāṣirī* ('The Ethics of Naṣīr al-Dīn Ṭūsī'), illustrated by Sanju for the great Emperor Akbar, *c.* 1595

100 Instruction sheet in Nastaʿlīq by the hand of the famous calligrapher Mīr ʿImād al-Ḥusaynī. The examples are mainly the letters *sh*, *s*, and *ṣ* combined with others. Early 17th century

101 A calligrapher's practice sheet in Nastaʿlīq, 17th century

میر عماد حسنی

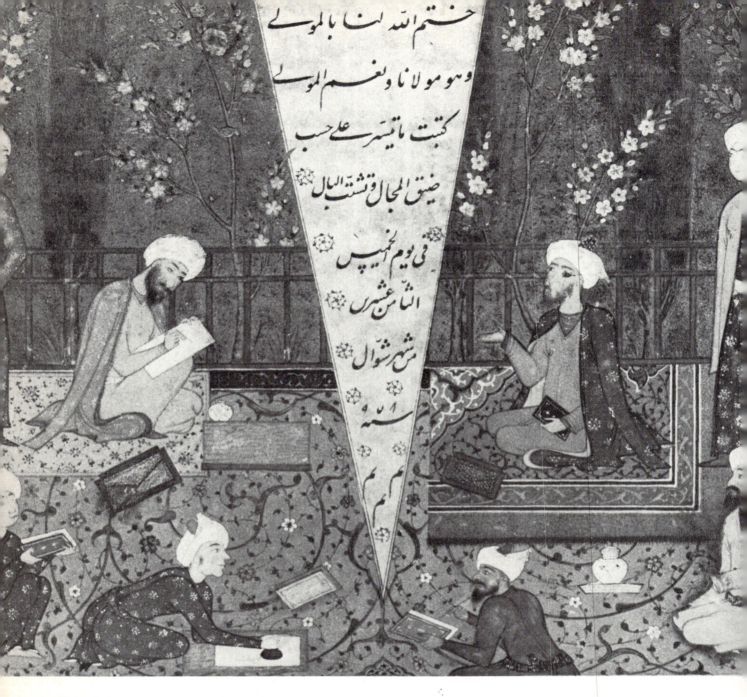

102　Calligraphy, book-binding and
paper-polishing in progress, watched
by a seated noble. The Taʿlīq script
in the triangle is the colophon of the
book containing the illustration, an
anthology of Persian poems dated
1570–1

103　Colophon containing the
words: 'Written by ʿAlī ibn Hilāl
. . .' – namely the calligrapher better
known as Ibn al-Bawwāb (see p. 18).
From an early Thuluth Qurʾān copied
in Baghdad in 1000

104 Colophon containing the words: 'Written by Yāqūt al-Mustaʿṣimī . . .' (see p. 18). From a Thuluth Qurʾān copied in Baghdad in 1282

105 The signatures of calligraphers: (a) Mīr ʿAlī Harawī (d. c. 1518); (b) Mīr ʿAlī al-Kātib al-Sulṭānī (d. 1558); (c) Shāh Maḥmūd al-Nīshābūrī, called 'Zarīn Qalam', or 'Golden Pen' (see p. 28); (d) Mīr ʿImād al-Dīn al-Ḥusaynī, who was assassinated by Shah ʿAbbās (see p. 28); (e) Ḥāfiẓ ʿUthmān (see p. 30)

a

b

c

d

e

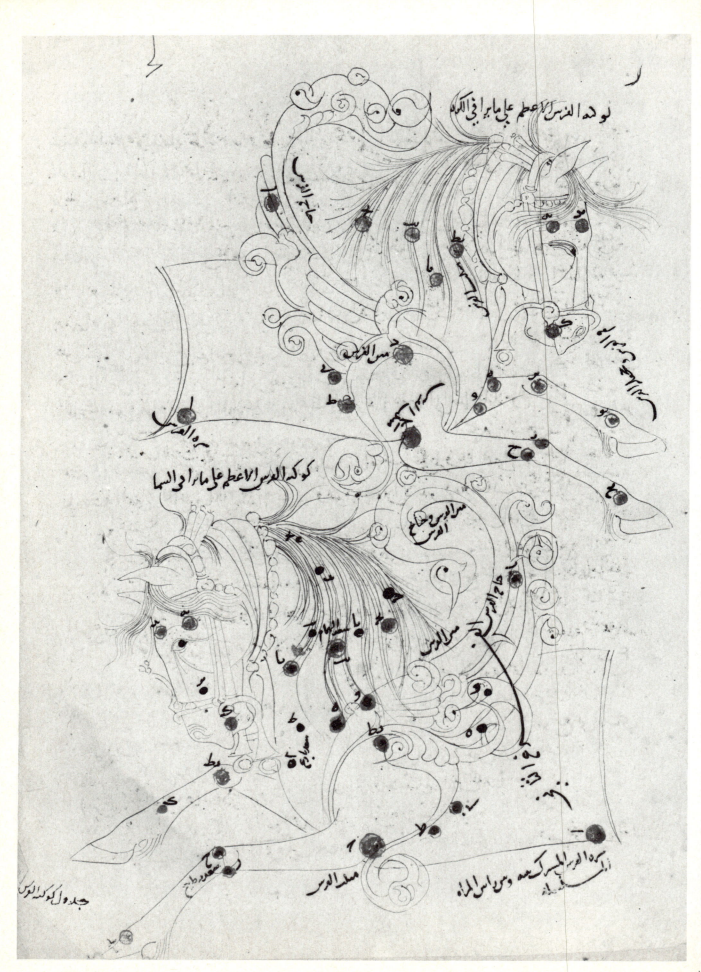

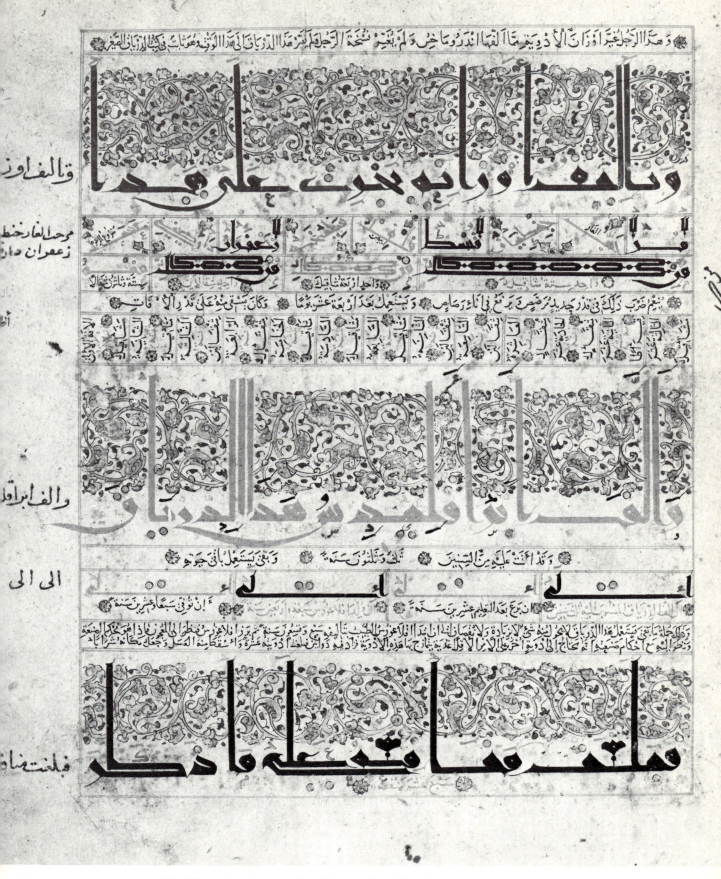

Pages on astronomy and medicine illustrating the virtuosity of the Muslim calligrapher

106 The constellation Pegasus with annotation in Naskhī, from *Ṣuwar al-Kawākib al-Thābitah* ('Forms of the Fixed Stars'), by ʿAbd al-Raḥmān al-Ṣūfī. Iraq, 13th century

107 Page from an Arabic manuscript on medicine attributed to Galinus, in Naskhī with headings in elegant ornamental Kufic. Iraq, 1199

In the Islamic decorative arts the page occupies a most honoured place. In Qur'āns the structure of a page may vary from the richly illuminated double-page *'Unwān* and those decorated with Sūrah headings and marginal ornaments to others which are without decoration except for a ruled border containing the text. Secular manuscripts display a much more varied page-structure. The text may be divided into compartments by the ornamentation. It may be written multi-directionally, and cover the entire page area without any margin or be framed in rich illumination. The text is frequently accompanied by commentary and supercommentary. Whatever the subject – a literary epic, an anthology, or a scientific subject such as astronomy or medicine (106, 107) – the page is frequently embellished with both ornamental calligraphy and decorative designs, with the emphasis always on artistic elegance. The artistic format of the single calligraphic page was a later development which flourished particularly in Persia under the Timurids and Safavids, and to a lesser extent in Turkey and the Arab countries during the Ottoman period.

108 Three words in Muḥaqqaq on a page of a Mamluk Qur'ān. They translate as 'God has spoken the truth', a formula which is used when a Quranic text has been recited

109 (top right) Page copied in elegant Nasta'līq by Mīr ʿAlī Sulṭān in Herat, in 1492. The text is from the *Khamsah* of Mīr ʿAlī Shāh Navā'ī

110 Composite page with texts in Nasta'līq and Ta'līq contributed by Sulṭān Maḥmūd, Kamāl al-Khujandī and Mīr ʿAlī Harawī, probably in Herat, about 1514

111 (opposite) Page of Persian Nasta'līq by Mīr ʿAlī Harawī (d. *c.* 1518), illuminated at a later date by a Moghul painter of Jahangīr's court, 1606–27

بِآيَاتِ رَبِّنَا وَنَكُونَ مِنَ الْمُؤْمِنِينَ

بَلْ بَدَا لَهُم مَّا كَانُوا يُخْفُونَ مِن قَبْلُ وَلَوْ رُدُّوا لَعَادُوا لِمَا نُهُوا عَنْهُ وَإِنَّهُمْ لَكَاذِبُونَ

وَقَالُوا إِنْ هِيَ إِلَّا حَيَاتُنَا الدُّنْيَا وَمَا نَحْنُ بِمَبْعُوثِينَ وَلَوْ تَرَىٰ إِذْ وُقِفُوا عَلَىٰ رَبِّهِمْ قَالَ أَلَيْسَ هَٰذَا

بِالْحَقِّ قَالُوا بَلَىٰ وَرَبِّنَا قَالَ فَذُوقُوا الْعَذَابَ بِمَا كُنتُمْ تَكْفُرُونَ

قَدْ خَسِرَ الَّذِينَ كَذَّبُوا بِلِقَاءِ اللَّهِ حَتَّىٰ إِذَا جَاءَتْهُمُ السَّاعَةُ بَغْتَةً قَالُوا يَا حَسْرَتَنَا عَلَىٰ مَا فَرَّطْنَا

فِيهَا وَهُمْ يَحْمِلُونَ أَوْزَارَهُمْ عَلَىٰ ظُهُورِهِمْ أَلَا سَاءَ مَا يَزِرُونَ وَمَا الْحَيَاةُ الدُّنْيَا إِلَّا لَعِبٌ وَلَهْوٌ

وَلَلدَّارُ الْآخِرَةُ خَيْرٌ لِّلَّذِينَ يَتَّقُونَ

أَفَلَا تَعْقِلُونَ قَدْ نَعْلَمُ إِنَّهُ لَيَحْزُنُكَ الَّذِي يَقُولُونَ فَإِنَّهُمْ لَا يُكَذِّبُونَكَ وَلَٰكِنَّ الظَّالِمِينَ

بِآيَاتِ اللَّهِ يَجْحَدُونَ وَلَقَدْ كُذِّبَتْ رُسُلٌ مِّن قَبْلِكَ فَصَبَرُوا عَلَىٰ مَا كُذِّبُوا وَأُوذُوا

حَتَّىٰ أَتَاهُمْ نَصْرُنَا وَلَا مُبَدِّلَ لِكَلِمَاتِ اللَّهِ وَلَقَدْ جَاءَكَ مِن نَّبَإِ

الْمُرْسَلِينَ وَإِن كَانَ كَبُرَ عَلَيْكَ إِعْرَاضُهُمْ فَإِنِ اسْتَطَعْتَ أَن تَبْتَغِيَ نَفَقًا فِي الْأَرْضِ

أَوْ سُلَّمًا فِي السَّمَاءِ فَتَأْتِيَهُم بِآيَةٍ وَلَوْ شَاءَ اللَّهُ لَجَمَعَهُمْ عَلَى الْهُدَىٰ فَلَا تَكُونَنَّ مِنَ الْجَاهِلِينَ

إِنَّمَا يَسْتَجِيبُ الَّذِينَ يَسْمَعُونَ وَالْمَوْتَىٰ

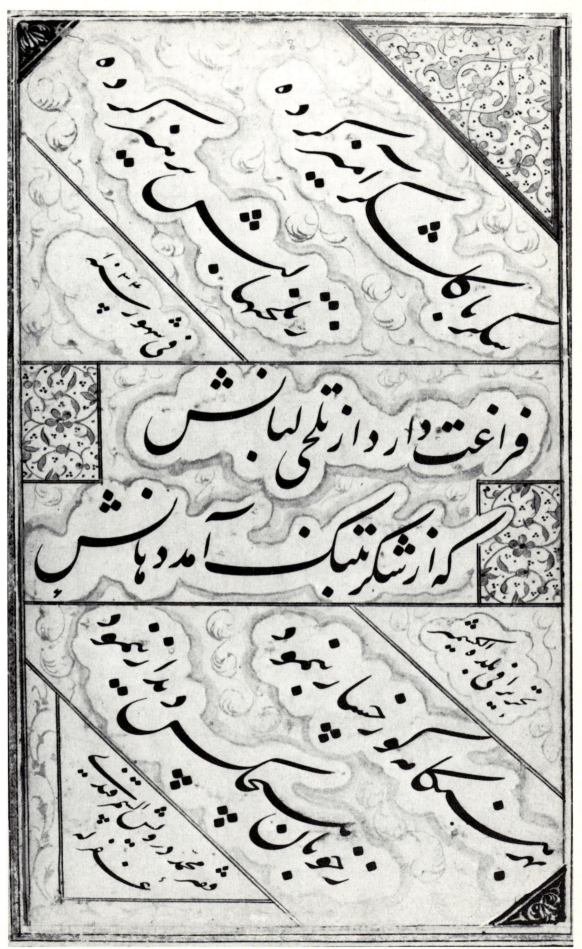

112 Bands of script written in different sizes alternated for decorative effect, using large Thuluth and smaller Naskhī, with large Muḥaqqaq at the centre. Page with Quranic inscriptions by the Ottoman calligrapher Aḥmad Qaraḥiṣārī, 1574

113 Compartments of varying shapes dividing sections of Persian verse in free-flowing Nastaʿlīq. Page written by Muḥammad Darwīsh al-Samarqandī in Kashmir in 1624

114 Calligraphic page in Ta'līq, set in clouds on a floral ground, by Jawhar Raqm Thānī. Persia, 17th century

115 Calligraphic page in Ta'līq written by Mīr 'Imād al-Dīn al-Ḥusaynī. Persia, c. 1610

116 (right) Calligraphic page of Shikasteh by Darwīsh 'Abd al-Majīd Ṭāliqānī, the celebrated Persian calligrapher who is considered by most to be the founder of this script. Dated AH 1207 (1792)

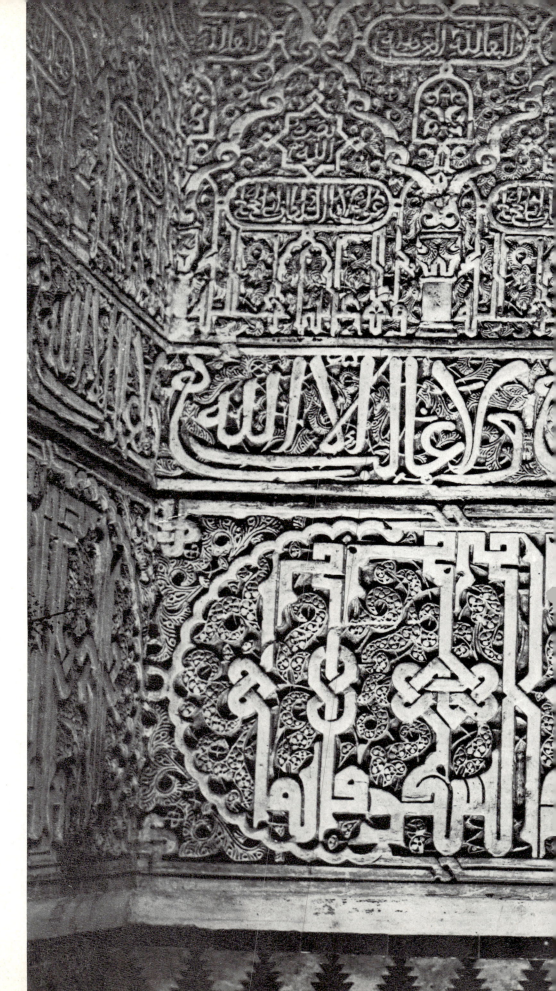

Composite styles and techniques

The splendid effect of Islamic calligraphy is enhanced by the deliberate juxtaposing of different scripts and the intricate interweaving of script and decoration.

117 Composite calligraphic panels of Andalusian Thuluth and ornamental Kufic on a wall of the Alhambra, Granada. The text of the central Thuluth band is the famous battle-cry of the Nasrid rulers of Granada: *wa-lā ghāliba illā-Llāh* – 'There is no Victor but God'; and the knotted Kufic inscription translates: 'O God, praise be to Thee always', and 'O God, to Thee thanksgivings everlasting'

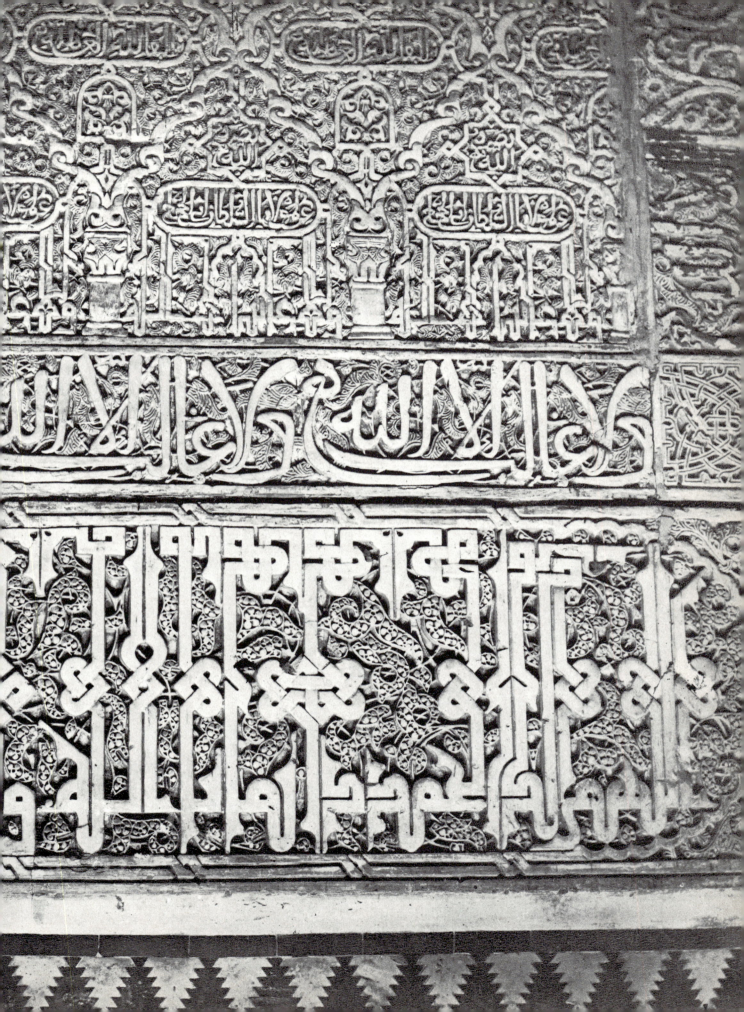

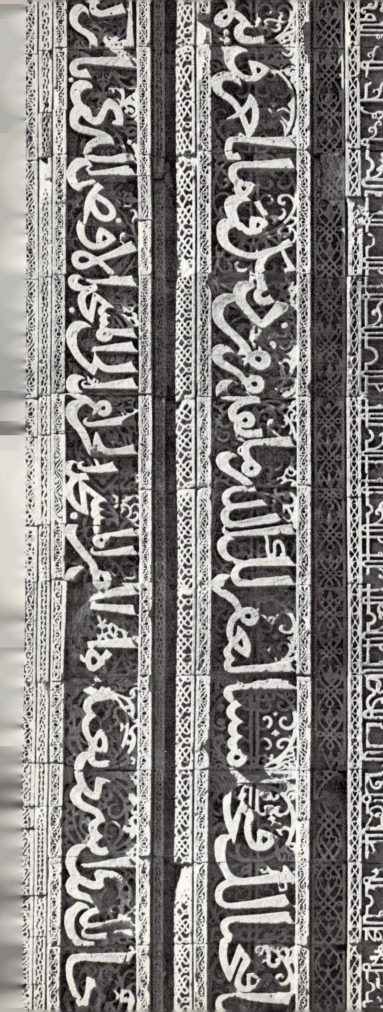

118 Indian Thuluth and
knotted and foliated Kufic in
brickwork, juxtaposed on the
Arhai-Dīn-ka-Jhonpra mosque
in Ajmer, India, built about
1200. All three bands are
Quranic inscriptions. The left-
hand band translates: 'Praise be
unto Him who transported his
servant by night from the Holy
Mosque [of Mecca] to the Farther
Mosque [of Jerusalem] which
we have blessed . . .'. From
Sūrat al-Isrā', 'The Night
Journey' (XVII, 1)

119 Thuluth and Kufic scripts
combined, on the wall of Ulu
Cami, Bursa, Turkey. The
Quranic verse is from Sūrat al-
Munāfiqīn, 'The Hypocrites'
(LXIII, 8), and translates: 'Glory
belongs to God, and to his
Apostles, and the true believers,
but the hypocrites know it not.'
The word wa ('and') is used
four times in the verse, and this
has been drawn with immense
boldness

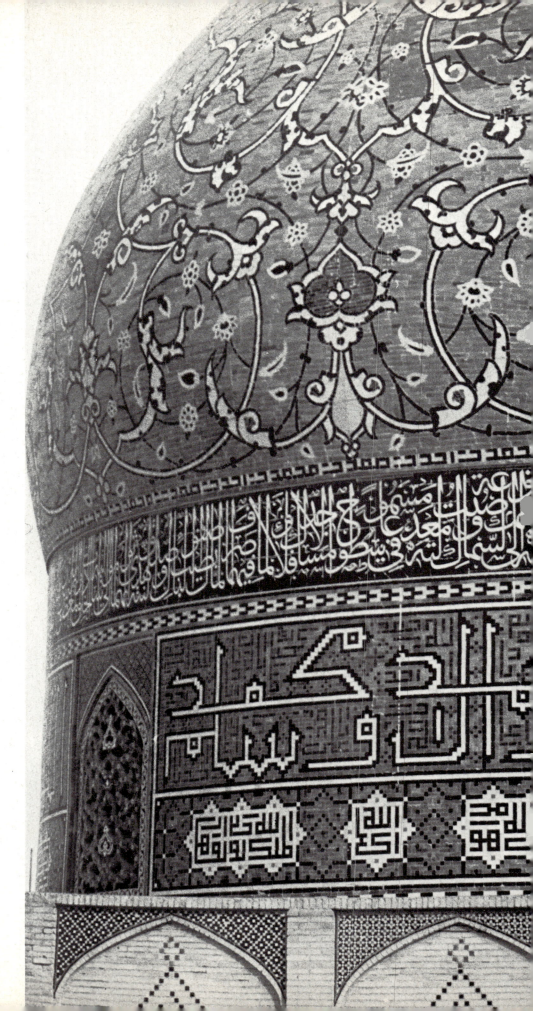

120 Composite calligraphy in its full magnificence in the mosaic-tile inscriptions on the dome of the Royal Mosque (Masjid-i Shāh), built for Shah ʿAbbās in Isfahan, Persia, c. 1613. A wide band of Jalī Thuluth surrounding the dome is an inscription in praise of Shah ʿAbbās and the Safavids, consisting of three integrated levels of script. The narrow strip above this band is square Kufic consisting mainly of the word 'Muḥammad'; the bands lower on the dome are ornamental bold Kufic inscriptions reading *Allāhumma ṣallī ʿalā Muḥammad wa-Āl Muḥammad wa-sallim* – 'O God bless Muḥammad and his family and grant them peace.' The background to the inscriptions is itself Kufic calligraphy, reading mainly *yā Allāh, yā Muḥammad, yā ʿAlī*. The lowest band is of square Kufic, reading 'God is most mighty' and 'Allāh is God and there is no other God but He'

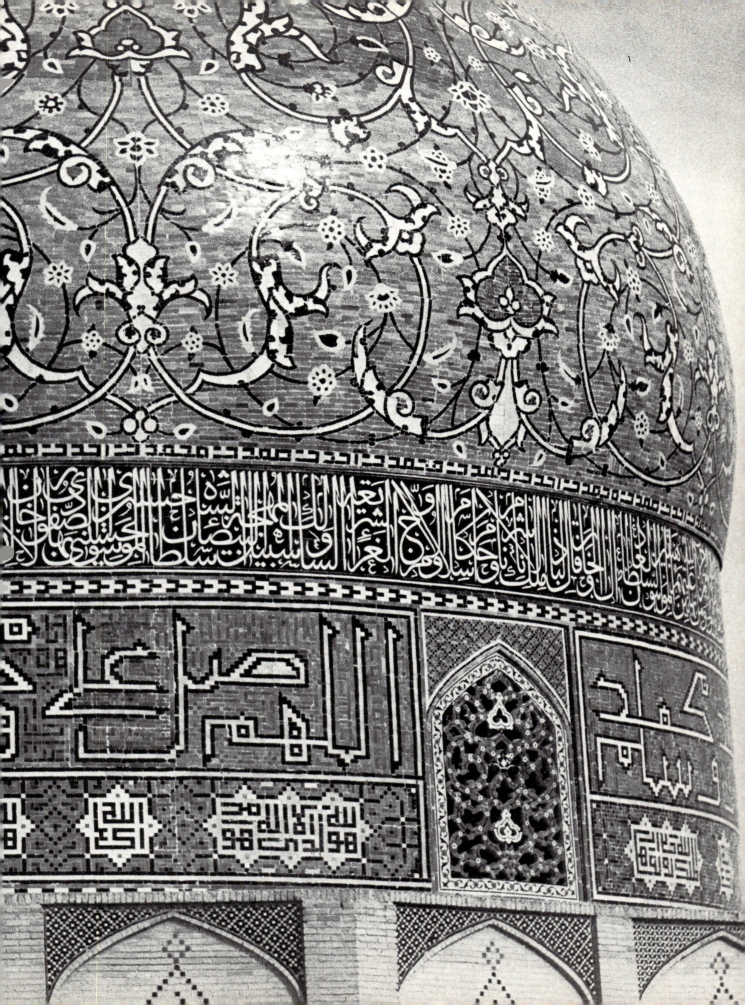

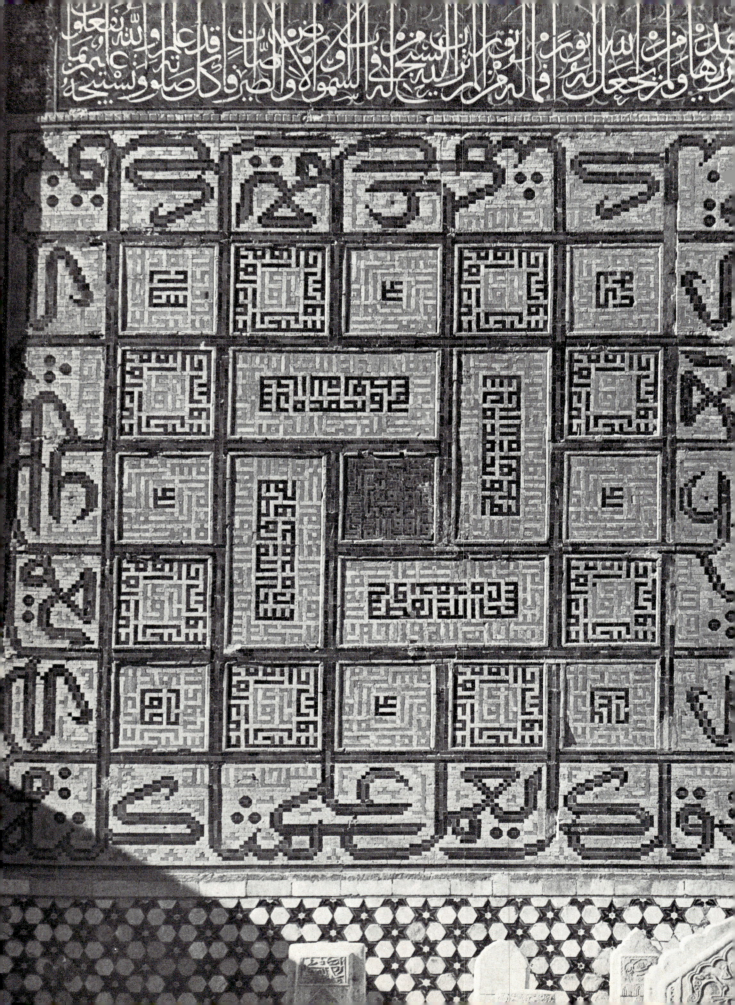

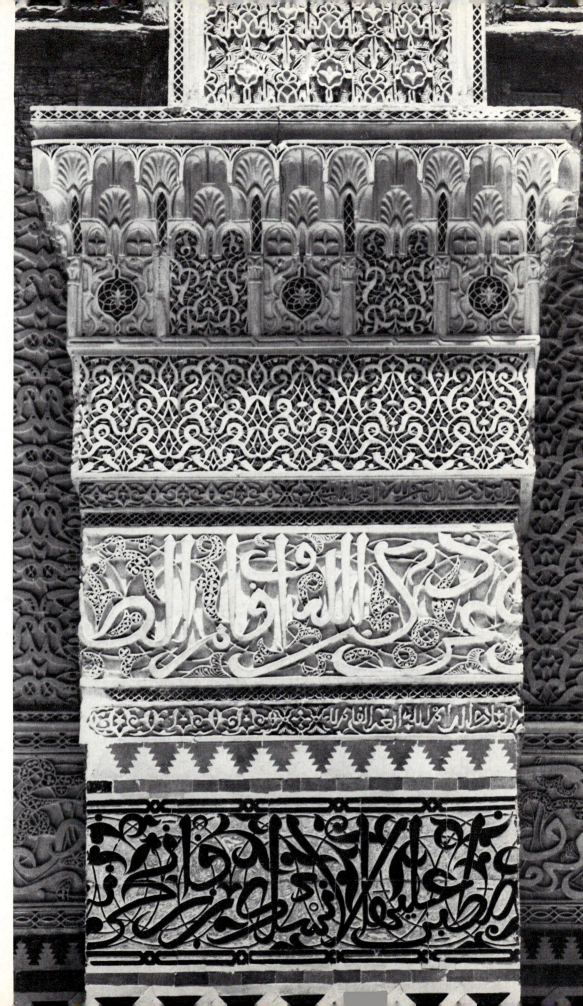

121 Mosaic tile-work in the shrine of the poet and Ṣufī saint ʿAbd Allāh Anṣārī (d. 1088), built by the Timurid Sultan Shah Rukh in the early 15th century, near Herat. At the top is Jalī Thuluth script, densely structured. The border is of Naskhī, with the stems of the letters manipulated to form square compartments. The maze-like patterns in the centre are square Kufic

122 Andalusian Thuluth in stucco above and tilework below, on a column from Madrasat al-ʿAṭṭārīn (School of perfume-makers) built in Fez in 1323–5 by Sultan Abū Saʿīd

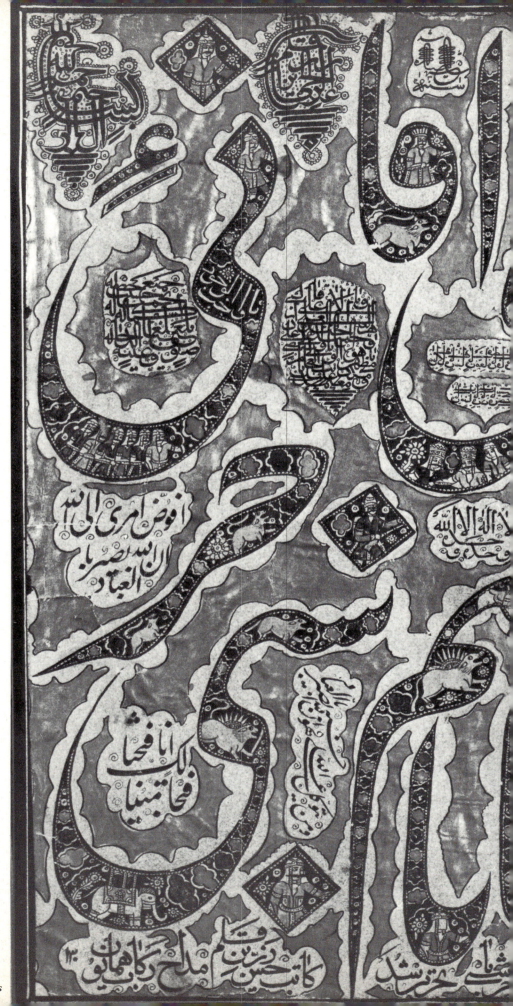

123　The decorative style
known as 'Gulzār'. This page by
the Persian calligrapher Ḥasan
Razīn Qalam, dated 1883,
contains styles particularly
favoured in Persia, including
Thuluth, Naskhī, Nastaʿlīq,
Shikasteh, Tawqīʿ, Kufic and
various Jalī scripts. The letters
themselves of the large Persian
Nastaʿlīq script are filled with
court and hunting scenes,
flowers, portraits and smaller
calligraphy

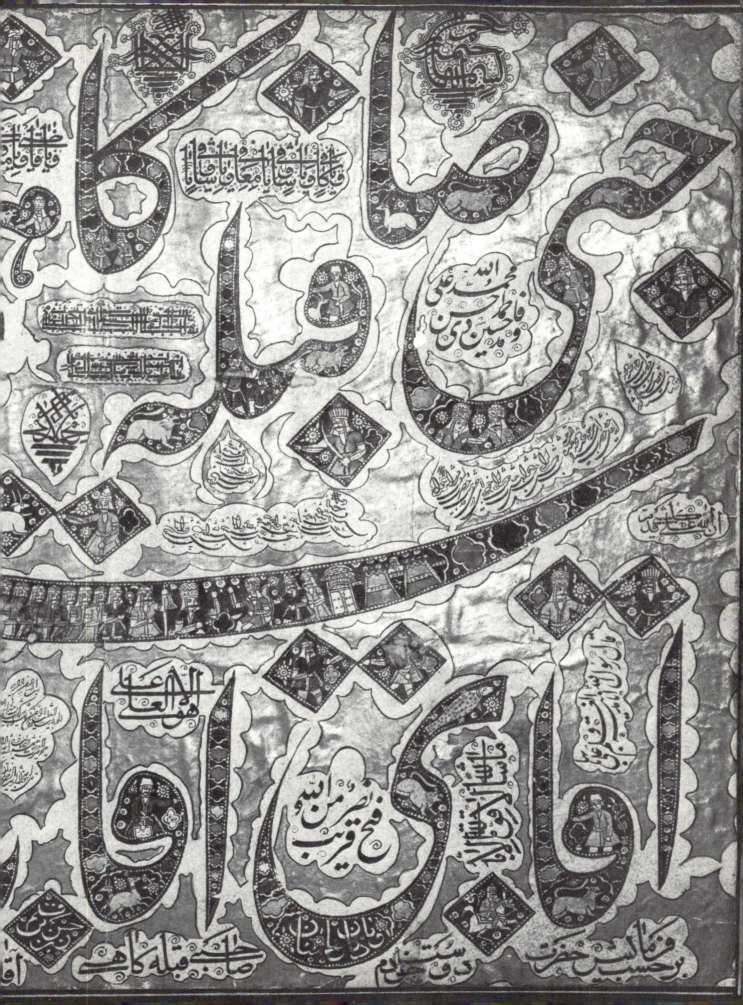

124 Brocade woven with Thuluth script in four of its different
forms, the most stylized being in the shape of medallions. The
most prominent band is the Shahādah – 'There is no God but
God, and Muḥammad is the Messenger of God' – repeated in
bold Jalī Thuluth. Syria, Ottoman period, probably 18th century

125 Tomb-cover with inscriptions in Maghribī, ornamental
Thuluth and square Kufic, arranged in panels of various shapes.
The text is mainly Quranic and benedictory. Morocco, 18th
century

127 Tombstone of Maḥmūd ibn Dādā Muḥammad, of which virtually the entire surface consists of different types of script. The outermost band contains ornamental foliated Kufic, Qur'ān, Sūrat al-Ikhlāṣ, 'Unity' (CXII, 1–4). The next band in ornamental Thuluth verging on Riqā' is a dated funerary dedication. The inner frame and the niche itself contain angular Kufic inscriptions. The maze set above the arch is the Shahādah, also in square Kufic. Persia, dated 1352

126 Plaited, knotted and foliated Kufic surrounded by a border of Thuluth verging on Riqā', carved on a wooden Qur'ān-stand. The Kufic is the word 'Allāh', the Thuluth is the Throne Verse (II, 255). Turkey, c. 13th century

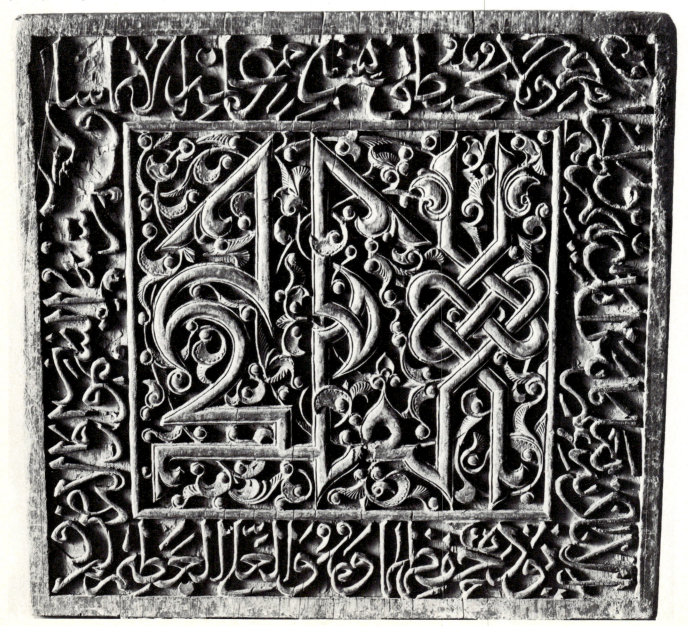

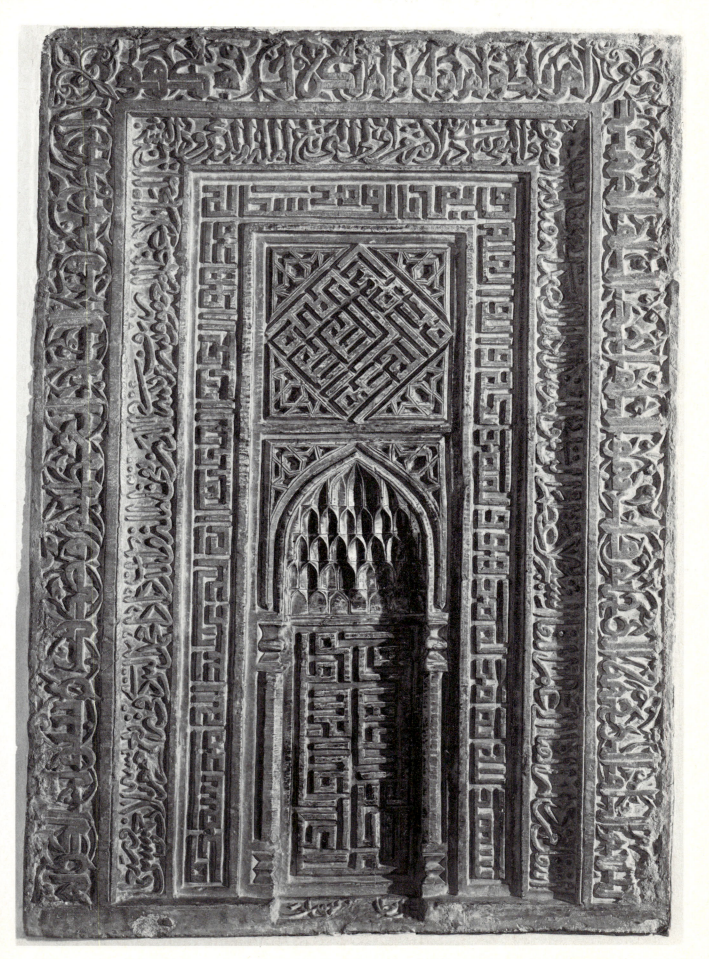

Calligraphy as primary motif

The primacy of the word in Islam is reflected in the virtually universal application of calligraphy. Writing is given pride of place on all kinds of objects – objects of everyday use as well as entire wall surfaces, mosque furniture, the interiors and exteriors of mosques, tombs, and al-Kaʿbah, the most famous sanctuary of Islam.

128 Plate decorated in Nishapuri style with Eastern Kufic, highly stylized, which reads: 'The pursuit of knowledge is bitter to the taste at first, but at the end is sweeter than honey.' The word *as-Salāmah*, 'safety', is used here as a space-filler at the end of the inscription. Samarqand, late 10th century

129 Plaited and ornamental Kufic script combined with Andalusian Thuluth covering a wall of the Alhambra, Granada. Some of the script has been deliberately manipulated to form arches and mirror images. The most legible phrase reads: *al-ʿIzzah li-Llāh* – 'Glory belongs to God'. Probably 13th century

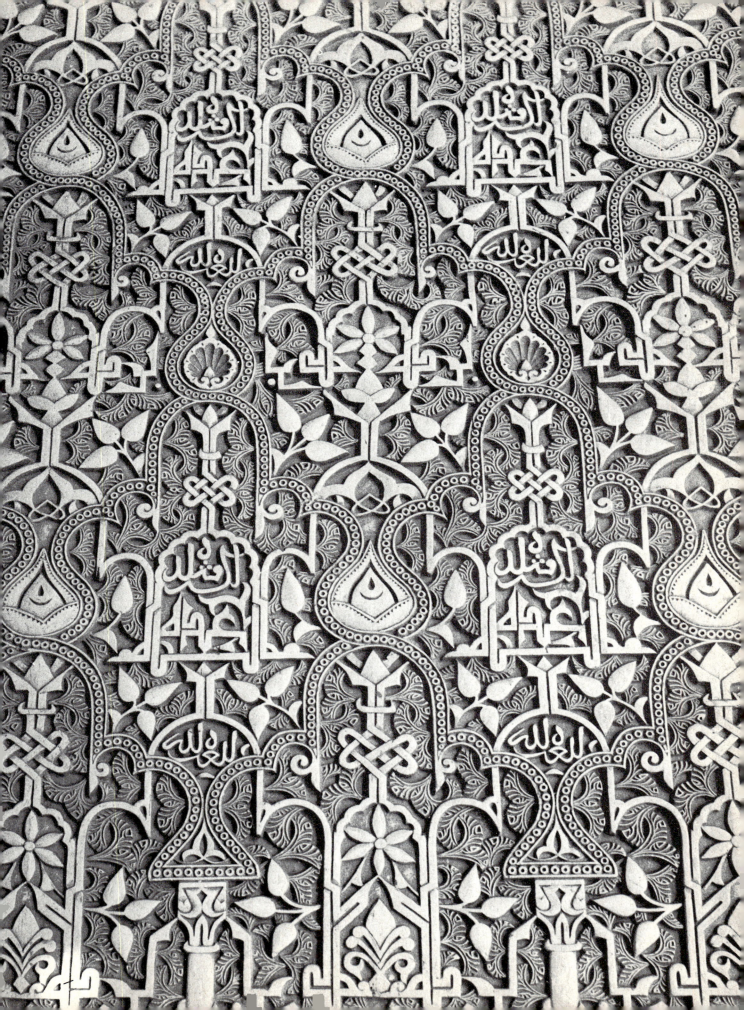

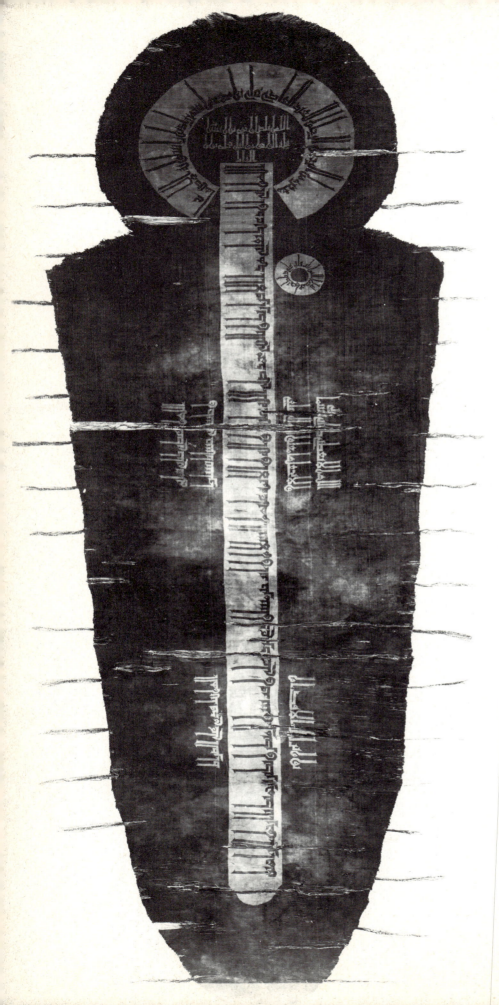

130 Silk pall found in a tomb near Teheran, Persia, early 11th century. The small circle of Kufic script is intended to be placed over the heart, and reads: 'May God keep my heart steadfast in His religion . . .'

131 Thuluth on a silk tomb cover, with Quranic verses and other writings. One of the phrases links the cloth with the Ottoman Sultan Sulaymān I (1520–66), for it reads: *Mawlānā al-Sulṭān Sulaymān*, 'Our lord Sultan Sulaymān'

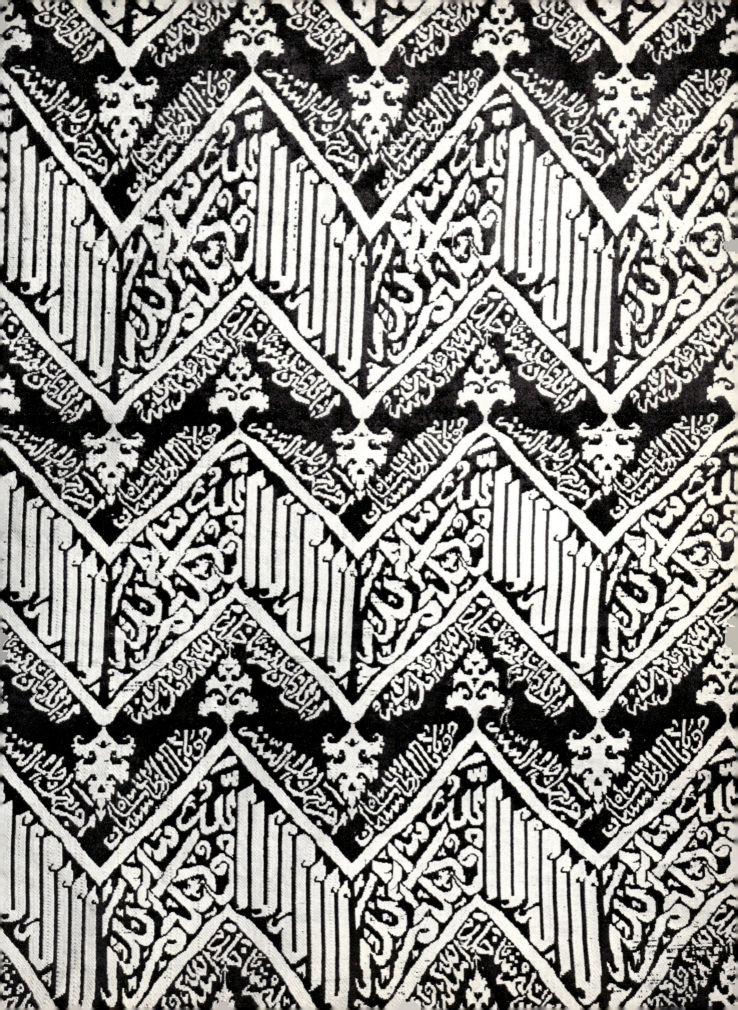

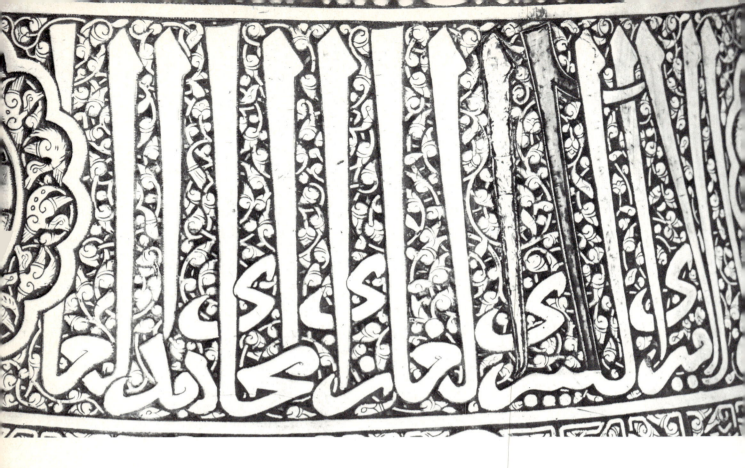

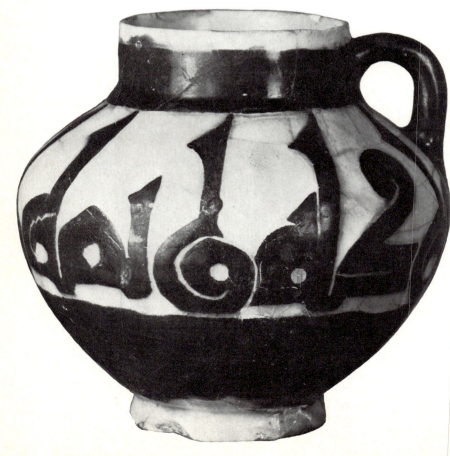

132 Mamluk Thuluth decoration on a candlestick made for the household of the Mamluk Sultan Qalāwūn (1279–90). The inscription reads: 'The royal prince, the great Emir, the conqueror, the campaigner in holy wars, the just . . .'

133 Kufic script on a jug from Persia, early 13th century, probably reading *Naḥmuduhu wa-na'buduhu*, 'We praise Him and worship Him'

134 The tip of a Persian battle standard engraved with Nasta'līq script giving the names of the Twelve Imāms of the Shī'ah sect on the palm, and Shī'ah prayers on the fingers. 18th century

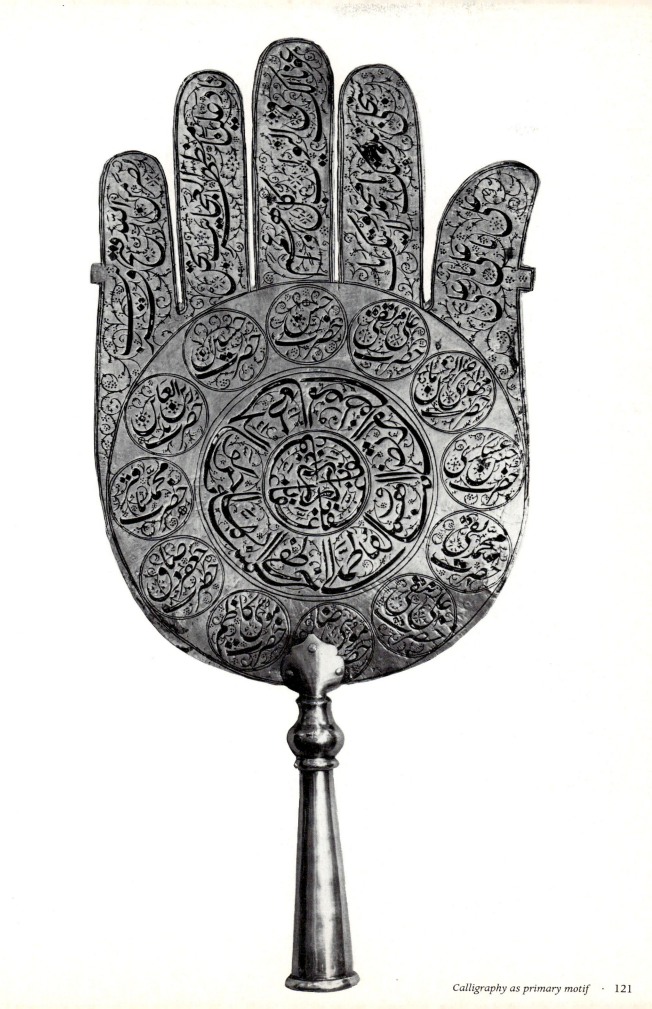

Calligraphy as primary motif · 121

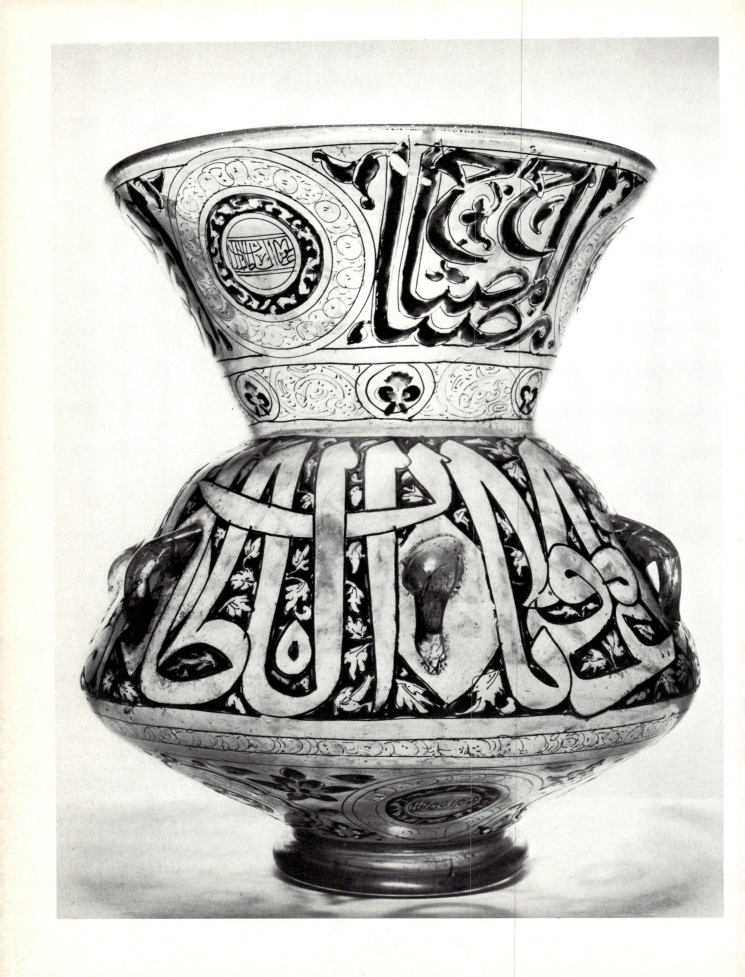

135　Glass mosque lamp with Mamluk Thuluth blazons on the neck, reading 'Glory to our lord the Sultan', and between them, text from Sūrat al-Nūr, 'Light' (XXIV), which translates: 'God is the light of the heavens and the earth, the likeness of His light is as a niche wherein there is a lamp encased by glass, the glass appearing as it were a shining star.' The main panel, on the body, is in Ṭūmār script and reads as the blazon. Syria, probably late 13th century

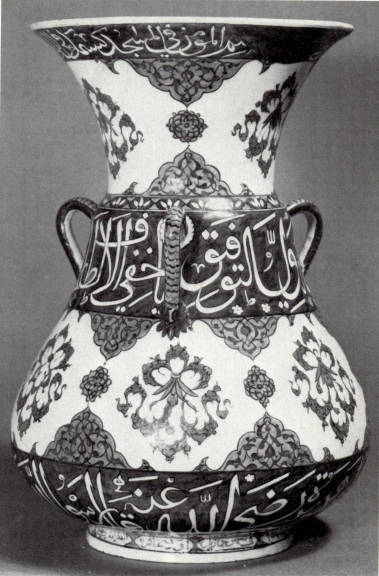

136　Ceramic mosque lamp with Thuluth inscription, from Turkey, 1549. The part of the middle band which is visible translates: 'God is the patron of success'

137　Tomb cover with Jalī Thuluth inscriptions, the Throne Verse (II, 255) on the top, *Ḥadīth* (Sayings of the Prophet) on the sides. Bursa, Turkey, 15th century

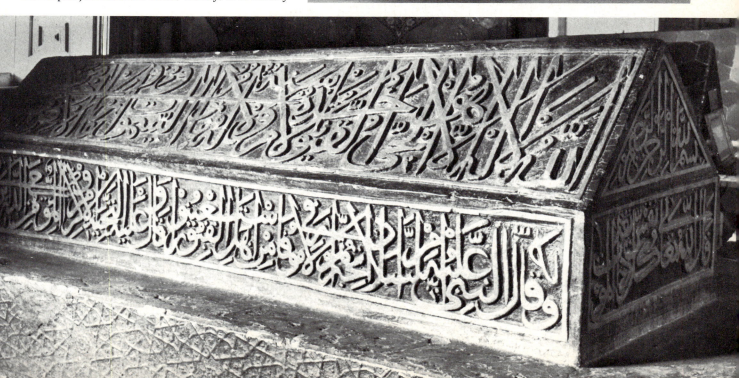

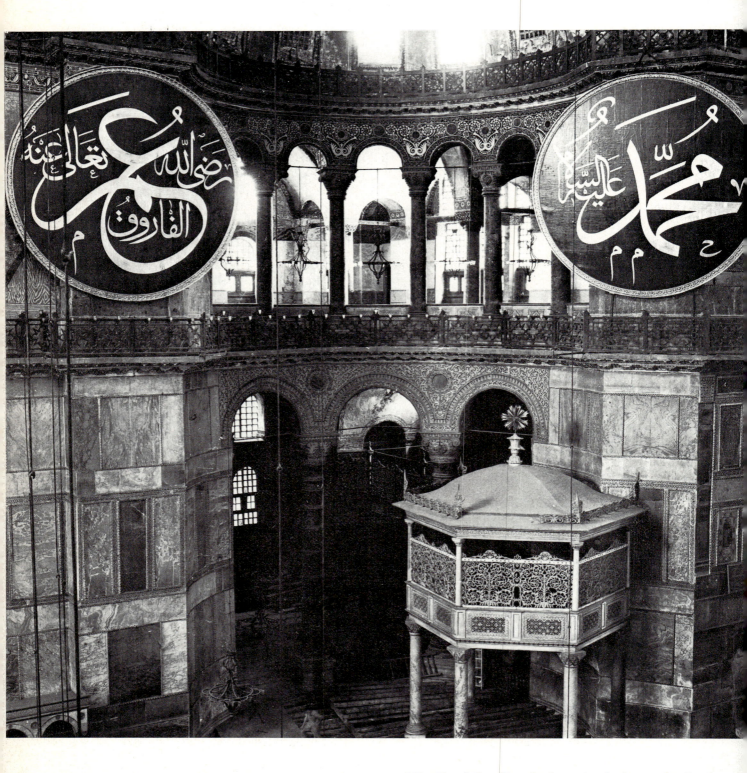

138 The great calligraphic medallions suspended inside the mosque of Hagia Sophia in Istanbul. The medallion on the left bears the name of the second Orthodox Caliph, ʿUmar al-Fārūq, and continues: 'May God the Exalted be pleased with him'; while the medallion on the right reads: 'Muḥammad, may peace be upon him'

139 Glazed tile calligraphy decorating the dome and walls of the 'Tomb of the Prince', the mausoleum in Samarqand where Tamerlane is buried, dating from 1443. The wide band of ornamental Kufic beneath the dome consists mainly of the words al-Baqāʾ li-Llāh, 'Eternity is for God'. The walls bear the names Allāh, Muḥammad and ʿAlī, in square Kufic

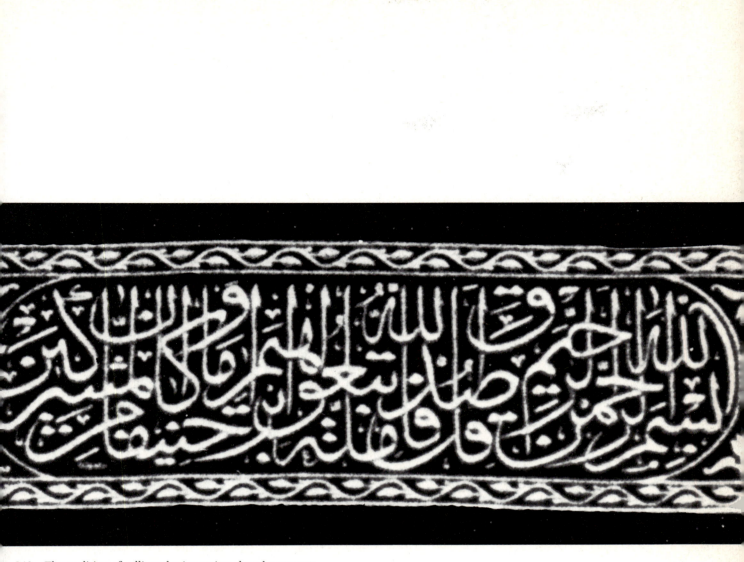

140 The tradition of calligraphy is continued to the present
day in the cloth which covers the Kaʿbah, the 'sacred house of
God'. This special cloth, called *Kiswah*, is renewed each year. It
is traditionally decorated with panels and bands in Jalī Thuluth
in gold and silver, with the words of the Shahādah, the Muslim
creed, faintly outlined in the weave of the fabric itself. The cloth
is traditionally provided by Egypt. Each year the superseded
cloth is cut up and the pieces are distributed to Muslim
dignitaries. The detail (above) in Jalī Thuluth is the Basmalah
followed by a Quranic verse from Sūrat Āl ʿImrān, 'The Family
of ʿImrān' (III, 95), which translates: 'Say: God speaks the truth,
so follow the religion of Abraham, the true faith, for he was not
one of the polytheists'

Islamic calligraphy and Western art

The impact of Arab-Islamic art on the artistic traditions of the Christian world in the Middle Ages was considerable. There was much sustained contact between the two cultures, and through these contacts, particularly across Spain and Sicily and during the Crusades, the West became fascinated by the exotic quality of Islamic art. This interest was often reflected in the imitation of style, motif and technique, and extended to architectural decorative design, textiles, ceramics, metalwork, glass, ivories and other objects of art.

Robes and haloes in countless Renaissance paintings are decorated with pseudo-Arabic calligraphy, and this is especially evident in paintings representing the Virgin and Child.

141 Stylized Kufic on the back of a marble chair in S. Pietro di Castello in Venice. It is claimed that this chair was used by St Peter in Antioch, which is unlikely, for although it emulates a Muslim tombstone, both the stylized Kufic script and the other decorative motifs suggest a European provenance, probably Sicily or even Venice

142 Plate reputed to have belonged to an Archbishop of Ravenna, Piero Crisologo, and to have been used in the celebration of Mass, with stylized ornamental Kufic inscription which may read: *Naḥmad Allāh lammā na'kul* – 'We praise God when we eat.' Italy, probably late 11th century

143 Cross found in Ballycottin Bog, Youghal, Co. Cork, with a crude rendering in Kufic script of the words *Bism Allāh* – 'In the Name of God'. Probably 9th century

144 Gold Dinar of Offa, King of Mercia (757–96), an imitation of an Abbasid Dinar. The Arabic Kufic inscriptions read (top): *Lā ilāh illā Llāh Waḥdah lā sharīk lah*, 'There is no god but God, He has no partners'; (below): 'Muḥammad is the Prophet of God', with the words Offa Rex between, and a date in corrupt Kufic which may read AH 173 (i.e. 789)

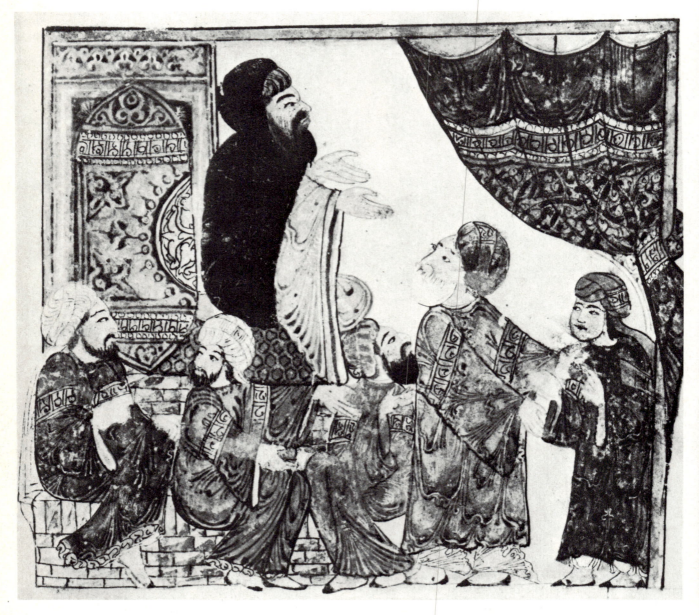

145, 146 Arabic miniature-painting depicting a scene from the
Maqāmāt, a literary narrative by al-Qāsim ibn ʿAlī al-Ḥarīrī
(d. 1122), produced in Iraq, probably in Baghdad, in 1236, with
pseudo-calligraphic designs decorating the borders of the robes
and the curtains, which no doubt directly influenced European
paintings of the Middle Ages. Compare the robe borders and
cushions in a painting of the Coronation of the Virgin by the
Italian painter Paolo Veneziano (d. 1362)

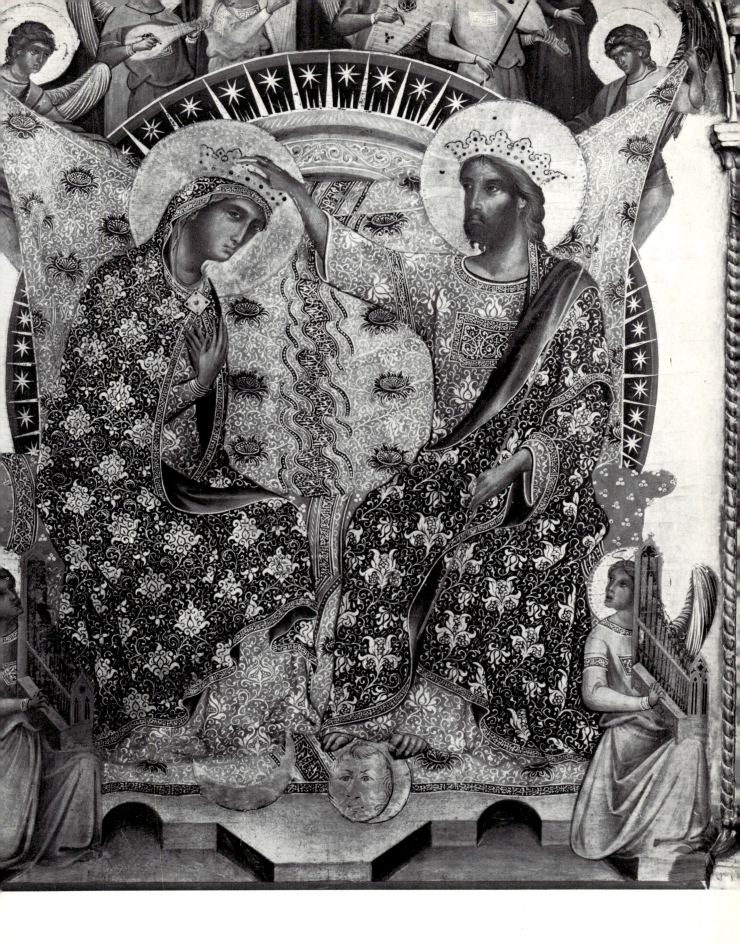

Calligraphic signs and devices

In general the historical development of Islamic
calligraphy is from the simple to the more elaborate.
Contrived decorative forms such as zoomorphic motifs
became increasingly popular during the 19th century.
The Ṭughrā, a calligraphic form invented by the
Ottoman Turks, is an elegant and decorative emblem
which each Ottoman sultan adopted to bear his name
and to serve as his official signature.

147 Ṭughrā of the Ottoman Sultan Bāyazīd II
(1481–1512)

148 Ṭughrā of the Ottoman Sultan Sulaymān the
Magnificent (1520–66), with the Sultan's epithet in
ornamental Dīvānī script at the base

149 The phrase al-Ḥamd, al-Walī, al-Ḥamd – 'Praise
to the worthy benefactor', written in connected
Thuluth in Gulzār style by Aḥmad Qaraḥiṣārī in 1547,
probably in Istanbul

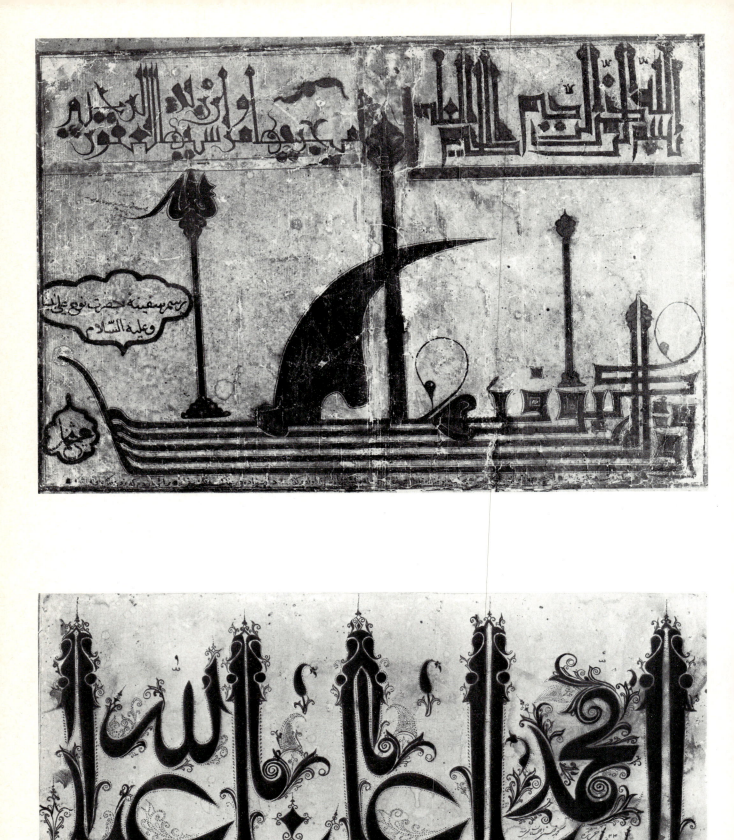

150 (left) Ornamental Kufic and Naskhī scripts manipulated to represent Noah's Ark. Composite calligraphic page from the Ottoman period. Turkey, probably early 19th century

151 Stylized ornamental Naskhī, Persia, dated 1883. The text translates: 'O Muḥammad ʿAbd Allāh, may peace be upon you'

152 Ornamental Kufic script in the shape of a mosque, from a wall of Ulu Cami in Bursa, Turkey, probably late 18th century. The text is praise of the Prophet Muḥammad

153 Calligraphic page of square Kufic script in the form of a mosque, probably by Darwīsh Amīn Naqshibandiyī. The text is the Shahādah: 'There is no god but God, and Muḥammad is the Messenger of God.' Turkey, Istanbul, 1743

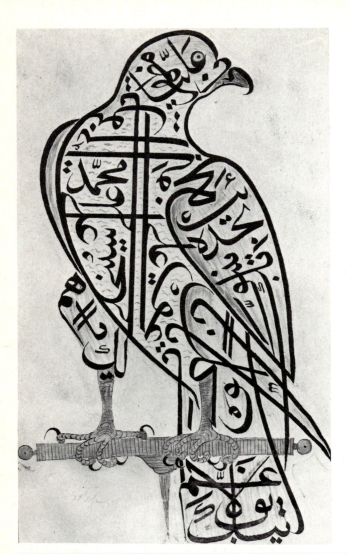

154 Zoomorphic calligraphy, Shīʿah prayer in Thuluth structured into the shape of a falcon, by Muḥammad Fatḥiyāb, Persia, early 19th century

155 Lion formed of ornamental Tawqīʿ script which reads: '*Alī ibn Abī Ṭālib, raḍiya Llāh Taʿālā ʿanhu wa-Karrama wajhahu* – ʿAlī ibn Abī Ṭālib, may God Almighty be pleased with him and honour him.' Persia, probably 19th century

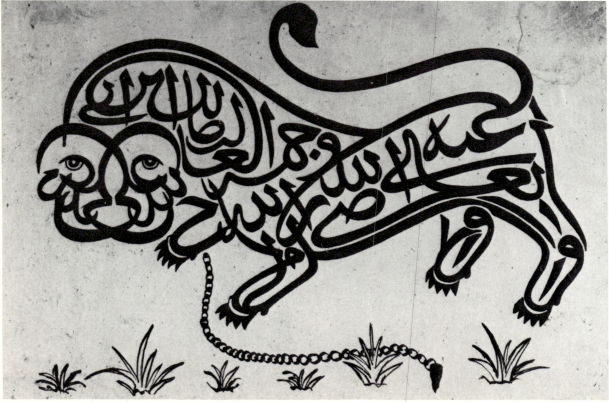

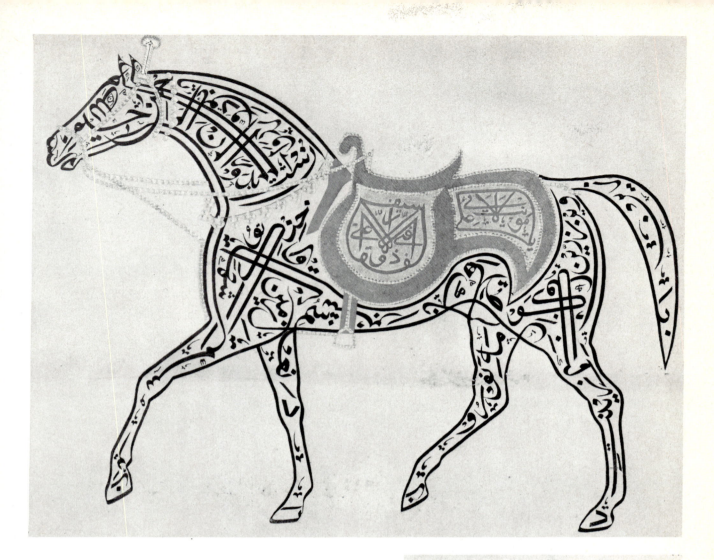

156 Shī'ah prayer in Naskhī structured into the shape of
a horse, by Sayyid Ḥusayn 'Alī, Persia, 1848

157 Mirror-writing, with the letter *waw* ('and') in Gulzār
style repeated reversed left to right in the body of a ewer.
This is followed, at the juncture of the letters, by a phrase
in Thuluth: *mā shā' Allāh* – 'whatever God wills'.
Turkey, probably late 18th century

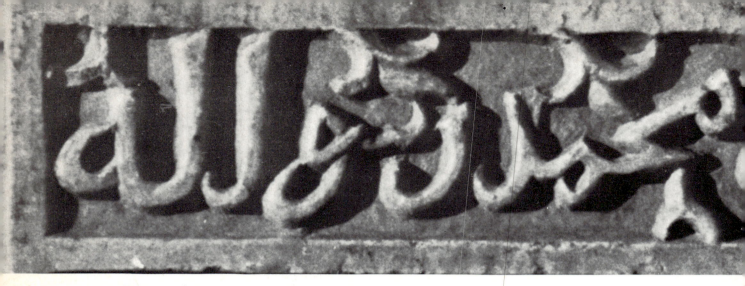

The Shahādah – 'There is no god but God, and Muḥammad is the Messenger of God'

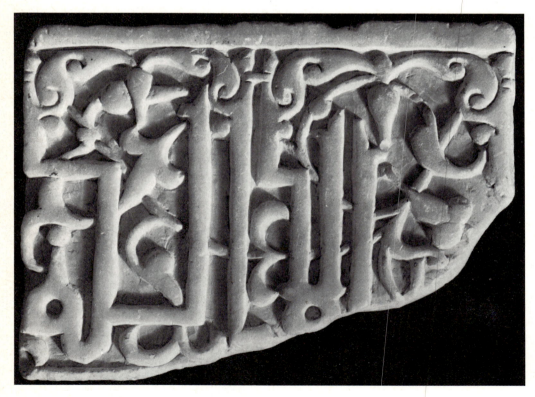

The Shahādah –
*Lā ilāh illā Llāh,
Muḥammad rasūl Allāh* –
is the profession of faith
which all Muslims must
proclaim.

158 The second part of the
Shahādah, *Muḥammad rasūl
Allāh*, in ornamental Indian
Naskhī verging on Thuluth.
India, probably 12th century
(above)

159 Part of the Shahādah
reading '. . . but God'.
Ghaznawid alabaster frieze-
fragment with ornamental
foliated Kufic. Afghanistan,
12th century

160 The second part of the
Shahādah, from the side of a
Chinese porcelain incense-
burner, 16th century

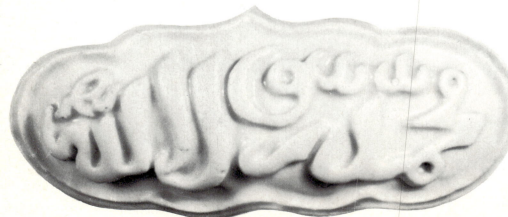

161 The second part of the
Shahādah carved on a
column in the Great Mosque
of Kairouan, 10/11th century

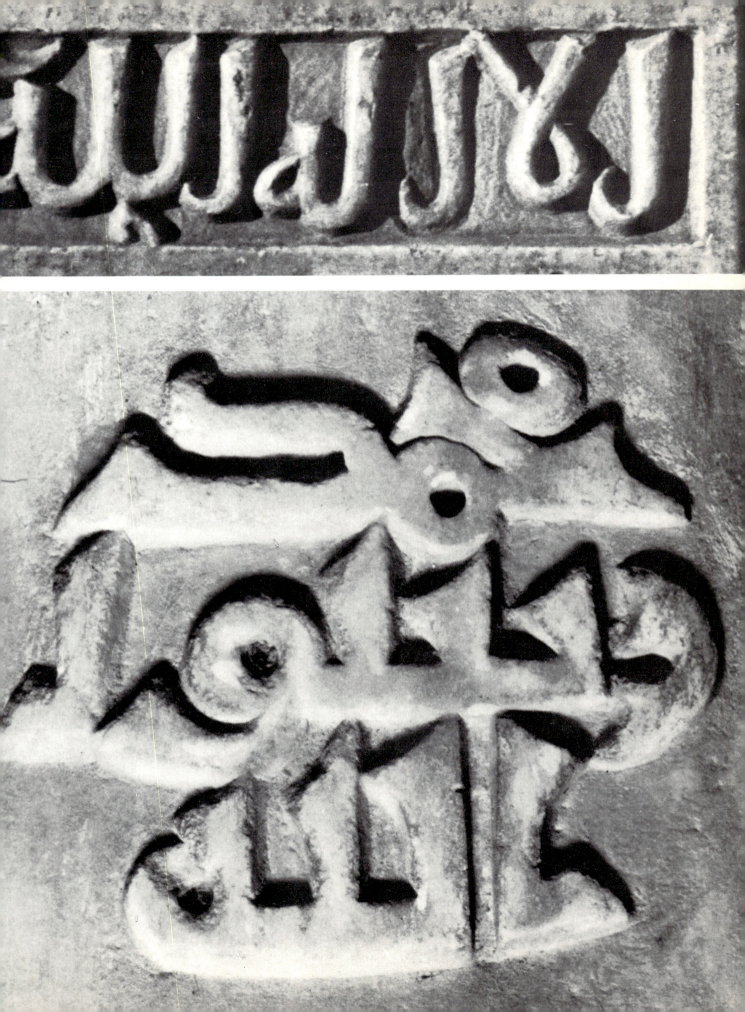

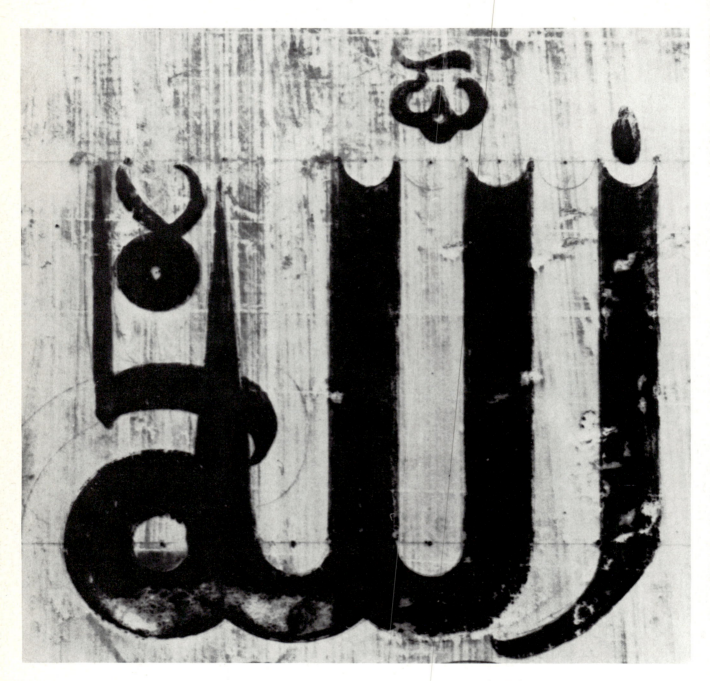

Allāh

162 The word 'Allāh' in modern Maghribī script, from a wooden calligraphic tablet, Morocco, late 19th century

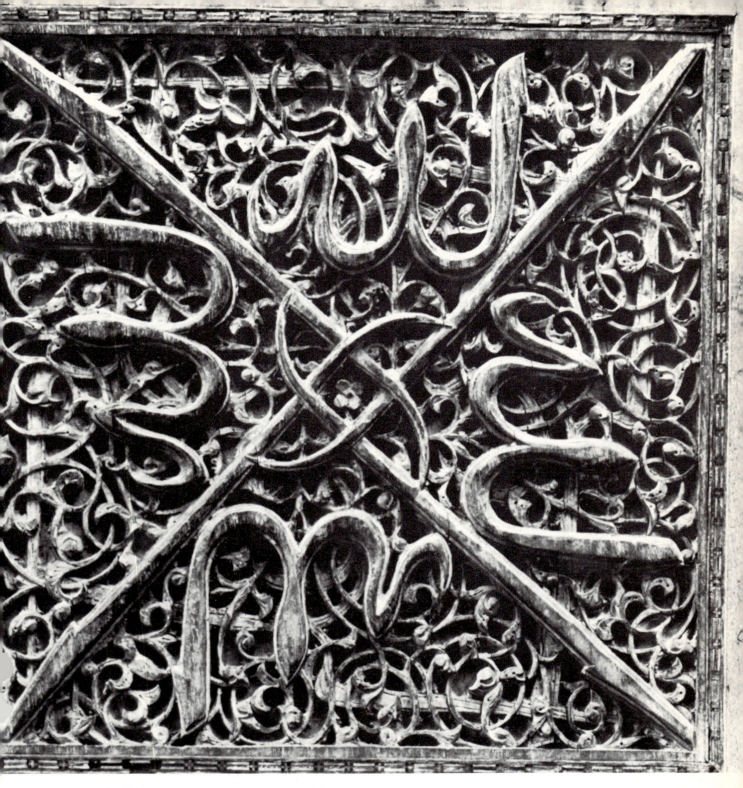

163 The word 'Allāh' in stylized Thuluth script, repeated four
times. From a carved wood Qur'ān-stand, Persia, dated 1360

The Arabic alphabet

Arabic	Translit.	Name	Arabic	Translit.	Name	Arabic	Translit.	Name	Arabic	Translit.	Name
ا	ā	Alif	د	d	Dāl	ض	ḍ	Ḍād	ك	k	Kāf
ب	b	Bā'	ذ	dh	Dhāl	ط	ṭ	Ṭā'	ل	l	Lām
ت	t	Tā'	ر	r	Rā'	ظ	ẓ	Ẓā'	م	m	Mīm
ث	th	Thā'	ز	z	Zāy	ع	'	'Ayn	ن	n	Nūn
ج	j	Jīm	س	s	Sīn	غ	gh	Ghayn	ه	h	Hā'
ح	ḥ	Ḥā'	ش	sh	Shīn	ف	f	Fā'	و	w(ū)	Wāw
خ	kh	Khā'	ص	ṣ	Ṣād	ق	q	Qāf	ى	y(ī)	Yā'
									ء	'	Hamzah

The Arabic alphabet consists of twenty-nine letters, and Arabic is written from right to left. Most Arabic letters alter their character form slightly, depending on whether their position in the word is initial, medial or final, and on whether they join another letter or they stand alone. Only the unjoined final forms of letters are given above.

All these letters, with the exception of *Alif*, represent consonants. و and ى are semivowels because, in addition to representing the consonants w and y respectively, they also represent the long vowels ū and ī and the diphthongs aw and ay. The short vowels are represented by orthographical signs called *Fatḥah* (a), *Ḍammah* (u) and *Kasrah* (i), placed above or below the letters, e.g. بَ (ba), بُ (bu), بِ (bi). Other orthographical signs are *Shaddah* ّ , *Maddah* ٓ and *Sukūn* ْ . ء is a glottal stop called *Hamzah*, of which there are two types: the *Cutting Hamzah* and the *Joining Hamzah*.

Glossary

AH (*anno hegirae*). The Muslim calendar is reckoned from the flight of the Prophet Muḥammad from Mecca to Medina in AD 622.

Alif The Arabic long vowel ā, also used as a standard unit of measurement for other Arabic characters.

Asnān, 'teeth' In writing, it denotes short vertical stems or elevations rising from a horizontal line.

al-Basmalah The expression *Bism Allāh al-Raḥmān al-Raḥīm*, 'In the name of God, the Compassionate, the Merciful', which appears at the head of every chapter of the Qur'ān, with the exception of Sūrat al-Tawbah, 'Repentance' (IX). In its complete form, the Basmalah occurs only once in the actual text of the Qur'ān, in Sūrat al-Naml, 'The Ant' (XXVII, 30). A contracted form of the Basmalah, consisting of the words *Bism Allāh*, 'In the name of God', is also often used and is called *Tasmiyah*. The invocation of the Basmalah or the Tasmiyah is considered to have great benedictory powers, and is therefore used in talismans and amulets, and before important acts in everyday life.

Ḍammah An orthographical sign placed above a letter to indicate that the consonant is followed by a short vowel (u).

Fatḥah An orthographical sign placed above a letter to indicate that the consonant is followed by a short vowel (a).

Hamzah A glottal stop. There are two types: *Hamzat al-Qaṭ'*, 'Cutting Hamzah', used initially, medially and finally in a word, and *Hamzat al-Waṣl*, 'Joining Hamzah', used only initially.

Ḥuffāẓ (plural of *Ḥāfiẓ*). A Muslim who has committed the whole Qur'ān to memory.

I'jām See *Naqt*.

Kasrah An orthographical sign placed under a letter to indicate that the consonant is followed by a short vowel (i).

Khafīf 'Light' or 'thin', used with the names of certain calligraphic styles to indicate that the lines have become thinner and the curves and flourishes more delicate.

al-Khaṭṭ (plural *Khuṭūṭ*). Arabic for calligraphic handwriting and pen-manship.

al-Khulafā'al - Rāshidūn 'Righteous or Orthodox Caliphs', a term given to the first four successors to the temporal powers of the Prophet Muḥammad.

Maddah An orthographical sign with the value of *Hamzah + Alif*.

Miḥrāb Arabic for a prayer niche, particularly a recess in a mosque indicating the direction of prayer.

Naqt 'Letter-pointing', also known as *I'jām*. The system of placing a certain number of small dots above or below a letter to differentiate consonants with identical outlines.

Qalam Pen. The main writing implement used on paper, parchment or papyri. It may be plain or highly embellished, and is of two types: a vegetable qalam, usually a reed pen; and an animal qalam, usually a brush made of animal hair. The traditional way to hold the qalam is with the middle and forefinger and the thumb evenly spread out, using the minimum of pressure.

Shaddah An orthographical sign placed above a letter to double its consonantal value.

Sukūn An orthographical sign placed above a letter to indicate that the consonant is vowelless.

Sūrah A chapter of the Qur'ān.

Tashkīl The application of the various orthographical signs to the Arabic consonants to represent the Fatḥah, Ḍammah, Kasrah, Sukūn, Shaddah, etc., by the various diacritical marks which were systematized by al-Khalīl ibn Aḥmad, and which superseded the system of diacritical dots initially developed by Abū l-Aswad al-Du'alī. Complete Tashkīl is known as 'full vocalization' and partial Tashkīl as 'semi-vocalization'.

Ṭughrā A calligraphical emblem used first by the Oghuz, then by the Seljuq rulers. It was later adopted by the Ottoman sultans, who developed it into a distinctive calligraphic art-form, usually bearing their individual names. It was normally used as their signature and coat-of-arms and displayed on official documents, coins and banknotes, monuments, ships, flags, jewellery, postage stamps, etc. It was often used highly embellished and illuminated in gold and colours.

'Unwān, or **'Unvān** Title-page of a book or a manuscript copy. In Qur'āns, it features as a double title-page, usually richly decorated and illuminated in gold and colours.

Illustration acknowledgments

H.H. Aga Khan Collection, Geneva: 2, 29, 51
Ashmolean Museum, Oxford: 160
Author's Collection, London: 73, 108
Bayerische Staatsbibliothek, Munich: title page
Bibliothèque Nationale, Paris: *p. 23*; 37, 107, 145

Collection of Edward Binney, 3rd: 94, 157
Boston, Museum of Fine Arts: 7, 150
Bluett & Son Ltd., London: *p. 31*; 123, 155
British Library, London: *pp. 7–9, 15, 21–2, 28, 30*; 4, 14, 29, 30, 34, 48, 52–4, 68, 76–7, 79, 80, 106
British Museum, London: *p. 13*; 5, 6, 10, 20, 22, 24, 29, 43, 86, 89, 93, 96, 100–1, 113–14, 116, 138, 143–4
Burgos, Monastery of Las Huelgas: 83
Cairo, Islamic Museum: 39, 98
Cairo, National Library: 58, 62, 64, 66
Chester Beatty Library, Dublin: 32, 88, 103

Chicago, Art Institute: 27
Cleveland Museum of Art, Wade Fund: 130
Christies, London: *p. 29*; 16, 59
C. L. David Collection, Copenhagen: 9
Fitzwilliam Museum, Cambridge, Major Ades Collection: 92
Fogg Art Museum, Harvard University: 7, 157

Select bibliography

Abbott, Nabia, *The rise of the North Arabic script and its Ḳurʾānic development*, Chicago 1939
Aḥmad, Qāḍī, *Calligraphers and painters . . .*, translated from the Persian by V. Minorsky, etc., Washington 1959
ʿAlī, Muṣṭafā, *Menāqib-i hünerverān*, edited by Mahmud Kemal Bey, Istanbul 1926
Arberry, Arthur J., *The Koran illuminated. A handlist of the Korans in the Chester Beatty Library*, Dublin 1967
ʿArif, ʿĀʾidah S., *Arabic lapidary Kūfic in Africa; Egypt, North Africa, Sudan*, London 1967
Berchem, Max van, *Matériaux pour un Corpus Inscriptionum Arabicarum. Deuxième partie: Syrie du Sud*, Cairo 1927
Çiġ, Kemal, *Hattat Hafiz Osman Efendi, 1642–1698*, Istanbul 1949
Creswell, Sir K. A. C., *Bibliography of the architecture, arts and crafts of Islam*, Cairo 1961; Supplement, January 1960–January 1972, Cairo 1973. Both contain extensive sections on calligraphy and palaeography.
Ettinghausen, Richard, *Arab Painting*, Geneva 1962
——, 'Manuscript illumination', in Pope, Arthur U., *Survey of Persian art*, III, London 1938
Flury, S., 'Calligraphy. Ornamental

Kūfic inscriptions on pottery', in Pope, Arthur U., *Survey of Persian art*, II, London 1938
——, *Islamische Schriftbänder Amida – Diarbekr XI. Jahrhundert*, Basel 1920
Grohmann, Adolf, *Arabische Paläographie*, Vienna 1967
al-Harawī, Muḥammad ʿAlī ʿAṭṭār, *Samples of various calligraphies named 'Ganjineh-e Khotoot' (Treasures of calligraphies)*, Kabul 1967
Houdas, O., 'Essai sur l'écriture maghrebine', in *Nouveaux Mélanges Orientaux*, Paris 1886
Huart, Clément, *Les calligraphes et les miniaturistes de l'Orient musulman*, Paris 1908
Inal, Ibnülemin Mahmud Kemal, *Son hattatlar*, Istanbul 1955
al-Jubūrī, Suhaylah Yāsīn, *al-Khaṭṭ al-ʿarabī wa-taṭauwuru-hu fiʾl-ʿuṣur al-ʿabbāsiyyah fiʾl-ʿIrāq*, Baghdad 1962
Khatibi, Abdelkebir, and Sijelmassi, Mohammed, *The Splendour of Islamic Calligraphy*, translated from the French *L'art calligraphique arabe*, London, New York 1976
al-Kurdī, Muḥammad Ṭāhir, *Taʾrīkh al-Khaṭṭ al-ʿarabī wa-adābuhu*, Cairo 1358 [1939]
Lanci, Michele A., *Trattato delle simboliche rappresentazioni arabiche e della varia generazione de' musul-

mani carattere sopra differenti materie operati*, Paris 1845–46
Lings, Martin, *The Quranic art of calligraphy and illumination*, London 1976
Lings, Martin, and Safadi, Yasin Hamid, *The Qurʾān*, exhibition catalogue, London 1976
Moritz, B., *Arabic Palaeography*, Cairo 1905
al-Munajjid, Salāh al-Dīn, *Dirāsāt fī taʾrīkh al-Khaṭṭ al-ʿarabī*, Beirut 1972
——, *al-Kitāb al-ʿarabī l-makhṭūṭ*, Cairo 1960
Mustaqīm-Zādah, Sulaymān, *Tuḥfah-yi Khaṭṭāṭīn*, Istanbul 1928
al-Nadīm, Muḥammad ibn Isḥāq, *Kitāb al-fihrist*, edited by G. Flügel, Leipzig 1871–72, photographic reprint Beirut 1965
al-Nāmī, Khalīl Yaḥyā, *Aṣl al-khaṭṭ al-ʿarabī*, etc., Cairo 1935
Pope, Arthur Upham, *Persian Architecture*, New York 1965
——, *Survey of Persian art*, London 1938, reprinted Tokyo 1969
al-Qalqashandī, Aḥmad ibn ʿAbd Allāh, *Subḥ al-Aʿshā*, Cairo 1913/14
al-Qurashī, ʿAbd al-Raḥīm ibn ʿAlī, *Maʿālim al-kitābah wa-maghānim al-iṣābah*, Beirut 1913
Rice, David S., *The unique Ibn al-Bawwāb manuscript in the Chester Beatty Library*, Dublin 1955

Robertson, Edward, 'Muḥammad ibn ʿAbd ar-Raḥmān on calligraphy', edited and translated by E. Robertson, in *Studia Semitica et Orientalia*, pp. 57–83, Glasgow 1920
Schimmel, Annemarie, *Islamic calligraphy*, Leyden 1970
al-Ṭībī, Muḥammad ibn Ḥasan, *Jāmi ʿmaḥāsin kitābat al-kuttāb*, edited by Salahuddin Munajjid, Beirut 1962
Titley, Norah M., 'Islam', in *The book through 5000 years*, 'The book in the Orient', pp. 51–83, London and New York, 1972
Ünver, A. Süheyl, *al-Khaṭṭāṭ al-Baghdādī ʿAlī ibn Hilāl*, Cairo 1958
Vajda, Georges, *Album de paléographie arabe*, Paris 1958
Wiet, G., *Matériaux pour un Corpus Inscriptionum Arabicarum. Première partie: Égypte*, Cairo 1929–30
Yazir, Mahmud Bedreddin, *Medeniyet âleminde yazıve islâm medeniyetinde kalem güzeli*, Ankara 1972
Zayn al-Dīn, Nājī, *Badāʾiʿ al-khaṭṭ al-ʿarabī*, Baghdad 1972
——, *Muṣawwar al-khaṭṭ al-ʿarabī*, Baghdad 1968–
al-Zubaidī, Muḥammad Murtaḍā, *Ḥikmat al-ishrāq ilā kuttāb al-āfāq*, edited by ʿAbd al-Salām Hārūn, Cairo 1954

Index

Page numbers in italics refer to illustrations